ARTEMISIA GENTILESCHI

Books in the RENAISSANCE LIVES series explore and illustrate the life histories and achievements of significant artists, intellectuals and scientists in the early modern world. They delve into literature, philosophy, the history of art, science and natural history and cover narratives of exploration, statecraft and technology.

Series Editor: François Quiviger

Already published

Artemisia Gentileschi and Feminism in Early Modern Europe
Mary D. Garrard

Blaise Pascal: Miracles and Reason *Mary Ann Caws*

Caravaggio and the Creation of Modernity *Troy Thomas*

Donatello and the Dawn of Renaissance Art *A. Victor Coonin*

Hans Holbein: The Artist in a Changing World *Jeanne Nuechterlein*

Hieronymus Bosch: Visions and Nightmares *Nils Büttner*

Isaac Newton and Natural Philosophy *Niccolò Guicciardini*

John Evelyn: A Life of Domesticity *John Dixon Hunt*

Leonardo da Vinci: Self, Art and Nature *François Quiviger*

Michelangelo and the Viewer in His Time *Bernadine Barnes*

Paracelsus: An Alchemical Life *Bruce T. Moran*

Petrarch: Everywhere a Wanderer *Christopher S. Celenza*

Pieter Bruegel and the Idea of Human Nature *Elizabeth Alice Honig*

Raphael and the Antique *Claudia La Malfa*

Rembrandt's Holland *Larry Silver*

Titian's Touch: Art, Magic and Philosophy *Maria H. Loh*

Tycho Brahe and the Measure of the Heavens *John Robert Christianson*

ARTEMISIA GENTILESCHI

and Feminism in Early Modern Europe

MARY D. GARRARD

REAKTION BOOKS

Published by Reaktion Books Ltd
Unit 32, Waterside
44–48 Wharf Road
London N1 7UX, UK
www.reaktionbooks.co.uk

First published 2020

Printed and bound in China by 1010 Printing International Ltd

A catalogue record for this book is available from the British Library

ISBN 978 1 78914 202 0

CONTENTS

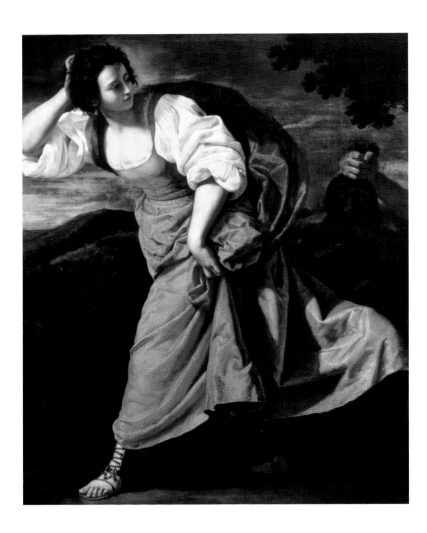

Preface

or too long, Artemisia Gentileschi has been treated as an isolated phenomenon whose radical pictorial assault on gender norms was unconnected to women's history. Many scholars prefer to avoid the gender issue in her art; some dismiss it as irrelevant to her place in art history. Meanwhile, the artist's large and growing audience, strongly female, savours her bold feminist expression and calls it just that. Scholars sniff that Artemisia's fans project a modern concept, anachronistically, on to an artist who painted before the term 'feminist' was invented. Yet feminism was a vital force before it was given that name, and Artemisia's embrace of feminism was a distinctive component of her claim to fame.

More than thirty years have passed since I wrote *Artemisia Gentileschi: The Image of the Female Hero in Italian Baroque Art*. In that first book to appear on the artist, I turned a modern feminist lens on her art and connected her in broad terms with the gender debates of her time known as the *querelles des femmes*. We now know more of the substance of those debates, thanks to the publication and translation of more women's writings than we ever imagined there to be, and it is evident that Artemisia dealt with the same issues that absorbed the

1 Detail of Artemisia Gentileschi, *Corisca and the Satyr*, c. 1635–7, oil on canvas (illus. 56).

writers: sexual violence, political power, the myth of female inferiority, and the cultural silencing of women's voices and achievements. As Artemisia's biography is being fleshed out, we learn that she could have known some of the writers. My goal in this book is to situate Artemisia's art firmly within a discourse that is now taking clearer historical shape, and to show how her paintings played a part in that discourse.

In early modern Europe, women were constantly advised to be 'chaste, obedient, and silent'. In reality, they were neither obedient nor silent, and perhaps not all that chaste. Because they were not silent, they were silenced, a condition that women overrode through speech both literary and visual. Their speech was overridden in turn by suppression and neglect. Over and over, women's voices are heard in their own time, then seem to die away. But history is created by repetition and magnification – something men have been quite good at – and if a woman artist or writer is not augmented through these tools, her *ars* will not be *longa*. When the writers discussed in this book admiringly cited past female writers, they intended to reclaim them to history. Their collective awareness of themselves as a community over time is an important cultural dynamic to be recognized.

Throughout the book, I use the term 'feminist', rather than 'proto-feminist' or 'pre-feminist', terms used by writers who would distinguish early modern feminist writers and texts from the 'real' feminist movements of the nineteenth and twentieth centuries. It is true that early modern pro-female and anti-misogynist writers were not called 'feminists' in their time. But, to repeat an analogy I have used before, the work of Galileo and Newton was not called science in

their day; it was natural philosophy. Today they are regarded
as foundational figures in the history of science – that is, sci-
entists. Like science, feminism existed before we knew what
to call it, and as with science, we must see the larger picture.
If we do not recognize feminism as a continuum that has
evolved over time, from the fourteenth century to the present,
we risk separating women from our history, and minimizing
feminism's significance in history writ large.

Some say that the early modern writers were not really
feminists because they didn't call for political action, that their
dialogues about 'the woman question' were essentially upper-
class parlour games. Ideas about gender injustice may have been
embroidered in courtly settings, but they were no less serious or
incisive for that. Arcangela Tarabotti's passion and pain scream
out in her words. Christine de Pizan and Veronica Franco
spoke out on behalf of women – who were not yet identified
as a social category – which surely counts as a political act.
Moreover, before the eighteenth century, few if any women
or men envisioned collective political action as a viable way
of righting social wrongs. We do not fault Leonardo da Vinci
because his aeroplane designs would not have worked; we see
his vision of human flight as an inspirational starting point
that led to the Wright brothers. The first writers to challenge
the gender status quo got people thinking and talking; they
inspired other writers, and created a conceptual foundation for
the political movements that brought change. If a distinction is
to be made between stages of feminism, we might distinguish
between the early modern theoretical phase and the modern
activist phase. But let us position and teach the entire history of
feminism as a major, continuous strand in our larger histories.

If feminist writings helped shape the larger history of early modern Europe, the visual arts were also part of the story. Images helped to shape the ideas and beliefs that defame women. Prints and paintings broadcast dangerous misogynist ideas about women across Europe – their diabolical nature, their deadly seductive charm – and they helped fuel the infamous witch-hunts. Visual images have also put forth benign and positive ideas about women, of course, yet until Artemisia came along, few images presented a picture of gender relations from a discernibly female point of view. Artemisia Gentileschi stands out in this respect for, more than any other pre-modern artist, she consistently contradicted and challenged patriarchal values.

Images provide a lasting counterpart to the transitory media of culture – musical and theatrical performances, or conversation. They literally have more weight, occupy real space and endure over time. Addressing the senses more quickly and directly than words, images cross linguistic boundaries to spread ideas in capsule form. A painting is disadvantaged by ambiguity, of course, for while feminist texts explain issues in unmistakably clear terms, a painting by Artemisia (or anyone) speaks more ambivalently. Yet polyvalence can also give visual images an advantage, multiplying meanings through embedded allusions to other images and identities. Characters such as Judith or Mary Magdalene, who are often given fixed typological identities by the feminist writers, gain depth and complexity in their changing iterations by Artemisia, with each new version of the character allusive in a different way.

Readers familiar with my earlier work on Artemisia will find here some key points restated, but also many new

propositions and interpretations to consider. These have arisen as much from engagement with the feminist literature as from consideration of recent art-historical scholarship and new attributions. This book is organized from the dual perspectives of feminist history and Renaissance–Baroque art history. Chapter One presents Artemisia's biography embedded in a broadly sketched history of feminism in early modern Europe; that larger history frames the chapter from beginning to end. In the subsequent chapters, I discuss Artemisia's art in relation to some important issues that have concerned women over time, and remain troublesome today.

Throughout this text, I call the subject 'Artemisia', as do most scholars nowadays. I used to explain that when writing about the artist, I called her by her first name (something often seen as patronizing to women) simply to distinguish her from her father. But as Artemisia approaches twenty-first-century superstardom, it is right that she is now known by one name, just like Michelangelo, Raphael and Caravaggio. After all, her gravestone was reportedly inscribed simply 'Haec Artemisia' – that single given name standing to attest her fame in her own time.

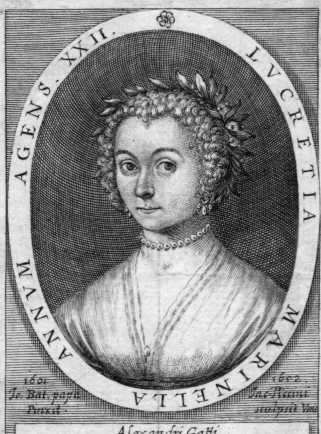

AGENS · XXII · LVCRETIA

ANNVM MARINELLA

1601
Io. Bat. pag.
Pinxit.

1600
Iac. Picini
sculpsit Ven.

Alexandri Gatti.

Obstupuit, Musis astantibus, altus Apollo,
 Versibus auditis, o Marinella tuis.
Hinc subito dixit; præsertim nomine Tassum,
 Exuperat uates hec poetria meos.
Auratam tibi tunc Citharam donauit eandem,
 Donauit radios tunc tibi quoque suos.

Artemisia and the Writers: Feminism in Early Modern Europe

n 1593, when Artemisia Gentileschi was born, women were legally the property of their fathers or husbands. They did not own their bodies, much less property, and many of them were economic pawns placed in arranged marriages or convents. Women were said to be weaker than men in reason and morality, and emotionally unstable. The medieval theological doctrine that women were evil and deceitful, the diabolical daughters of Eve, drove the witch-hunts that reached a frenzied peak between 1580 and 1630. These patent untruths served the ongoing determination of many men to maintain power in a patriarchal system. In the late sixteenth century, threatened by the rising proof that women were their intellectual equals, as women published sophisticated writings in growing numbers, insecure men perpetuated the misogynist lies and doubled down on them.

In Italy the growing control of Counter-Reformation institutions and reforms brought a rise in misogynist practices and writings. More and more women were cloistered in increasingly repressive convents, separated from the outside

2 Giacomo Piccini, *Lucrezia Marinella*, 1652, engraving after a painting of 1601 by Giovanni Battista Papa. Epigram by Alessandro Gatti.

world by high walls, veiled windows and iron grates. The reclusion of women in Italy was extreme by European standards. One French traveller reported that Venetian husbands treated their wives like criminals, imprisoning them in their rooms – a practice that paralleled their confinement in convents.[1] In a climate of growing social conservatism, misogynous treatises were produced, including one by the celebrated poet Torquato Tasso, author of *Gerusalemme liberata*.[2] As misogynist texts proliferated, a certain Giuseppe Passi recommended that wives be segregated like animals, since they existed only to propagate the species.

Giuseppe Passi's treatise *The Defects of Women* was published in Venice in 1599, and widely read during Artemisia Gentileschi's childhood.[3] According to Passi, women are evil to the core, irresponsible, uncivilized, untrustworthy, lazy, lustful, depraved, vain, fickle and more – a litany detailed in 35 chapters. This vitriolic diatribe, which repeated time-worn misogynist accusations, was met by outrage from the infuriated women of Ravenna (Passi's native city), who had to be officially placated. A Venetian publisher, Giovanni Battista Ciotti, commissioned several women to respond to Passi, one of them the Venetian poet Lucrezia Marinella (illus. 2), who was driven by passionate indignation to write a polemical treatise unique in her literary *oeuvre*: *The Nobility and Excellence of Women and the Defects and Vices of Men* (1600).[4]

Marinella's response to Passi includes a detailed account of illustrious women through history, from great queens such as Dido, Semiramis and Zenobia, to learned women skilled in arts and sciences, Hypatia, Sappho, Hildegard of Bingen and many more. In a scathing challenge to Passi's vituperation

of her sex, she accuses men of the very vices he had assigned to women. Addressing those who believe that learned women never existed ('even though they listen to these women every day'), and who revile the female sex ('though their mothers are women'), Marinella offers a multiplicity of examples in an argumentative tone: 'What shall we say of Queen Dido?' 'What of Semiramis?' 'Where is Sappho of Lesbos?' Marinella constructed intricate philosophical arguments to define woman's honourable nature and the equality of her soul, and jauntily blamed Aristotle for faulty reasoning along the way.[5]

Marinella's *Nobility* went into second and third editions in 1601 and 1621, vying with Passi's *Defects* in popularity, and it continued to provoke an angry response from women. In 1614 Bianca Naldi, in faraway Palermo, Sicily, was so enraged by Passi's treatise she wrote a response defending female honour that echoed Marinella, and was published by a Venetian bookseller.[6] The publication project that ensued from the Passi controversy signalled an active public interest in women's thoughts on the matter. Yet this gender controversy was not new, merely another iteration of a long-standing debate about the nature of women, the *querelle des femmes*, or the 'woman question' – a debate then two centuries old.

The so-called 'woman question' was, more accurately, women's ongoing resistance to the status quo, for without it, there would not have been a question at all. Women's challenge of patriarchal misogyny began with *The Book of the City of Ladies* (1405), written by Christine de Pizan to protest misogyny in the male-authored *Romance of the Rose*.[7] In Christine's treatise, women construct an allegorical city, a female counterpart to St Augustine's *City of God*, conceived as a building project (illus. 3).

Within this architectural metaphor, Christine deconstructs key axioms of misogynist thought, such as the idea that women are weak and irrational. She expounds a vision of women's capabilities, unrolling a long litany of exceptional women throughout history, from mythological goddesses and illustrious queens of antiquity down to modern queens of France. Christine's immediate model for the *City of Ladies* was Boccaccio's *De mulieribus claris* (1361–2), the collected biographies of famous historical and mythological women, which she consistently refuted and revised to show women in a more favourable light.[8] Whereas Boccaccio praised illustrious women as exceptions to their sex, unusually free of that sex's deficiencies, Christine saw them as outstanding examples of all women's capabilities. The *City of Ladies* was enormously influential and widely read across Europe, and is generally acknowledged as the starting point for the feminist resistance to misogyny in Western Europe, a breakthrough in thought that initiated a vigorous and lasting discourse. Because the writers were grappling with social injustices that have continued, they shaped a troubled debate about gender roles that remained alive far beyond their time. The early modern feminist movement provided a firm intellectual foundation for the political feminist movements of the modern era.

In the later fifteenth century, humanist scholars in northern Italy, including Cassandra Fedele, Isotta Nogarola and Laura Cereta (illus. 4), advanced the case of women's equality through oratory and writings.[9] Cereta argued for women's right to a liberal arts education, and eulogized their contributions to learning.[10] She traced a family tree of learned women across historical time, from Pallas Athena and Sappho to her

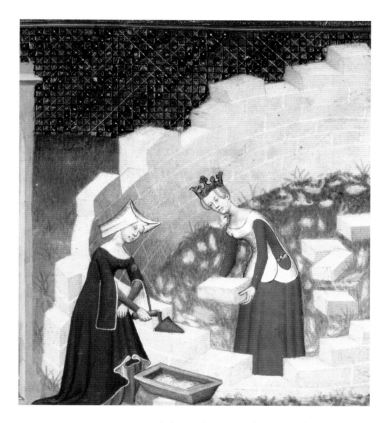

own contemporaries Fedele and Nogarola. It is a lineage, she claimed, that constitutes a 'republic of women', inverting a familiar humanist trope of a transhistorical republic of literary men. Cereta's ideal community was given life over time. A century later, Lucrezia Marinella added branches to Cereta's female family tree, inserting modern writers such as Laura Terracina, Vittoria Colonna and Laura Cereta herself. The ideal of a transhistorical community of women that extends into the present permeates the long catalogues of female

3 Lady Reason helps Christine construct the city, detail from *La Livre de la cité des dames* by Christine de Pizan (Paris, *c.* 1410), parchment.

paragons named by Christine de Pizan, Nogarola, Marinella and others. The same impulse motivated Judy Chicago to create *The Dinner Party* during the 'second-wave' feminist movement in 1970s America.

By naming contemporary female writers who inspired them, the feminist writers created an international community of women (today we would call it a network), linked laterally as well as transhistorically by their common cause. In Venice Moderata Fonte was cited by Marinella and Arcangela Tarabotti. In Holland Anna van Schurman expressed admiration for Marie le Jars de Gournay in France, and the praise was reciprocated. In England Bathsua Makin was inspired by Schurman. Male writers also name their heroes and acknowledge literary debts, of course, but naming heroes held more urgency for women. Perceived as culturally exceptional, their literary production and speech resisted as 'unnatural', the women writers sought affinity with others of their kind, justifying their very existence and reinforcing their professional validity through gender pride.

The ideal of a feminist community was translated into contemporary terms in Moderata Fonte's dialogue *The Worth of Women*, in which seven women representing all stages and kinds of womanhood – single, married, widowed, young and old – have assembled in the garden of their hostess, Leonora, for a two-day discussion of women's issues.[11] Moderata Fonte (the nom de plume of a Venetian matron, Modesta Pozzo) completed *The Worth of Women* in 1592, just before she died giving birth to her fourth child. It was published in 1600, soon after Passi's misogynist *Defects of Women* appeared in print. In her short life Fonte published two major works: a

chivalric romance, *Floridoro* (1581), which reinvented Ludovico Ariosto's *Orlando furioso* from a female perspective; and *The Worth of Women*, which constituted the first full-scale feminist volley against patriarchal misogyny since Laura Cereta.

In Fonte's *Worth*, seven women have gathered to claim a literary space, the dialogue, which since Plato had been a masculine genre.[12] The dialogues of Baldassare Castiglione, Ludovico Ariosto and Pietro Bembo included women, but

4 Anonymous, 'Laura Cereta', engraved portrait from *Laurae Ceretae Brixiensis feminae clarissimae epistolae* (Padua, 1640).

are dominated by men. In Castiglione's influential *Book of the Courtier* (1528), the *querelle des femmes* is debated by male speakers at the court of Duke Guidobaldo da Montefeltro in Urbino.[13] The Magnifico Giuliano advances feminist arguments, while the misogynist Signor Gasparo ridicules them. Also present are the Duchess of Urbino, Elisabetta Gonzaga, and her attendant Emilia Pia. In reality, the duchess exercised considerable political power in the absence of her sickly husband, and was entitled to speak with authority. Yet the voices of Elisabetta and Emilia are virtually unheard in Castiglione's text. They defer to the men and behave as if the debate about women is beyond their comprehension.[14] Castiglione's distortion of the Urbino court was likely a reaction to the political agency of a constellation of women who ruled north Italian courts at the time, such as Isabella d'Este, Caterina Sforza and Caterina Cornaro.[15] Purporting to defend women, Castiglione aimed to contain the threat to male dominance posed by culturally powerful duchesses, and intellectually assertive writers such as Nogarola and Cereta, by modelling men's right to speak for the female sex. Just below the surface of this debate about the capabilities of the sexes was the question of power, and men's fear of women getting it.[16]

Moderata Fonte's *Worth of Women* was a radical intervention in the tradition: Leonora's garden has become an alternative power base where women control the debate. Unlike Marinella's polemical treatise, *The Worth of Women* is a nuanced discussion of social problems faced by contemporary women. Fonte's speakers consider men's tyrannical cruelty to women, their aggressively violent sexuality and the 'slavery' of modern

marriage. They take on the dowry and its disadvantages for women, who lose control of their own money upon marriage. They point out that men have achieved their superior status by bullying entrenched as law. Recognizing that women are pawns in a system designed to benefit men, Fonte questions whether women need men at all, considering that they are actually better than men at friendship, and she proposes the creation of an all-female community. The feminist argument is diffused, and anger is muted by humour, yet it would be a mistake to dismiss Fonte's treatise as merely playful, for its underlying political thrust is deadly serious.

ARTEMISIA IN ROME, 1593–1612

The young Artemisia Gentileschi, who could barely read, was surely unfamiliar with the feminist texts. But she knew at first hand many issues the writers addressed. When she was six years old, Artemisia could have witnessed the public beheading in Piazza Ponte Sant'Angelo of young Beatrice Cenci for murdering the father who had raped and abused her – which under inverted gender terms would have been excused as a crime of passion. While in her teens, Artemisia was also raped, not by her father, but by a man her father had given access to their household. And, like Cenci, she was tainted as promiscuous in the public glare of a court trial.

Artemisia was born in Rome on 8 July 1593, the only daughter and eldest child of Orazio Gentileschi, a painter originally from Tuscany, and Prudentia Montone, who died in childbirth when her daughter was twelve years old. Though she would later gain higher social status by successful career

management, Artemisia started out as part of the artisanal working class. She grew up in a rough world where violence was endemic. Artemisia encountered the debate about female capability, not as a theoretical claim, but as an argument that could be heard in the streets of her Roman neighbourhood, which rang with misogynist insults and coarse rebuttals.

The papal city in Artemisia's adolescent years was a motley mix of Italians, foreigners, pilgrims, tricksters, rivermen and artists that could be disorderly and violent. Roman urban spaces were masculine spheres, where violence and street fighting were common, and dangerous for women in general.[17] The Gentileschi family's neighbourhood in the artists' quarter included prostitutes who drew a rough clientele. Though he fraternized with bohemian artists, Orazio aimed for social respectability and, like artists in general, he sought to rise in social status. As commissions came in, he was able by 1610 to move his family to a larger house.[18] Even so, it was a difficult environment, especially for a single father, in which to bring up and protect a daughter, and harder still for the daughter to navigate a world of womanizers and sexual opportunists.

Artemisia was trained in painting by her father, and likely began her apprenticeship as early as 1607, when she was fourteen.[19] She was clearly precocious, and her artistic proficiency can be judged from her first signed and dated painting, the *Susanna and the Elders* of 1610 (see illus. 16). Of the few extant paintings that can be securely dated in Artemisia's early years, two certainly or probably executed in that period, the *Susanna* and *Lucretia* (see illus. 18), concern female victims of sexual intimidation and sexual violence. The relationship of these two paintings with the best-known event in Artemisia's life,

the trial of 1612 ensuing from her rape by Agostino Tassi, is discussed below in Chapter Two.

During those early years in Rome, Artemisia was isolated as the only girl in the household, unmarried and motherless, in a dangerous environment where girls were vulnerable to sexual predators. Orazio secluded her in the house and allowed her to visit churches (effectively, the art galleries of the day) only when carefully chaperoned. Strict parental control of daughters was not unusual at that time, but Orazio was an erratic jailer, paranoid and quick to anger.[20] He turned his daughter over to his tenant, Donna Tutia, who, according to Artemisia, was an unreliable chaperone, effectively a procuress for the man who raped her.

In May 1611 Artemisia was accosted at home by Agostino Tassi, a painter and friend of Orazio Gentileschi, who had become a familiar to the household. Orazio reportedly asked Tassi to teach Artemisia perspective, a technical skill, but he was in no other respect her teacher. Tassi flirted with Artemisia, then forced sexual intercourse on her, despite her vigorous resistance. When he promised marriage, Artemisia agreed to continue the sexual relationship, assuming that this would restore her respectability ('What I was doing with him I did only so that, as he had dishonoured me, he would marry me'[21]). This went on until March 1612, when Orazio charged Tassi with forcible defloration of his daughter, giving 'serious and great injury and damage to the poor plaintiff' (himself). The issues at stake were honour and property. In his petition to the court, Orazio coupled the rape accusation with the charge, apparently equally serious to him, of the theft of some paintings.

Artemisia testified under oath that she had been forcibly deprived of her virginity by Tassi, which she was obliged to prove through examination by midwives, and she was required to confirm her veracity by enduring torture, which was standard under Roman rules of evidence at that time.[22] Tassi denied the charge, arguing that Artemisia had given herself to many men, including even Orazio, offering other stories so implausible and inconsistent that the judges cautioned him frequently about bearing false witness. The highly public trial continued until November 1612, when Tassi was convicted (but never served his sentence). Tassi's conviction resulted less from Artemisia's plausible defence than from his own bad reputation, for he had earlier been imprisoned for incest with his sister-in-law Costanza Francini, with whom he had children, and he was charged with having had his wife murdered.[23]

The young Artemisia was also isolated as an artist, with no female cohort. Roman male artists did not train daughters in painting.[24] Although women artists appeared in growing numbers in the early modern period, they remained exceptions in the masculine art world. Unlike women writers, who often knew each other personally or through their writings, female painters and sculptors were less connected with one another. Their works could not be 'published', unless by a stray printmaker, and were known outside their cities only by hearsay. Female writers generated energy as they stimulated one another, but female artists rarely benefited from a critical mass of women. An exception was Renaissance Bologna, unique among European cities, where a school of women artists flourished.[25] But elsewhere, no existing social

structures brought female artists together – such as the studio /workshops where male artists studied anatomy (off-limits for women), and the taverns and clubs where they enjoyed camaraderie. In her formative years as an artist, Artemisia's only known friend was a candle-painter named Costanza Francini (Agostino Tassi's sister-in-law).[26] Her primary artistic interchange was with Orazio and, perhaps briefly, with her father's colleague Caravaggio, whose art was the major influence on her development, but who died in 1610. In her early paintings, Artemisia initiated a dialogue with male masters, learning from and challenging them: first Caravaggio, then Michelangelo.[27] Enormously ambitious, she sought to establish herself as a painter of large-scale biblical or historical subjects – implicitly, to separate herself from the artisans who made dolls or painted candlesticks. During Artemisia's youth, the famous Bolognese painter Lavinia Fontana lived in Rome (from 1604 until her death in 1614), but they are not known to have met. Even so, Artemisia was aware of Fontana and built on her work. During her Florentine years, she repeatedly expressed a desire to move to Bologna where she expected to find better fortune, quite likely because of that city's renowned support of women artists.[28]

The circumstances Artemisia enjoyed in Florence were, in fact, relatively favourable – for a woman. She was supported by a cultural matriarchy that actively welcomed female artists, musicians and theatrical performers. But Artemisia Gentileschi wanted to be judged and treated by the same rules as male artists. Her restless dissatisfaction with her situation was a lifelong pattern, and she frequently expressed

outrage at gender inequity in her letters. Typical was her complaint to a patron when another patron cheated her on a commission: 'If I were a man, I can't imagine it would have turned out this way.'[29] Artemisia's keen sense of gender injustice drove her ambition and indirectly shaped her art.

ARTEMISIA IN FLORENCE, 1613–20

Immediately following the rape trial, Artemisia was married to a Florentine apothecary, Pierantonio Stiattesi. The marriage was arranged for the purpose of restoring the Gentileschi family honour, and Pierantonio was a good candidate, as the relative of a trial witness, Giovanni Battista Stiattesi, who had testified on Artemisia's behalf. Yet Artemisia may have expressed a preference for a Florentine husband, seeing that city as an especially promising site for her artistic career.[30] The couple arrived in Florence in the winter of 1612/13. Later that year their first child was born, followed by a new baby almost every year. Only one of their five children, Prudentia (also called Palmira), survived past the age of five. Typically, marriage and motherhood seriously limited a woman's independence, but Artemisia, an increasingly successful breadwinner, radically subordinated these demands to pursuing her career as an artist.

From as early as 1613, she cultivated contacts with a network of Florentine male patricians, through whom she gained access to patrons and clients for her art. Assisted by her husband, who functioned as a business partner, Artemisia engaged in an entrepreneurial practice in which she financed her business by pledging personal luxury items against her debts,

and gained status in the process.[31] Each connection led to a higher one, and Artemisia's shrewd enterprise put her in early contact with two major centres of patronage for artists and musicians in Florence: the Medici court at Palazzo Pitti and Michelangelo Buonarroti the Younger's Casa Buonarroti.

In 1615 Artemisia requested matriculation in the artists' guild, the Accademia del Disegno, for membership, and in 1616 she joined the prestigious, strongly masculine academy as its first female painter. Membership in the Accademia del Disegno signified Artemisia's legal and artistic autonomy, boosted her status and provided networking opportunities.[32] She had gained recognition by both talent and entrepreneurship, yet her way may also have been paved by the culturally powerful Michelangelo Buonarroti the Younger, grand-nephew of the great Florentine artist. Buonarroti had been a family friend at least since 1614, when Artemisia gave a form of his name to her second child, Agnola (who died before she could be baptized), and he was perhaps the child's godfather.[33] In 1615 Buonarroti gave Artemisia one of her earliest major commissions, the panel of *Inclination* that she painted for the ceiling painting cycle in the Galleria of Casa Buonarroti, which is discussed in Chapter Six.

At the ruling Medici court, Grand Duke Cosimo II de' Medici was officially in charge of art patronage, but as he was in poor health, his mother Christine of Lorraine and his wife Grand Duchess Maria Maddalena directed and dominated cultural activity (illus. 5). Christine's maternal grandmother was the dowager queen of France, Catherine de' Medici; Maria Maddalena was the granddaughter of the Habsburg emperor Ferdinand I. As descendants of European ruling

dynasties, both women assumed power with ease and a sense of prerogative. Together, they ran what has been called a 'gynocratic universe', in which they wielded prime political and cultural power, handling matters of state, arranging marriages and supporting women.[34] The matriarchs commissioned theatrical performances that featured the prominent composer and lutenist Francesca Caccini and the singer Adriana Basile, and they welcomed the painters Giovanna Garzoni and Arcangela Paladini.[35] When Cosimo II died in 1621 and Maria Maddalena officially became regent, she remodelled the Medici Villa Imperiale as her private retreat, and commissioned a cycle of frescoes (by male artists) that celebrated heroic biblical and historical women.[36]

Orazio Gentileschi had written to Dowager Grand Duchess Christine in 1612, recommending his daughter to the Medici court, but received no known reply.[37] Instead, Artemisia gained her own access to Medici patronage, and by October 1614 Grand Duke Cosimo II had commissioned three paintings from her.[38] Patronage officially came from the grand duke, who made the payments.[39] The presence of Grand Duchess Maria Maddalena is evident, however, in several of Artemisia's Medici commissions. One example (others are discussed in Chapter Three) is the lost painting of Diana and eight nymphs, which appears in Medici inventories. The theme of Diana the huntress and her female coterie was particularly relevant to the grand duchess, who defined herself as an Amazonian huntswoman and gathered a female entourage. Diana, with her Amazonian nymphs, was the model for an ideal community of women that runs through the literature of the period, from Moderata Fonte's

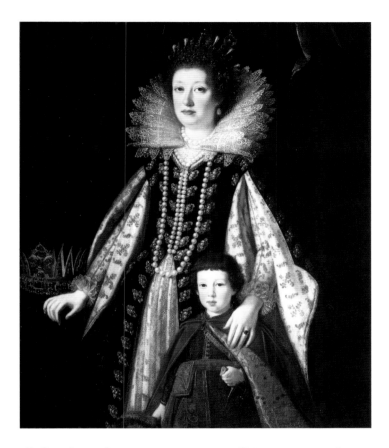

all-female garden to Lucrezia Marinella's epic poem *L'Enrico* (1635), in which the Diana-like Erina is surrounded by virgin warriors.[40] The Diana theme also resounded at the English court of Queen Henrietta Maria, for whom Artemisia painted her second, also lost, 'Diana and her Nymphs' inventoried in Charles I's collection.[41]

Lucrezia Marinella's *L'Enrico* may have been modelled on the gynocratic Medici court, for Marinella dedicated one of

5 Justus Sustermans, *Maria Maddalena of Austria, Grand Duchess of Tuscany, with her Son, the Future Ferdinando II*, c. 1623, oil on canvas.

her writings to Christine of Lorraine in 1597, and another to Maria Maddalena de' Medici in 1624. The scope of the queens' power encouraged such dedications, and it fostered as well the publication in Florence of five treatises praising women.[42] One of these was written by a young aristocrat, Cristofano Bronzini, who entered the Medici service in 1615 as master of ecclesiastical ceremonies. Bronzini was a great champion of Marinella, and modelled his own treatise, *On the Nobility and Excellence of Women*, on Marinella's pioneering treatise of the same name.[43] Marinella, in turn, admired Bronzini's treatise and they became correspondents. Because Bronzini was also in contact with Artemisia Gentileschi at the Medici court, he was a potential link between the two women.

Pro-female treatises by male authors were not unusual. Quattrocento humanists such as Giovanni Sabadino degli Arienti and Bartolomeo Goggio argued that women were as capable as men.[44] Henricus Cornelius Agrippa claimed in an influential treatise of 1509 that women were men's equals in every sphere, held back only by social custom and men's 'excessive tyranny'. Cinquecento writers such as Lodovico Dolce and Luigi Dardano praised distinguished women and advocated female education.[45] Their treatises did not so much celebrate women, however, as prescribe correct female behaviour – for example, recommending education as preparation for marriage and motherhood, as did Thomas More in England.[46] Moreover, the production of pro-female treatises by court-affiliated males was often a form of political posturing: a bid for the patronage of duchesses and queens to whom they dedicated the treatises, and a way to set themselves apart from 'ill-bred' misogynist males.[47]

Bronzini's ambitious treatise differed from its male-authored predecessors in the writer's serious commitment to a project that engaged him for two decades. Fully aware of the feminist writers, from Pizan to Fonte and Marinella, Bronzini included extensive biographies of his female contemporaries — not only the Venetian feminists and female rulers, but musicians and artists, including Artemisia Gentileschi.[48] While he cribbed the lives of earlier artists such as Properzia de' Rossi and Sofonisba Anguissola from Vasari, Bronzini drew his biographies of modern artists from direct knowledge or contact. He knew Lavinia Fontana personally and described her pictures in detail.[49]

Cristofano Bronzini and Artemisia Gentileschi were surely acquainted, because, as Sheila Barker has pointed out, his Artemisia biography is a strategically fictionalized account of her artistic origins, which the artist herself most likely gave him.[50] Key points of Artemisia's history are completely changed. Entirely absent is the episode of her rape and Tassi's trial. Credit for her artistic training is given to her mother for initial inspiration, and to the abbess in a convent (where, in this account, the young Artemisia conveniently spent the rape trial years) who recognized her artistic talent. Orazio appears only as the father who had refused to teach her painting and had put her in the convent. In revising her own biography thus, Artemisia could simultaneously shore up her reputation as a virtuous woman and get back at the father whose lawsuit against Tassi had damaged that reputation in the first place.

Did Artemisia Gentileschi learn about Marinella's feminist treatise from Bronzini? Did he mention to Marinella Artemisia's powerfully feminist paintings, most obviously

the *Judith*s that crashed on to the polite Florentine scene in the 1610s, stark embodiments of female power that surely ruffled feathers? We can only speculate, but that ardently pro-feminist man would probably have made a connection between the writer and the painter: one of them had praised powerful, independent women and the other had depicted them. Further, since Artemisia was living in Rome when Marinella visited Bronzini there in 1624, he might have arranged their meeting.[51] Such a convergence of like minds, whether in person or through Bronzini's descriptions of the Venetian feminists, could explain Artemisia's unusual decision to relocate to Venice in 1627.

By 1618 Artemisia was in control of her dowry, solely responsible for her debts and perhaps living apart from her husband.[52] In her last three years in Florence, she began a relationship with a young nobleman, Francesco Maria Maringhi, which was, like her marriage, part business and part personal. Artemisia's letters to the young man, presumably her lover, are fascinating documents, as valuable for her wit and playful repartee as for information about her business practices.[53] Pressures from the Medici court, ostensibly regarding an uncompleted commission for the grand duke, forced Artemisia to leave Florence abruptly in 1620. She fled, first to Prato, then to Rome with her husband, leaving their children and Artemisia's studio property with Maringhi. Artemisia's blatantly indecorous affair probably offended the grand duchess, and may have precipitated her departure. Maria Maddalena, a deeply religious woman and paragon of female chastity, might have sniffed at Artemisia's Roman reputation – a good reason for its whitewash in Bronzini's

biography – and though that didn't prevent Artemisia from receiving Medici commissions and participating in court life, the grand duchess may well have withdrawn support when she heard of the artist's affair with Maringhi, and as other harmful gossip about Artemisia circulated.[54]

Artemisia's other Florentine patron was less likely to have been critical. There was a temperamental difference between the conventional Medici court and the more freewheeling circle of Michelangelo Buonarroti the Younger, a noted poet and playwright. Artemisia befriended artists, dramatists and poets in Buonarroti's circle, and she would have known his collaborator the composer Francesca Caccini. (In this context, she also met the physicist/astronomer Galileo Galilei, whose help she later enlisted in obtaining payments owed her by Cosimo II's successor.[55]) Buonarroti's irreverent sensibility is manifest in his comedies that mocked high culture, challenged heterosexual love conventions and supported women's independent sexual agency.[56] It precisely matches the impudent, iconoclastic spirit that Artemisia brought to some of her Florentine pictures (see Chapter Three), and one imagines that her natural cheekiness and visual wit were better appreciated at Casa Buonarroti than at the more formal Medici court.

Lucrezia Marinella might also have kept her distance for moral reasons, and it may be significant that we find no mention of Artemisia in her writings (though the feminist writers almost never mentioned artists). Marinella was a firm advocate for female decorum, lauded by Bronzini as 'the purest of virgins' (despite being married with children). She privileged chastity above all other virtues, and believed that sexual

entanglements inhibited a woman's independence.[57] In her flamboyantly unconventional lifestyle, Artemisia Gentileschi challenged the conventions of aristocratic Florence, and, in both life and art, she embraced contradictions the feminist writers tended to compartmentalize into virtue and vice.

Yet despite their lifestyle differences, Marinella and Gentileschi had something fundamental in common. Each took on the patriarchy fearlessly, presenting her young self as qualified to challenge settled authority. In a painter's world the authorities were Michelangelo and Caravaggio, and Artemisia unhesitatingly took them on, putting herself forward as a woman who could improve on their examples. In the opening lines of *Nobility and Excellence*, Marinella took on Plato and Aristotle, applauding the former for his progressive views on gender equality and chastising the latter for his scornful slander of the female sex. She detected human weakness in the great philosophers: Plato was not advanced enough in his thinking to recognize woman's superiority; Aristotle was probably motivated by hate or envy. Both women, artist and writer, had the distinctly unfeminine audacity to confront patriarchal giants from a position of seeming equality, challenging them in the terms of their own game – whether philosophy or art – while calling its value structure into question.

ARTEMISIA IN ROME, 1620–26

Although Artemisia and Pierantonio left Florence under extreme circumstances, they were quickly on their feet again in Rome. They obtained a house on the Corso, near Santa

Maria del Popolo (the church where Artemisia's mother was buried), a well-furnished home that Pierantonio described as 'fit for the cardinals and princes who visited'.[58] In Rome Artemisia reconnected with her father, but in March 1620, scarcely a month after she arrived, their relationship broke down in acrimony. Orazio disapproved of her scandalous behaviour in Florence, while Artemisia and Pierantonio resented his efforts to control her use of the dowry he had given her.[59] Underlying their disputes, perhaps fuelling them, was Artemisia's rising recognition as an artist. While she took wing in Florence, Orazio was casting about for commissions in the provinces; eventually her celebrity and fame, though gender-enhanced, outstretched his. Father and daughter are not known to have been in contact again until they met in England in the late 1630s.

By 1624 Artemisia's husband had also faded from her life; he is not named in the household census of that year, and in 1636, on the brink of her daughter's marriage, Artemisia inquired whether he was still alive.[60] She might have sought his contribution to the dowry, but if she wished to marry again herself, she would have needed to know (by Church law, she couldn't divorce). Scholars have surmised the existence of a second daughter by another man, for Artemisia mentions the imminent marriage of a daughter twice, in 1636 and again in 1649 – possibly, but unlikely to be, the same daughter.[61] Both daughters (or the one) were trained in painting, presumably by their mother.

Patronage in Rome came first through Artemisia's Florentine connections. Four months after arriving, she mentions generous commissions from the Duke of Bavaria, a relative

of Christine of Lorraine.[62] When the Florentine-born Maffeo Barberini, a familiar of Maria Maddalena, became Pope Urban VIII in 1623, Artemisia received support from the new pope's nephews, the cardinals Francesco and Antonio Barberini. Other patrons followed. In the mid-1620s, the Spanish collector Fernando Afán de Ribera, Duke of Alcalà, purchased several of Artemisia's paintings and took them back to Seville. Artemisia's growing fame in these years was signalled by a medal struck in her honour, on which she is described as 'pictrix celebris'.[63]

Artemisia's contacts in the Barberini circle included Cassiano dal Pozzo, a scholar and art patron whose extensive collections embraced scientific instruments and books, a museum of rarities and the 'Paper Museum' that documented Roman antiquities. She also befriended the French painter Simon Vouet, whose portrait of Artemisia (illus. 6) was owned by Cassiano dal Pozzo, and Virginia da Vezzo, a prominent woman painter who was Vouet's wife.[64] The Barberini group manifestly encouraged women artists. Francesco Barberini supported Virginia da Vezzo and Plautilla Bricci, the first recorded female architect, and others.[65] Cassiano dal Pozzo patronized both Artemisia and Giovanna Garzoni, a painter of miniature portraits and still-lifes of fruit and botanical specimens, and perhaps the most prominent female artist in early modern Italy, next to Artemisia.

Another source of support came Artemisia's way. When Cassiano dal Pozzo accompanied Francesco Barberini on a diplomatic mission to Paris in 1625, he wrote home that the French were consumed by interest in women and the court.[66] The court in question was that of King Louis XIII and Queen

6 Simon Vouet, *Artemisia Gentileschi*, c. 1622–5, oil on canvas.

Anne of Austria. The king's mother, Queen Regent Marie de' Medici, who had recently returned from exile (by her son), was very much in residence in Paris. Marie de' Medici showed Cassiano dal Pozzo her sumptuous apartment in the Louvre, and surely also the magnificent cycle of 24 large paintings she had commissioned from Peter Paul Rubens for her newly built Luxembourg Palace.[67] The cycle narrated the glories and vicissitudes of Marie's rule as queen regent, and was a rare example of a monumental, quasi-public glorification of a powerful contemporary woman. Yet Marie de' Medici posed a perennial threat to her son and his minister Cardinal Richelieu, and her political and cultural activism triggered long-standing caveats about the dangerous power of women and the perils of female rule.

A recurring question in France was the ability of women to govern. This was settled in principle by the Salic Law, which allowed only males to inherit the throne, but challenged in reality by the regencies of Catherine de' Medici, Marie de' Medici and Anne of Austria. Marie de' Medici's presentation in the Luxembourg cycle as a bold equestrian general and as the goddess of war, Bellona (illus. 7), did not reassure her critics, but it positioned her as an exemplary leader with a feminist lineage.[68] Her frequent appearance in the cycle with one breast bared, an allusion to the ancient Amazons who challenged the patriarchal order, reflected the emerging concept of the *femme forte*, or strong female leader, which would be consolidated during the rule of her daughter-in-law, Anne of Austria.[69] Anti-feminist literature surged in France around 1616–17, some of it aimed at Marie de' Medici, and provoked numerous pro-female defences.[70] Salient among them was

7 Peter Paul Rubens, *Marie de' Medici as Bellona*, 1622–5, oil on canvas.

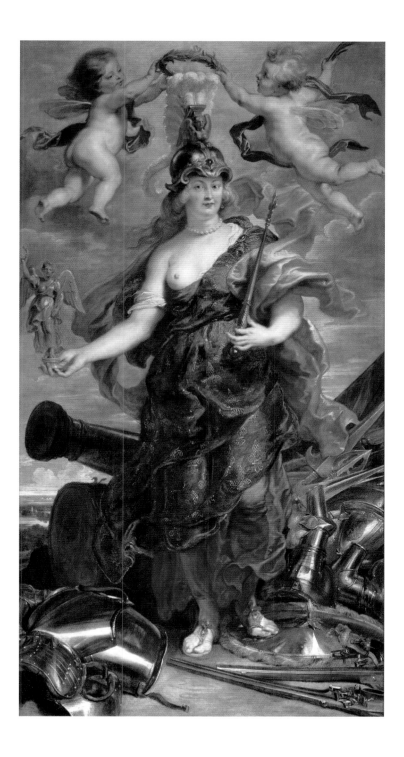

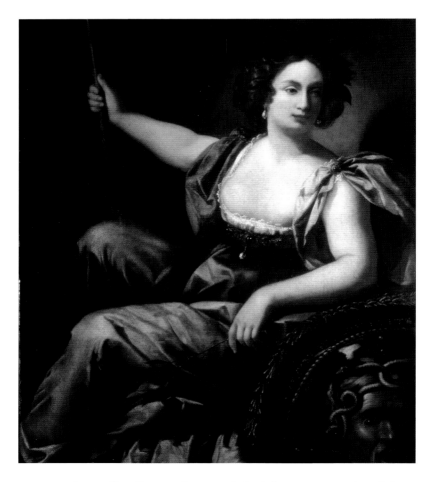

The Equality of Men and Women (1622), by a young writer, Marie
le Jars de Gournay, which drew the attention and support of
Marie de' Medici and Anne of Austria.[71] The French court's
discussion of issues raised by de Gournay, as well as the power
moves of the two queens, may have provoked Cassiano's per-
ception that the French were preoccupied with women.

8 Artemisia Gentileschi, *Anne of Austria as Minerva*, 1630–35, oil on canvas.

Artemisia Gentileschi would have first heard about Marie de' Medici at the Florentine court (where the future French queen was born and raised), and Cassiano probably told her about the art patronage. Conversely, Marie de' Medici and Anne of Austria surely knew about Artemisia Gentileschi, if only because Orazio Gentileschi worked for Marie de' Medici in Paris in 1624–6. A commission ensued, to be followed by later patronage. Artemisia's signed and dated *Minerva* (illus. 8) is probably an allegorical portrait of Anne of Austria as Minerva. This figure's laurel crown and olive branch are not Minerva's attributes, but they appear in the imagery of French female rulers in the guise of Minerva: Blanche of Castile, Marie de' Medici and Anne of Austria.[72] Artemisia asserted in a letter of 1635 that she had served the kings of France, Spain and England; her pictures for the latter two are documented, but there are no known paintings for the king of France.[73] The *Minerva* fills that bill, paid for by the king but engineered by the queen or, perhaps, by the Queen Mother, Marie de' Medici, who would later meet up with Artemisia at the English royal court of her daughter Queen Henrietta Maria.

Despite their social support of women artists, Cassiano dal Pozzo and the Barberini brothers sought paintings by Artemisia that were palatable to masculine tastes. Antonio Barberini acquired a Venus and Cupid; Cassiano dal Pozzo wanted a self-portrait (and owned Vouet's portrait); and the Duke of Alcalá bought two portraits, perhaps self-portraits, of Artemisia.[74] These subjects fitted a stereotype of the woman artist as a portrayer of female beauty and a beauty herself – the conceit of the double beauty of female artist and subject.[75]

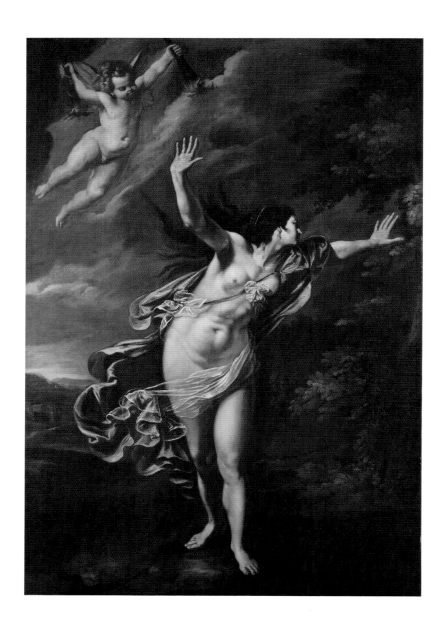

9 Artemisia Gentileschi, *Aurora*, c. 1625–7, oil on canvas.

But Artemisia's most strongly feminist paintings of these years, the *Jael and Sisera* and *Joseph and Potiphar's Wife* (see illus. 44 and 50), had no known patron and have no early provenance, which suggests they were painted on speculation and not soon acquired. Two of her largest and most imposing paintings of the 1620s, the Detroit *Judith* and the *Esther before Ahasuerus* (see illus. 42 and 48), were ambitiously conceived, though without a known commission, and they evidently met an unreceptive market. Artemisia's vision of female heroism might have been the problem. Since both paintings feature a mature, hefty and distinctly unglamorous female protagonist, they would have had little appeal for buyers in search of conventional female beauty.

Artemisia's heroic women may have been inspired by Marie de' Medici, the contemporary icon of a strong female leader. *Aurora* (illus. 9), the largest of the Roman pictures, presents a powerful goddess of dawn who plants her feet squarely on the ground. Unlike contemporary Auroras – the bland, anonymous procession-leaders of Reni and Guercino – Artemisia's Aurora strides the earth alone, a 'new woman' who parts the clouds of darkness with powerful hands, displaying a muscular anatomy that empowers the female nude with Michelangelesque agency.[76] Marie de' Medici hovers more visibly in the queenly heroines of this period, the stately *Esther* and, especially, the monumental Detroit *Judith* who, against iconographic precedent, wears a crown (illus. 10). This crown may overtly reference the French queen, whose wary dodging of her political enemies assimilates her story to that of Judith, with whom she avowedly identified. As discussed in Chapter Four, Artemisia's crowned

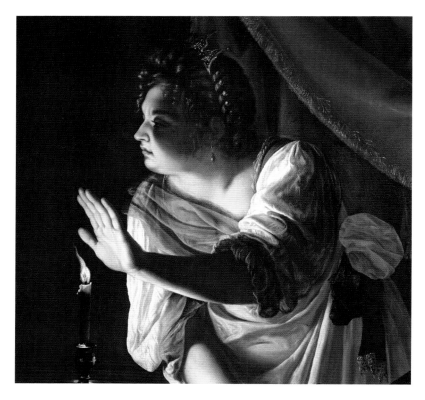

Judith alludes simultaneously to Marie de' Medici and Queen Artemisia of Caria, the artist's namesake, and is thus a homage to heroic queenship in both ancient and modern examples.

ARTEMISIA IN VENICE, 1627–30

In late 1626 or early 1627 Artemisia left Rome for Venice, where she remained until 1630. Why she left a city that continued to offer patronage for one that offered few if any

10 Detail of Artemisia Gentileschi, *Judith and her Maidservant* (illus. 42), 1625–7, oil on canvas. Detroit Institute of Arts, USA.

prospects is unknown. Only one Venetian client is known: Jacomo Pighetti, a lawyer, owned a *Sleeping Cupid* by her hand. Pighetti's connection with Artemisia may have come through Gian Francesco Loredan, the probable author of some poems addressed to Artemisia, published anonymously in Venice in 1627, in which Pighetti's *Cupid* is mentioned.[77] Loredan was a powerful cultural figure in Venice, the founder of an informal group called the Accademia de' Desiosi, with which Artemisia was connected according to the inscription on an engraving based on a lost self-portrait (illus. 11).[78] In 1630 Loredan founded the Accademia degli Incogniti, an academy in which Pighetti and Artemisia both participated. Discussions of Artemisia's stay in Venice rightly focus on her connection with Loredan and the academies, yet her motivation for going there has not been probed.

She might have been drawn to Venice for its publishing industry that strongly supported women, and for the prominent female advocacy of the Venetian writers Moderata Fonte and Lucrezia Marinella. A third Venetian writer, Arcangela Tarabotti, was at that time composing a treatise, *Paternal Tyranny*, which has been called the first feminist manifesto.[79] Tarabotti's treatise arose from her direct experience of patriarchal oppression. Born lame, she was deemed unfit for marriage by her father, who put her in a convent at the age of eleven, and she remained cloistered for the rest of her life. During her early convent years, Tarabotti began writing *Paternal Tyranny*, in which she bitterly criticized the 'hideous iniquity' of consigning innocent girls to convents, observing that contemporary fathers, intent on saving the cost of a dowry, offered as brides of Christ their most 'repulsive and

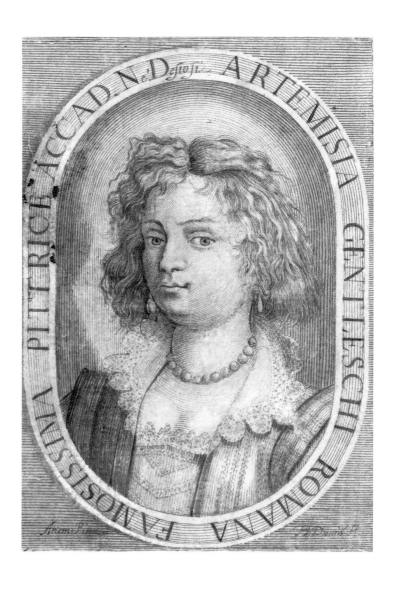

11 Jérôme David, *Artemisia Gentileschi*, engraving after lost self-portrait by Artemisia Gentileschi, 1627–8.

deformed' offspring, blaming them for their natural defects and condemning them to a life in prison.[80]

Tarabotti's social reach was broader than the convent. In *Paternal Tyranny*, she takes on the double standard for adultery, argues for women's freedom of sexual choice and financial independence, and bemoans their lack of access to equal education and the right to hold public office. Throughout her life, Tarabotti was in active contact with the outside world, conversing with visitors in her convent parlour and corresponding with doges and popes, dukes and duchesses, to whom she also addressed her defence of women.[81] In the interlocking circles of Venetian society, Tarabotti's primary benefactor was Gian Francesco Loredan. Tarabotti openly disagreed with her patron over a theological issue, Eve's responsibility for the Fall. Resisting Loredan's exaggerated privileging of Adam in his novel *L'Adamo* (1640), she observed that Adam was a coward who 'excused himself by blaming his wife'.[82] Like Marinella, Tarabotti punctured age-old theological arguments and masculine self-inflation with the sharp point of common sense and a dose of sly wit.

As it happens, Arcangela Tarabotti's sister Lorenzina was married to Jacomo Pighetti, Artemisia's patron, into whose milieu Artemisia fell so quickly. Conceivably, we've had this backward: Tarabotti might have been Artemisia's initial contact in the city, the one who led her brother-in-law to acquire a painting by the famous female artist. When Artemisia arrived in Venice, Tarabotti was already circulating drafts of *Paternal Tyranny* informally to friends, who might have told Artemisia about the nun and her treatise.[83] (Artemisia too had known paternal tyranny.) But if Arcangela and Artemisia

never met at all, it would be an ironic pity, considering that they were both social rebels who championed female wholeness through defiant images and texts.

Gian Francesco Loredan, avowedly smitten by Artemisia's beauty, spirit and wit, may have welcomed her to gatherings of the Accademia delle Incogniti, but it was a strongly masculine sphere. Some women are known to have attended its events, though probably not as formal members: the singer and composer Barbara Strozzi, the soprano and opera diva Anna Renzi, the Jewish poet Sara Copia Sullam and the scholar and musician Elena Cornaro Piscopia. They likely joined in poetry readings, singing and dancing, but not in the oral arguments and discussions that were a centrepiece of Incogniti meetings. Artemisia's inclusion has been inferred from her praise by Loredan as a 'new Thalia' (the muse of comedy and idyllic poetry) for her 'canto divin', referring perhaps to her poetry improvisations.[84] Artemisia's capacity for such poetic invention seems entirely consistent with the articulate wit of her letters to Maringhi, yet it is difficult to imagine any woman taking a comfortable role in the academic debates of the Incogniti.

The Accademia degli Incogniti was noted for the 'militant sexual libertinism' of its members.[85] Central among the topics they debated was *la questione delle donne*, on which the dominant position was, apparently, that women's sexual power and dangerous beauty could lead men to temptation and to ruin. The debates were sophisticated, laced with satire and double meaning. Speakers playfully considered opposing viewpoints, yet, in Wendy Heller's description, 'what emerges is a negative view of women masked by a pretense of chivalry

that is at once exaggerated and patronizing.'[86] In *Bizzarrie accademiche* (1654), a widely known and often reprinted book, Gian Francesco Loredan was still at it. He described women's sexual power over men and its remedies in chilling terms: 'With her eyes she enchants, with her arms enchains, with kisses stupefies, and with the other delights robs the intellect and reason, and changes men into beasts.' And he claimed that taking sexual pleasure by force from unresponsive women – that is, rape – is man's inherent right.[87]

Loredan's anti-feminist thrusts eerily echoed, and closely followed, the misogynist treatises of Giuseppe Passi and Torquato Tasso. Since misogyny is not a steady cultural condition, but tends to manifest in eruptions and outbreaks, it makes sense to look for causes. The 'woman question' was debated in the Accademia degli Incogniti with some anxiety, I would suggest, in response to the growing proof that women were indeed men's intellectual equals. Some men's efforts to contain and control the damage constituted what we would call backlash.

Venice, the centre of the publishing industry in Europe, had long supported literary women. Venetian presses brought out the writings of Petrarch, Dante and Castiglione in inexpensive formats that reached a wide reading public, which increasingly included women, for at this high point of European women's intellectual development, female literacy was widespread. Moreover, texts such as Ludovico Ariosto's *Orlando furioso* (1532) and Torquato Tasso's *Gerusalemme liberata* (1581) were known in popular culture far beyond their literary readership. Artemisia Gentileschi, for example, was not highly educated, but exhibited a passing familiarity with

Ariosto, Tasso, Ovid and Petrarch during her residence in Florence.[88]

The battle of the sexes was fought out in Cinquecento literature. Ariosto's *Orlando furioso* was cited to support arguments on both sides of the controversy about women.[89] Ariosto ostensibly praised women but, as modern scholars have shown, his epic poem reinforces the masculinist positions it seems to critique.[90] Although the poem was novel in having independent, active female characters, Bradamante succumbs in the end to domination by Ruggiero, in accord with the view that woman's ultimate role was domestic subservience. In Tasso's *Gerusalemme liberata*, similarly, memorable female characters fight battles (Clorinda) and practise magic (Armida), yet they are brought down in the end, tamed by conversion to Christianity, their stories subordinated to the heroic deeds of the men who liberate Jerusalem.[91]

Distinctly opposing these male authors were the many women poets and dramatists who exploded on the scene: Veronica Gambara, Vittoria Colonna, Gaspara Stampa, Laura Battiferri Ammannati, Laura Terracina, Tullia d'Aragona and others.[92] Laura Terracina subtly challenged stances taken in *Orlando furioso*, interlineating Ariosto's poem with verses of her own to create a counterpoint of female and male voices, and to cast Ariosto's pronouncements on women as conservatively masculinist.[93] In her own dialogue, Tullia d'Aragona debates the nature of love with the renowned Florentine intellectual Benedetto Varchi, besting him with subtle philosophical arguments.[94] With sly humour, she undermines what today we would call 'mansplaining'. When Varchi quotes Petrarch to support his claim that women are incapable of

sustained love, Tullia replies, 'Do you think I can't see what you are up to? Just think what would have happened if Madonna Laura had gotten around to writing as much about Petrarch as he wrote about her: you'd have seen things turn out quite differently.'[95]

Tullia d'Aragona was one of the *cortigiane oneste*, well-educated Venetian courtesans who were financially independent and held considerable social power. They positioned themselves as men's equals and, unlike wives, they could participate in the erotic love dialogues that took place outside marriage.[96] Veronica Franco, another *cortigiana onesta*, discussed sexuality with expertise and ease. The frank eroticism of her *Poems in Terza Rima* (1575) stands in bold contrast to euphemistic Petrarchan idealism, and offers a rare articulation of female sexual desire.[97] When she was insulted in verse by Maffeo Venier, Franco staged a literary duel. Rebutting his misogynist insults, she argued that women could become men's equals through training, and declared herself their champion: 'Setting an example for all [women] to follow . . . I will show you how much the female sex excels your own.'[98]

Fonte, Marinella and Tarabotti were the direct heirs of these strong exponents of feminist ideas, who bantered and debated with a sophistication that men openly admired but may also have feared. When Loredan and his Incogniti brothers reiterated the misogynist stances of Passi and Tasso, they now had a growing body of pro-female literature, including the treatises of Fonte, Marinella and Tarabotti, to contend with and resist. Tarabotti encountered backlash when she repeatedly had difficulty getting her feminist treatise published. Although Gian Francesco Loredan facilitated

the publication of her other writings, he is thought to have intervened to prevent *Paternal Tyranny* being published until it was given a new title, *Innocence Betrayed*. Her biting critique of misogynist social practices was thus 'rebaptized' (her term) to portray nuns as innocent victims whose suffering was a matter of God's will.[99]

Loredan's poetic tributes to Artemisia's paintings show similar resistance to the feminist thrust of her art. As discussed in Chapter Five, he chose to write about the mildest and least controversial of her pictures. Professing passionate admiration for Artemisia's art, Loredan damns her with subtly misogynist praise. He values a self-portrait for its reflection of the artist's incomparable beauty, and in another poem compares her face to that of Venus.[100] He admires the life-likeness of the *Sleeping Cupid* as a natural product of a woman artist, 'since women alone can create a living child out of love'.[101] Loredan's conceit implies that for Artemisia, art-making is virtually a natural bodily function, like childbirth – just as, to create beauty, a woman painter need only look in the mirror – and it sets women artists categorically apart from male artists, whose art-making is touted as a demanding intellectual endeavour.

As an intelligent and gender-sensitive woman, Artemisia likely recognized the patronizing, manipulative treatment of women for what it was. Just as the feminist polemicists had stirred up trouble in Venice, driving men to reactionary misogynist outbursts, so the underlying gender threat in Artemisia's paintings drove poets to change the subject and elevate her to benign literary glory, lest the real issues come out in the open.

ARTEMISIA IN NAPLES, 1630–36

Artemisia left Venice in 1630, perhaps to escape the bubonic
plague that was sweeping northern Italy and would take a
third of Venice's population. By August, she was in Naples.
Close behind was Giovanna Garzoni. The two artists are likely
to have been friends: both were in Rome in the 1620s, then
Venice in 1627–8; and in 1630 they each went to Naples and
set up a studio. The timing of their moves indicates that
Artemisia paved the way for Giovanna, first with Cassiano
dal Pozzo and then with her Spanish patron in Rome, the
Duke of Alcalà, who became viceroy in Naples in 1629.[102]

 In Naples Artemisia served Spanish patrons, first the Duke
of Alcalà and then his successor, the Count of Monterrey. For
a major commission from King Philip IV of Spain for his
Buen Retiro Palace, she painted the *Birth and Naming of St John
the Baptist* (illus. 12). She also served the king's sister, Maria
Anna of Spain, who spent four months in residence at the
Spanish viceregal court as top-ranking royalty. In August 1630
Artemisia wrote to Cassiano dal Pozzo that she was finishing
some paintings for 'the Empress' (Maria Anna), and asked him
to send her six pairs of gloves as gifts for ladies of the court.
We do not know what these paintings were; nor do we learn
the identity of a certain duchess whose portrait Artemisia
left Naples to paint, for in letters to her male patrons and
supporters she is brief and vague about women she served.[103]

 In this period Artemisia enjoyed ample patronage, in-
cluding church commissions for altar paintings in Naples
and Pozzuoli. But Naples was not to her liking, because it
was poor, overcrowded and dangerous. Soon after arriving,

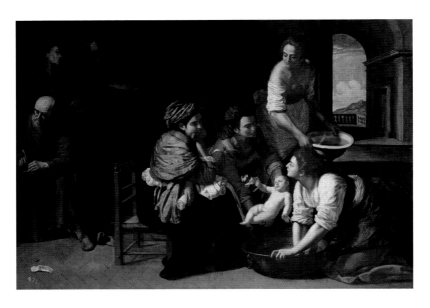

she asked Cassiano to help her assistant obtain a licence to carry arms. Early biographers paint a rosier picture of her first Neapolitan period, emphasizing Artemisia's success and fame; one traveller observed that she lived 'in great splendor'.[104] Perhaps so, yet to judge from the *Birth of the Baptist*, in which subtly differentiated working-class women dominate the scene, Artemisia appears to have empathized with the lives of working women.

By 1635 Artemisia was angling to return to Rome or Florence. She complained that she didn't want to stay in Naples because of the fighting, the hard life and the high cost of living.[105] Soon after, Artemisia left for a sojourn in England. Yet she returned to Naples in or after 1640, and spent the rest of her life, some fifteen years, in a city that displeased her. She probably had no good prospects elsewhere. Her appeals

12 Artemisia Gentileschi, *Birth and Naming of St John the Baptist*, 1633–4, oil on canvas.

to her previous Florentine and Roman patrons had evidently been ignored or rebuffed. While in England in 1638–40 she reached out to an earlier patron, Francesco I d'Este, Duke of Modena, yet with no apparent success.[106] Our knowledge of Artemisia's professional motivations and decisions, however, is drawn entirely from her letters to the men she was obliged to cultivate and please. They do not capture the whole of Artemisia's social experience, which inevitably included relationships with women.

In the absence of fuller documentation, we must pay attention to indirect signals. What were her possibilities for female patronage or support? One path seems to have gone unexplored. While Artemisia remained in Naples, Giovanna Garzoni (who also disliked the city) soon returned to Rome, where she attracted the patronage of Anna Colonna Barberini, sister-in-law of Antonio and Francesco Barberini. As the most powerful woman in Rome during the Barberini pontificate, Anna Colonna Barberini founded a convent and commissioned paintings to represent the recently canonized St Teresa of Avila, to whom she was devoted.[107] There is no known contact between this defender of women and Artemisia Gentileschi. When, in 1637, Artemisia sought a way back to Rome, she offered pictures to Francesco and Antonio, but not to Anna Barberini.[108] One wonders, why not? Did Artemisia prefer the more prestigious male patrons? Was Anna Barberini unreceptive to Artemisia's art, or averse to her reputation?

Another kind of female support is hinted at in the appeal of Artemisia's paintings to differing tastes, a divide that first appeared in Rome. In the Neapolitan 1630s, alongside her

church commissions, Artemisia painted a number of pictures with beautiful, often nude, female protagonists – Bathsheba, Lucretia, Susanna – presumably to serve a growing market for pictures of religious subjects with sensual and erotic appeal. Some of these were commissioned or acquired early by known patrons, such as a prince of Liechtenstein and Farnese dukes in Parma.[109] Commissions also came for portraits, or paintings of a noble female allegory, like the *Clío* (see illus. 60).

Yet Artemisia also painted women who were neither sexy nor noble, pictures that are outliers. The so-called *donne infame*, infamous women who trick and deceive men, or murder their children – Potiphar's wife, Delilah, Corisca and Medea – had no known seventeenth-century buyers. Why did she paint them? Was there an invisible network of female viewers or clients who enjoyed seeing power and autonomy in a female body where men saw passivity and prey? The question is reasonable, because there was a vigorous female audience for early modern women's writing. Female-authored pastoral dramas were very popular with women, including some that featured nymphs outwitting satyrs. In *Corisca and the Satyr* (see illus. 56) Artemisia extended the gender-role reversals of the women's pastorals into the world of painting, presenting a clever, resourceful anti-heroine who was more likely to appeal to a female than a male audience. Yet this picture had no known female admirer (before its present owner).

Some of Artemisia's themes might have resonated differently for women and men. The subject of Diana and her nude female companions, which she painted for the Amazonian grand duchess, for the English king and queen, and for her Sicilian patron, Don Antonio Ruffo, potentially carried

contradictory appeals – to women for the protagonists' agency, and to men for the female nudes. The notion of gendered tastes gives new meaning to Artemisia's promise to Ruffo that her Diana painting will 'suit my taste and yours'.[110] From her earliest work, the 1610 *Susanna*, Artemisia demonstrated that a picture could express opposing gender perspectives simultaneously, and that she could have it both ways. She could give the men what they wanted, because, no matter how subversively her women behaved, men praised their beauty. Artemisia could thus indulge in open parody of masculine models while appealing in different terms to women in general, speaking to them in code. Such coding depends on masculine deafness to the feminist voice.

The outlaw heroines can be thought of as coded metaphors for the female artist's need to manipulate her male patrons. The woman artist (Corisca) deceives the rapacious collector (the satyr) by offering him what he wants (the wig), then ridicules his pathetic lust, as he grabs the trick wig while letting the real thing (her serious art) escape. Artemisia could paint risky female characters with no market appeal because she was motivated – from within, by other women or some combination of the two – to improve women's lot in this world by inventing another one, where bold women exhibit unbelievable strength and courage, and clever women win.

ARTEMISIA IN ENGLAND, 1638–40

By 1638 Artemisia Gentileschi was in London, having accepted the repeated invitations of King Charles I to join his court.[111] The Stuart monarchs, Charles I and his wife Henrietta Maria,

invited a number of Italian artists to London. Guercino and Albani declined, but Orazio Gentileschi accepted, and was in residence from 1626 until his death in 1639. The king's invitations to Artemisia began in the early to mid-1630s, and were issued to her independently. Her father had yet to begin the ceiling paintings for the Queen's House in Greenwich that Artemisia would help finalize.

Though formally invited by Charles I, Artemisia primarily served Queen Henrietta Maria, whose leading role in arts patronage and English politics is discussed in Chapter Seven. The queen's central project was the completion and decoration of the Queen's House in Greenwich. For the Great Hall of the Queen's House, Henrietta Maria acquired several paintings by Orazio and Artemisia Gentileschi. She then commissioned Orazio for an ambitious programme of ceiling paintings, a cycle that echoed the artistic projects of her mother, Marie de' Medici. With the Anne of Austria portrait commission in this mix as well (see illus. 8) it seems likely that Artemisia's invitations to England were prompted by Queen Henrietta Maria, with input from Marie de' Medici.

Despite the potential for generous support, Artemisia delayed her journey to England for several years. She was genuinely busy with work in Naples, but she may also have wanted to avoid contact with her father, given their mutual hostility. In a letter of 20 July 1635 she announces that she will go to London to work for the king of England, 'who has many times requested my service'.[112] She'll go, she says, conducted by her brother Francesco, as soon as she finishes work for the king of Spain and receives clearance for passage through France from the Duchess of Savoy. (This was Christine of France,

the second daughter of Marie de' Medici – another hint of Marie's backstage involvement.) Artemisia may have needed diplomatic assistance, since at the time France was at war with Spain, which controlled Naples. In 1637 she was still in Naples, now completing three paintings for the cathedral in Pozzuoli. In October 1637, still keeping her options open, she announced to Cassiano dal Pozzo her intention to offer the Barberini new pictures and return to Rome soon.[113] By the following year, having apparently run out of alternatives, she was in England.

Artemisia Gentileschi and Marie de' Medici met at the English court, when the French queen mother, now in exile, arrived from Holland in November 1638, to spend her final years with her daughter. Officially, Artemisia worked for both queens. This is documented in a letter Artemisia wrote near the end of her English sojourn, in which she names as her mistresses (*signore*) 'Her Majesty [the Queen] and the Queen Mother'.[114] The explicit naming of her two patrons, Henrietta Maria and Marie de' Medici, supports the probability of their combined participation in Artemisia's finalizing additions to the Greenwich ceiling.

When Henrietta Maria arrived in her newly adopted country in 1625, unable to speak the language and unwelcome to the natives, she brought a modest form of French feminism to England, which coincided with, but differed greatly from, the gender battles that had roiled England for decades, known as the Pamphlet Wars. Here, the *querelle des femmes* was debated in cheaply printed pamphlets that reached a large middle-class public and aimed to influence public opinion. John Knox's polemic *The First Blast of the Trumpet against the Monstrous Regiment*

of Women (1558) was met by defences of women, first from men. Jane Anger's *Protection for Women* (1589) is said to be the first English defence written by a woman ('it was ANGER that did write it,' the author claimed). Like the Italian feminists, Anger argued that women's minds were as good as or better than men's, and she protested the sexual double standard.[115]

Another battle was precipitated when Joseph Swetnam published an inflammatory diatribe, *The Araignment of Lewde, Idle, Froward and Unconstant Women* (1615). Rebuttals came quickly from women – Rachel Speght, Ester Sowernam and Constantia Munda.[116] Of the three, only Rachel Speght was the name of a real woman, an outraged eighteen-year-old poet who wrote a carefully argued defence of her sex. Many scholars consider Sowernam (a play on Sw[ee]tnam) and Munda to be pseudonyms of men representing themselves as women.[117] Tellingly, Sowernam distances herself from female defences, dismissing them as nothing more than entertaining table talk, and ridicules Speght's allegedly slender argument and earnest idealism.[118] Thus did the English patriarchy manage its challengers.

A broader challenge was women's disturbing adoption of masculine dress. In 1620, King James I ordered clergymen to criticize the 'insolence' of women who wear broad-brimmed hats, pointed doublets, short hair, or carry poniards (daggers). An anonymous pamphlet backed up the king: *Hic Mulier; or, The Man-Woman* (1620) attacked masculine dress as a crime against nature, God and society. A simultaneously published pamphlet, *Haec Vir; or, The Womanish Man* (1620) (illus. 13), presented a parallel figure, the effeminate fop, drawn from the growing masculine fashion trend towards wide breeches, broad-skirted

coats, lace collars and long hair, and set the pair in debate.[119] The masculine woman rebuts the feminine man's objections to her 'shameless' dress: her behaviour does not offend nature, but custom. Shame, she argues, is a concept invented by men to control women and restrict their natural expression. *Hic Mulier*'s eloquent case for women's self-determination is a genuine feminist argument, whatever the sex of its author.

The feminist rebellion in England was spearheaded by middle-class women, and the issue of class may have crippled it. Rachel Speght appealed to aristocratic women for gender

13 *Haec-Vir; or, The Womanish Man*, 1620, pamphlet printed in London.

solidarity and support but apparently didn't receive it, no doubt because such arguments threatened their privileged positions.[120] But a yearning for female solidarity recurred. We find it in *The Women's Sharpe Revenge*, written in 1640 by Mary Tattle-well and Joane Hit-him-home, to counter a misogynist pamphlet by a man they call 'Sir Seldome Sober'. Asking whether the entire female sex should be convicted by 'one poore ignorant silly Sot', the authors ask to be tried by a jury of their peers, which would include 'the Wives, the Widowes, the Country wench, the Countesse, the Laundresse, the Lady, the Maid-marrion, the Matron, even from the Shepherdess to the Scepter'.[121] In her unusual claim that the female gender embraces all social and class distinctions, Tattle-well took a step beyond the Italian feminists. Lucrezia Marinella had chastised Torquato Tasso for separating the female sex into two classes, woman (*femina*) and lady (*donna*), retorting that 'every one of our sex is a *donna*'.[122] The aristocrat Marinella would sooner make working-class women honorary noblewomen than honour their actual class status.

Queen Henrietta Maria, who might have seen this pamphlet inviting her to join laundresses and shepherdesses, probably wouldn't have accepted the invitation. Artemisia Gentileschi is unlikely to have read it, yet she might have been more sympathetic. Artemisia had boldly visualized women uniting to fight the patriarchy, long before Tattle-well articulated it. In the Pitti *Judith* (see illus. 38), as in the Uffizi *Judith* but with greater focus, Artemisia created an iconic image of the two assassins as a political unit. These women stand facing in opposite directions, one bejewelled as a fine lady and the other in plain servant's garb, locked together like statues,

and melded into a unit by their joint purpose. Judith places
a hand on Abra's shoulder to underline a female solidarity
that cuts across class lines.

AFTERMATH: 1640 AND BEYOND

Artemisia wrote to Francesco I d'Este, Duke of Modena, on
16 December 1639, to say she was no longer content to be in
the service of the English crown, 'from which I receive honors
and singular favours'.[123] The date of her return to Naples is
assumed to be 1640, but no documents establish that, and it
could have been a year or so later. The primary documenta-
tion of her final fifteen years in Naples is her correspondence
with Don Antonio Ruffo of Sicily, which began in 1649. On
13 March of that year, Artemisia wrote that she had married
off her daughter that day, 'to a knight of St James',[124] a bland
reference to the current turmoil in England. In the preceding
months, King Charles I had been defeated and captured by
Cromwell's armies, and on 30 January 1649 he was executed
for high treason. Quite likely, a knight of the royalist court of
St James who met Artemisia and her daughter in England
had found refuge in Italy.

After 1640, Artemisia's *oeuvre* is inchoate, with little cor-
respondence between existing paintings and those mentioned
in the literature. Paintings datable to this period present a
baffling diversity of style; some of them almost parody her
earlier pictures. The feminist energy of the early years has
disappeared, replaced by hyperbolic images of convention-
ally beautiful women. In part, the change can be explained by
Artemisia's struggle to survive in a changing art world. She

was avowedly quite broke in the late 1640s, acknowledging to Ruffo that her daughter's marriage had bankrupted her, and that money and work were now scarce in war-torn Naples.[125] As the gap between rich and poor widened in Naples, Artemisia's Bathshebas, Lucretias and Susannas grew more aristocratic, their settings more palatial, the women more refined. To serve a shrinking pool of buyers, she evidently made pictures to stoke the fantasies of the rich.

But the conservatism of Artemisia's late paintings also corresponds to the broader retreat of feminist writers from the public stage. In Italy, as Counter-Reformation 'reform' spread, the Church began to condemn secular texts as immoral, censoring them through the infamous Index of Prohibited Books. These measures had a chilling effect on intellectual life. Over the seventeenth century, as the clergy advocated passive spiritual conformity for women, presses began to print more devotional books than secular ones. Few defences of women were written, and women writers increasingly produced devotional literature.[126]

In this changed atmosphere, at the age of 74, Lucrezia Marinella reversed herself entirely. In a book called *Exhortations to Women, and to Others if They Please,* she appears to recant her earlier feminist views. Marinella now advises women to refrain from attempting to transcend their sex and instead take up gender-appropriate activities. Because the needle arts have been women's designated sphere, Marinella counsels women not to be ashamed to be seen weaving, but to spin and sew proudly. This activity will bring them praise and fame, whereas the learned woman attracts only envy and jealousy, misunderstanding and neglect.[127] Encouraging women to keep up

their domestic work, Marinella assures them that at the end of this earthly life, they will 'rise to heaven to spin silver and golden threads to make dresses for the angels'.[128] There is in her exhortation a certain 'barely suppressed bitterness', as one scholar put it, and some have seen the book as an ironic social critique.[129]

Marinella's hyperbole seems calibrated to appease conventional readers while speaking sotto voce to sharper ones – learned women perhaps – who recall her feminist treatise and recognize the irony. Marinella's tactic can help us understand the peculiar late paintings by Artemisia, such as the Potsdam *Lucretia* (illus. 14), Capodimonte *Judith* and Brno *Susanna* of the later 1640s, works contemporary with the *Exhortations*.[130] Like Marinella, Artemisia employs rhetorical exaggeration and over-the-top bombast that invokes what it seems to repudiate – the heroic resistance of Artemisia's early Susanna, Lucretia's angry challenge – nudging the cognoscenti that someone's leg is being pulled. The particular historical moment that gave birth to Marinella's feminist treatise and Artemisia's feminist art did not last, and this is their sardonic, perhaps bitter, response to that fact. Having given up on being valued for their woman-championing work, they now take satisfaction in being misunderstood by those who take their work at face value, perhaps deriving pleasure from outwitting the gullible.

In England early modern feminism took a different turn. The Pamphlet Wars heralded a taste for political agency, and raised the prospect of a world in which women had more power and men were content with less. The mannish woman, Hic Mulier, voiced the possibility that the world might change.

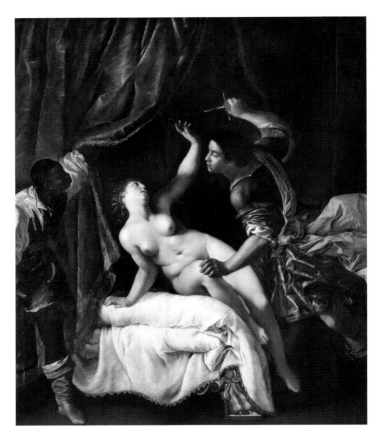

She argued that women's embrace of change was entirely
consistent with the natural order: 'For what is the world, but
a very shop or ware-house of change? . . . Nature to every thing
she hath created, hath given a singular delight in change, as
to Hearbs, Plants and Trees a time to wither and shead their
leaves, a time to budde and bring forth their leaves.'[131] The
idea that women might lift themselves out of inequality, as a
natural evolutionary development, was a powerful stepping

14 Artemisia Gentileschi, *Tarquin and Lucretia*, *c.* 1645–50, oil on canvas.
Neues Palais, Obere Galerie, Potsdam.

stone to the idea that equality was a natural right and to the
call for action.

As the feminist pamphleteers were beneficiaries of the
'Elizabeth effect' – the example of Queen Elizabeth I's
exceptional reign as a stimulus for a female political imagi-
nary[132] – so the next generations of feminists were heirs to the
imaginary of progress that emerged in the Pamphlet Wars. In
the later seventeenth century Margaret Cavendish (Duchess
of Newcastle), Bathsua Makin and Hannah Woolley wrote
feminist texts that challenged the sexual power imbalance and
called for social change. They have been described as the first
writers to consider women a 'sociological group' whose condi-
tion needed remedy.[133] Cavendish called for 'schools to mature
our brains'; lacking such access herself, she was self-taught in
natural philosophy, and went on to write scientific treatises,
science fiction and poetry. Bathsua Makin, who taught the
children of Charles I and Henrietta Maria, designed a school
in which girls would be educated in languages, logic and phi-
losophy. At the turn of the eighteenth century Mary Astell gave
Cavendish's nascent feminist theory firmer structure, weaving
Cartesian philosophy and Anglican theology into coherent
feminist arguments. Upping Makin's ante, Astell called for
the foundation of a women's college. All of the educational
institutions and opportunities that girls and women have
today were first envisioned by seventeenth-century English
feminists.

When the call for revolutionary action was issued in the
late eighteenth century, it came from England and France. The
Enlightenment produced the foundational treatises of Mary
Wollstonecraft and Olympe de Gouges, whose passionate

definitions of women's natural political rights inspired concrete advances toward legal equality. In nineteenth-century America, Susan B. Anthony and Elizabeth Cady Stanton initiated the long campaign for women's suffrage, and Sojourner Truth, who fought against both slavery and gender inequality, addressed the first women's rights convention. In twentieth-century England, Emmeline Pankhurst and her daughters were jailed for their efforts to gain the vote for women, force-fed when they staged hunger strikes. During the First World War, American women marched for equality and the right to vote, and in the 1970s a massive feminist 'second wave' fought for economic independence, equal pay and reproductive freedom. More recently, women of the #MeToo movement have claimed the right not to be sexually molested, and society has demanded retributive justice for the offenders.

Feminists have won some battles and lost others, and full equality still remains a dream. It is sadly true that feminist movements never last more than one generation, each advancing wave followed by an undertow of backlash. Yet feminist waves have recurred in every century since the fifteenth, each time bringing measurable advances. In the longer perspective, to extend the metaphor, the waves are steadily eroding the misogynist sands. And they are sometimes inspired by examples from the past. In the wake of dramatic congressional hearings in September 2018, when a candidate credibly accused of sexual assault was confirmed to the U.S. Supreme Court and the victim-witness was jeered by congressmen, an image of Artemisia's Gentileschi's Uffizi *Judith* (see illus. 36) went viral on social media, as an icon of solidarity for resisters of sexual assault. I wish she could have known.

Sexuality and Sexual Violation: Susanna and Lucretia

The biblical Susanna was a paragon of female virtue. In the apocryphal Old Testament story, the virtuous and chaste Susanna, wife of a wealthy Jewish patriarch, was assaulted while bathing in her private garden by two elders, judges perhaps, who had frequently visited the patriarch's home. Smitten by Susanna's beauty and fired by lust, the elders conspired to force her sexual submission by using her virtue against her. They told her that if she didn't yield to them, they would broadcast the false news that she had committed adultery with a young man. Susanna's dilemma was acute: since adultery was a crime punishable by death, she faced the choice of being gang-raped or dying. She chose to resist the old men's sexual demands. But on the elders' false testimony, Susanna herself was brought to trial, convicted and sentenced to die. Suddenly, the heroic Daniel came to her rescue, demanding a new trial on the basis of the elders' false witness. Conducting the trial himself, he interrogated the elders separately, found discrepancies in their accounts of Susanna's transgression and was thus able to prove her innocence.

Susanna's faithful defence of her chastity, to the point of dying for it, must be understood in the context of the honour codes that prevailed in Renaissance Italy, as in Old Testament times. In those patriarchal societies chastity was a woman's primary virtue, essential for proving to husbands, both prospective and actual, that she had not had sexual relations with other men. Female chastity was the protective seal that ensured the honour of daughters and the legitimacy of children, and buttressed the social power of the male head of the household. Adultery was a crime for both sexes, but only for women was it punishable by death. An unchaste female was said to bring dishonour to her husband's name, and in Christian societies she carried an extra burden of blame as a daughter of Eve, who brought original sin into the world. Not only were such views of women's unique culpability commonly held, they were supported by law and custom.[1]

Male control of female sexuality is the key feature of all patriarchal cultures, invariably supported by a sexual double standard. Susanna faced capital punishment for a hypothetical adultery with a young man, but the adultery the elders planned to carry out would not have been punished at all. The elders were ultimately convicted and executed, not for their sexual threatening of an innocent woman, but for the crime of false testimony. In early modern Europe this rampantly unjust double standard went largely unquestioned, enjoyed unthinkingly by many men and tolerated uncritically by many women. But around the turn of the seventeenth century, the issue became more self-consciously foregrounded. Defences of male privilege and invectives against women

began to appear, in which the double standard in adultery was explicitly defended.

Giuseppe Passi's *I donneschi difetti*, first published in 1599, was the most prominent of the misogynist treatises. In his long catalogue of women's defects, a full chapter is devoted to women's libidinous and lecherous carnal natures, buttressed by texts from Aristotle, Virgil, Ovid and Dante.[2] In another chapter Passi indicts adulterous women for disobeying divine and canon law. In lieu of arguments he cites ancient writers (such as the notoriously misogynist Juvenal) and infamous literary exempla, such as Medea and Penelope (oddly, Homer's heroine is described as a prostitute). Passi approves of severe punishment for female adultery, including death, and while he discourages husbands' adultery, he does not favour punishing them.[3]

Passi's treatise was sharply challenged by feminist writers. Lucrezia Marinella wrote *The Nobility and Excellence of Women, and the Defects and Vices of Men* specifically to refute it. Marinella countered Passi's blanket indictment of women with examples of good women in history, listing their virtues against Passi's catalogue of their vices, and staging etymological and philosophical arguments about woman's superiority and the nobility of her soul.[4] Arcangela Tarabotti rejected Passi's arguments with anger and passion. In *Paternal Tyranny*, she explosively dismissed his three justifications for the severe punishment of adulteresses (damage to the husband's honour, the risk of illegitimate children and the danger that either the adulteress or her lover might kill the husband):

But these are not reasons; they are the ravings of evil, unbridled thoughts to allow yourself greater freedom to commit crimes without fear of reproof . . . [God] allows you to put aside your wife if you catch her *in flagrante*, but you have made it legal to kill her on the slightest suspicion.[5]

Tarabotti bore down on the sexual double standard. Against Passi's claim that women are unfaithful, Tarabotti charges men with hypocrisy. 'With all the devices and fables supplied by poets, you portray yourselves as true lovers, all for the sake of getting your way with us . . . You make it your profession to capture fortresses guarded by the severest chastity,' then 'preach a sheltered life for women'.[6] Against Passi's critique of the beautiful Bathsheba for inciting King David's lust and ruining him,[7] Tarabotti defends the innocent woman who was 'at home, minding her own affairs bathing – whether for enjoyment or necessity, it matters little'. 'Ask yourselves, witless ones, who was the true cause of her fall?' It was David himself, she explains, for 'by various ruses he obtained the satisfaction his sensuality demanded' (as she clarified earlier, David had Bathsheba's husband killed so that he could marry her). Tarabotti continues: 'You don't even mention chaste Susanna, her honour threatened by the lust of two old men within the privacy of her own garden: then her life was threatened as well, had she not been delivered at a single stroke from shame and death by God.'[8]

Art amplified the idea that women's seductive beauty was to blame for men's sinful lust. In many of the Susanna images that were produced in early seventeenth-century Rome, a

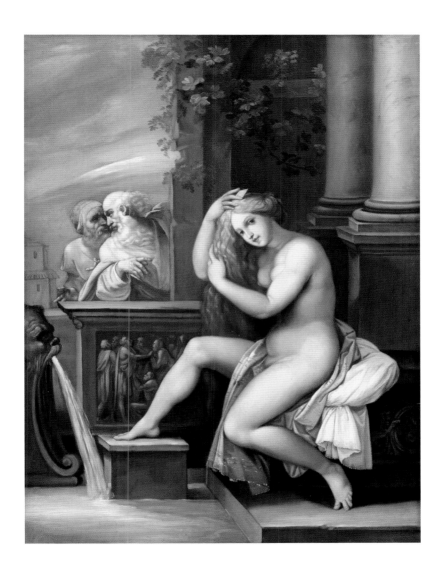

15 Giuseppe Cesari (Cavaliere d'Arpino), *Susanna and the Elders*, 1607, oil on canvas.

sexually attractive heroine turns responsively to the beseeching elders, her breasts heaving in sensual display above the drapery she clutches in a nod to decorum.[9] A family friend of the Gentileschi, Cavaliere d'Arpino (Giuseppe Cesari), made Susanna's seductive nature the expressive core of the picture, her gaze directed at the viewer who is the beneficiary of the elders' fantasized conquest (illus. 15). To enhance the erotic fantasy, a sexually suggestive fountain is echoed by a spurting curve of drapery between Susanna's bare thighs. Despite its morally instructive theme, the story of Susanna and the elders had by this time become a voyeuristic opportunity for male art patrons and viewers. Altogether lost, it would seem, was the point of the story, which was the innocent Susanna's defence of her chastity on pain of death.

Seventeen-year-old Artemisia Gentileschi gave Susanna back her story. Artemisia's first known painting, signed and dated 1610 (illus. 16), presents a heroine dramatically different from those of most male contemporaries.[10] Twisting uncomfortably on a hard stone bench, Susanna turns away from the whispering assailants who loom above her, her head bent awkwardly off axis, her arms raised in resistance. Susanna's pose, extraordinary for the theme at that time, telegraphs the young girl's response to the would-be rapists: just like the biblical heroine, she says no. With this compositional choice, Artemisia changes the narrative focus from the men's pleasure to the woman's distress. Selective realism of detail – a frowning brow, irregular exposed teeth and strain wrinkles at shoulder and groin – magnifies Susanna's discomfort, and her radical difference from the generic beauties in many Renaissance and Baroque paintings. Susanna's nude body,

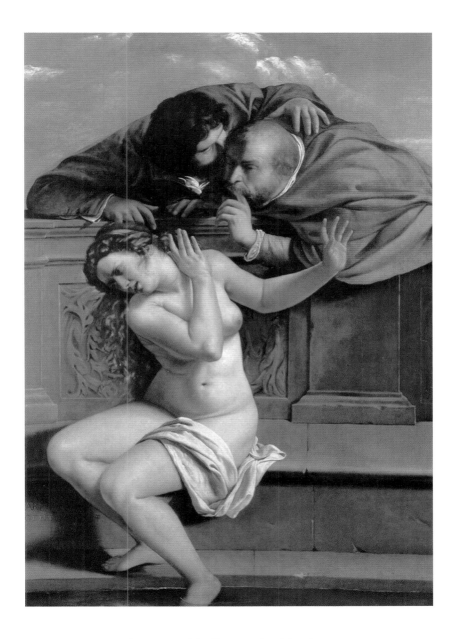

16 Artemisia Gentileschi, *Susanna and the Elders*, signed and dated 1610,
oil on canvas. Collection Graf von Schönborn, Pommersfelden, Germany.

with a sensuous, natural breast visible, affirms the feminine beauty that aroused the elders, yet the ungainly nakedness of this body conveys her vulnerability.

An unusual detail in Artemisia's *Susanna* is the relative youth of one elder. The younger man with thick dark hair, a somewhat dashing figure with a mysteriously hidden face and in an open-necked shirt, hovers uncomfortably close to Susanna, his hand almost touching her hair and fingers. The elders are typically presented as bearded old men to whom Susanna would not normally be attracted – which makes the depictions of her seductive receptivity all the more implausible. But such pictures are essentially male fantasies, a genre in which women invariably welcome men's overtures. Artemisia's *Susanna* brings us closer to the world of flesh-and-blood women who might need to say no, yet are not immune to sexual attraction. By casting one elder as a possibly appealing younger man, Artemisia brings new depth to the character of Susanna: in resisting his demand, she is not simply defending her honour as a flat moral absolute, she is also resisting potential sexual temptation. Her rejection is a test of her willpower.

For the feminist writers, similarly, chastity is a matter of will, a woman's self-restraint. A full-scale discussion of women's chastity that takes female hormones into account is found in Moderata Fonte's treatise, *The Worth of Women*. The speakers in this dialogue include an elderly widow (Adriana), a young widow (Leonora), a marriageable daughter (Virginia), a newlywed (Helena), a young married woman (Cornelia), a matronly wife (Lucretia) and a scholarly young woman who is single by choice (Corinna).[11] As they converse, Fonte's protagonists envision an ideal social order based on women's

values. They discuss chastity at great length, presenting subtly argued positions on women's and men's sexual appetites.[12] The women rehearse the Aristotelian argument that women are less passionate by nature, calmer and gentler, whereas men's desire is so strong that their reason is overpowered by their senses. Helena observes that if women are better by nature, and less passionate, they don't deserve credit for abstaining from sex.

But Corinna doesn't agree that women have less sexual desire than men, for she knows women who have 'suffered the torments of sensuality more violently than many men'. In addition to struggling against their natural sexuality, women must also summon the strength to oppose men's corrupting overtures; they must suppress desire 'at the cost of great violence to their hearts'. Lucretia objects to this argument, claiming that women are all too easy and yielding, which encourages men to try their luck. Corinna decries Lucretia's attack on women, evoking Aristotle to make a distinctly un-Aristotelian case: 'if men through their actions are the efficient cause and the prime movers in awakening women's senses . . . then why should women bear the blame for . . . a sin that arises from accidental causes and not from their own nature?' Cornelia laments the imbalance of power: 'I don't quite know how they've managed to make this law in their favor, or who exactly it was who gave them a greater license to sin than is allowed to us.'[13] Arcangela Tarabotti would later catch the essence of the argument about female sexuality: 'Let us be clear: Christ did not desire the virginity of an imprisoned body with the contradiction of freely roaming desires . . . If women are fickle, why force them to be constant?'[14]

In a single image, Artemisia consolidates the human dimensions of the sexually vulnerable woman's dilemma. While Susanna is visibly tormented by the elders' sexual bullying, it is subtly suggested that she is also distressed by their manipulative warping of her natural sexual identity. This is implied in the contrast between the decorous and tightly bound coiffure at the back of her head, the 'face' of rejection she presents to the elders, and the loose, luxuriant tresses that flow down her side (illus. 17). Artemisia's Susanna embodies the contradictory demands that are socially imposed on a young woman, forced by custom to feel shame in her beautiful, God-given sexuality until it is officially given to a man. The artificial repression of this young woman's innate sexuality is underlined in the classicizing foliage of the sculptural relief behind her. Its organic fronds rhyme and merge with the wavy locks of Susanna's hair, both pulsing with nature's energy. Yet, like Susanna herself, the fronds are confined by a severely rectilinear architectural frame. At the left of the picture, the architectural balustrade and line of the steps bend slightly forward, suggesting a spatial enclosure from which there is no escape. The picture articulates the lamentable control of nature by culture, in a social world where women are induced to believe that virtue matters more than their own life.

Critics who have dwelt on the physical allure of this Susanna's body and its appeal to the voyeuristic viewer may have gotten hold of the wrong end of the stick, for it is unlikely that the picture was primarily intended to provide erotic pleasure.[15] Certainly it can function that way but, considering the gender of the artist, the painting more fundamentally involves

the inner experience of sexuality – what it feels like to be a girl becoming a woman, her body filled with youthful erotic libido (Artemisia conveys this with precision, combining a slender girlish torso with a womanish breast). In a gender-balanced world, the perspectives of the male viewer and the female subject would not be inconsistent. But under the patriarchal conditions replicated in most Renaissance paintings of the female nude, the gazing male steals pleasure in viewing a body that no credibly sentient creature inhabits. Artemisia's

17 Artemisia Gentileschi, *Susanna and the Elders*, detail.

Susanna insists on the reality and validity of the girl-woman's experience, and the contradictory, gendered responses to the painting in modern times speak to its radical disruption of pictorial and social norms.

Like Artemisia, Fonte and Marinella powerfully challenged society's gender imbalance, yet they accepted the social contract, criticizing, but not demanding that society overthrow, the double standard and rules of chastity of the world they lived in. It would be a century and a half more before women, or indeed anyone, engaged in political protest in the modern sense. At the turn of the seventeenth century, women could only escape the prisons of gender through the power of imagination. Fonte envisions a female-ruled society, and Marinella imaginatively extols women's creative resourcefulness in preserving their chastity. She catalogues the virtuous women in history who have successfully resisted the threat of rape, such as Penelope, who, she says, in a swipe at Passi, was described by Homer as 'chaste, prudent, and wise'. Then comes a long list of women who preserved their virtue by giving up their life, beginning with Sophronia, Lucretia, Virginia and Dido. The Princess of Taranto locked herself in a dark little room to escape the Goths. Diana, the very goddess of chastity, turned the accidental voyeur Actaeon into a stag. Metamorphosis provided a clever escape for Greek nymphs: Diana's companion Arethusa sweated so much in escaping the river god Alpheus, she turned into a fountain; Syrinx escaped Pan by turning into marsh reeds; Daphne evaded Apollo by becoming a laurel.

As Marinella goes on, she warms to her sub-theme of the escaping women's ingenuity. The Spartan maidens kept

themselves spotless by disfiguring 'their faces with filth and with knives'. Fiordiligi locked herself up for life in a cell inside her husband's tomb. Isabella, in Ariosto's *Orlando furioso*, had her head cut off, having bathed her neck with herbs to harden the body, so that said head bounced three times – a rare way to escape the Saracen, as Ariosto notes. Marinella ascribes these stories to Ariosto, Petrarch, Ovid and Livy, and her narrative is carefully verified by respected authors. Yet the cumulative effect of these increasingly bizarre stories is comical, if only inadvertently, and the rather dull subject of chastity is unexpectedly enlivened. Although Marinella does not openly question the cultural ideal of female chastity, she holds it up to ridicule by exaggerating its fables.

Like Fonte, Marinella viewed the world of gender from the standpoint of Venetian nobility. Their knowledge of women's behaviour in rape cultures was derived largely from literature. Like most aristocratic women, they lived relatively secluded lives, without access to wide social experience or travel.[16] But in the wider world, the circumstances of rape were less melodramatic than those in Marinella's mythic fantasies, the menace of sexual assault less obvious and escape less possible. Women of lower status were far less protected than patrician women by the social boundaries set for Eros (in Guido Ruggiero's phrase), and their sexual victimization tended to be regarded, in Ruggiero's description, as 'merely an extension of an exploitative sexuality that was quite common and not particularly troubling'.[17]

Artemisia Gentileschi's life differed radically from those of the feminist writers, not only by social position, but in her experience of rape. The details of this experience, as

discussed in Chapter One, and particularly the transcript of
the rape trial, provide a vivid picture of sexual violence and
the prosecution of sex crimes in early seventeenth-century
Rome. Female victimization often began at home. Orazio
Gentileschi attempted to raise his daughter according to
bourgeois moral values, yet he allowed his friend Agostino
Tassi unsupervised access to Artemisia, and at the time he
charged Tassi with rape, he had long known that the couple's
relationship was seemingly headed towards marriage – an
accepted way to restore a family's honour following a rape
– so he may have been motivated by something other than
moral outrage at his daughter's violation.[18]

Yet Artemisia was not a passive victim. Before the rape
event, Orazio had tried to persuade his daughter to enter a
convent, presumably to protect her, but Artemisia resisted,
allegedly announcing that he 'need not waste his time because
every time he spoke to her of becoming a nun he alienated
her'.[19] The daughter's defiance of her father is suggested in
the witness testimony that Artemisia could often be seen at
a window looking out, a provocative violation of the code that
young girls should be modest and invisible.[20] Although the
witnesses were partisans of Tassi and flagrant liars, this report
could have been true, for Artemisia clearly sought greater
independence.

Ultimately, she may have resented her father as much as
her assailant, because Orazio's self-serving lawsuit against his
fellow artist set in motion the events that caused his daughter
lasting damage, subjecting her to community exposure and
psychological stress. Artemisia's virginity was disputed by
both Tassi and Tuzia, the neighbour who facilitated Tassi's

access to her, as well as by a series of witnesses for Tassi who described her as having loose morals. The slanderous assaults on Artemisia's character by Tassi's supporters – who accused her of being a whore, and spread the rumour that she posed nude for her father[21] – set up for Artemisia, as for so many young women, a polarized identity as either saint or sinner, without regard for natural sexual urges, an artificial dichotomy that she explored in her art.

The accusations of promiscuity threatened to taint Artemisia's reputation beyond the courtroom. In this sense, as the historian Elizabeth Cohen pointed out, Artemisia was as much on trial as Tassi. To defend her personal honour and public respectability, which others had betrayed, the eighteen-year-old adopted a strikingly assertive posture.[22] She described her honourable conduct and avoidance of improper advances, and narrated the rape incident in graphic detail. Artemisia's account checked all the boxes that the court required in rape cases. She dramatized her active resistance, which included wounding Tassi with a knife in self-defence, and described her pain on penetration and the bleeding that followed, and Tassi's subsequent promise to marry her.[23]

Artemisia's shrewd and strategic testimony, the overriding concern she expressed for her reputation and her rapid recovery to develop her career in Florence soon after the trial led Cohen to caution modern feminists against overstating the male aggressor/female victim dimension of the rape, and to suggest instead that the damage to Artemisia's psyche was probably minimal. This argument was challenged by law professor Rachel Van Cleave, who conceded that women of Artemisia's time expressed greater concern for their honour

than about the psychological damage that might concern a modern rape victim, yet pointed out that the law and culture of that time did not provide a language or context for their consideration.[24] As Van Cleave points out, Artemisia might well have had strong feelings, both about being physically violated and about the power imbalances of gender, which as we have seen were also expressed by the feminist writers of her time.

Noting the striking similarities between Artemisia's painting of *Susanna and the Elders* and her own experience of rape – the issues of sexual honour, false accusation and false witness – some writers have speculated that the date 1610 might have been inscribed on the painting after the fact, backdated by Orazio and/or Artemisia to separate it from the stigma of the trial, and perhaps painted specifically to affirm her innocence and honour.[25] But it is simplest to take the inscription at face value, and to accept that the prodigious young painter conceived and largely painted the picture at the age of seventeen (Raphael, another prodigy, had completed a major altar painting by that age; Mozart had written three operas). The feelings expressed by the fictive Susanna, it still seems to me, most likely echo those of a young Artemisia who, to judge from the trial testimony alone, was harassed sexually by men in her world prior to the Tassi incident.[26] The picture's expression draws upon and incorporates the artist's experience, yet it is not a self-portrait in any literal sense. Artemisia may have recognized the connection between Susanna's story and her own only after the fact, but she took the opportunity thereafter to embed herself in her characters (though in a more subtle way than Michelangelo and

Caravaggio, who participated in their narratives through overt self-portraiture).[27]

In an honour society, the danger posed to a woman's reputation by rumours of sexual impropriety could be offset by a solid reputation as a proper woman. Artemisia settled in Florence as a married woman, gave birth to several children and took steps to establish herself as a respectable, independent artist and businesswoman. We may infer from her support by patrons at the highest social levels that she had effectively separated herself from the rape trial scandal. Yet five years after her arrival in Florence, Artemisia was involved in an extramarital affair. This was evidently a real scandal for, as Artemisia wrote to her lover Francesco Maria Maringhi shortly after she left Florence in 1620, she could no longer safely walk the streets because of her reputation.[28] Slanderous rumours followed Artemisia to Rome: she names an officer employed by the Medici who sent a crudely defamatory letter to Orazio Gentileschi, and she hotly criticizes a certain Margherita as a gossip-monger who had accused her of theft. Artemisia describes Margherita as a whore and, a little later, when she has heard of Maringhi's other women, she describes them as whores too.[29]

If Artemisia had been exclusively concerned for her reputation in Florence, she would not have embarked on an affair that was likely to become public knowledge. She broke the rules that she endeavoured to play by. Writers both early modern and contemporary have judged Artemisia as promiscuous or 'libertine', perpetuating the virgin–whore dichotomy that has plagued women for so long: if they are not saints, they must be sinners.[30] Under the double standard, a women's

'promiscuity' is a man's libido, and Artemisia often behaved as if she had a male's freedom of action. In modern feminist terms her behaviour exactly matches our definition of the sexually liberated woman, who values her independence and freedom of choice, including sexual choice, above society's conventions.

Unlike Susanna, Lucretia succumbed to rape. Both narratives revolve around the axis of chastity, however, and the consequences of its violation. Lucretia's story takes place in ancient Rome, during the kingship of Tarquinius Superbus. Over dinner, Tarquin's kinsmen debate the relative virtues of their wives. When Tarquinius Collatinus brags of the loyalty of his wife Lucretia, the men ride back to Rome to see what their own wives are doing. Lucretia is found to be the most virtuously engaged, industriously spinning wool while the other wives are idly carousing. Her beauty and virtue arouse the ardour of Sextus Tarquinius. He returns later, slips into her bedroom and threatens to kill her if she doesn't yield to him. When she refuses even on pain of death, he threatens to kill a slave and put him naked into the dead Lucretia's bed, so they would appear to have committed adultery. Faced with disgrace, Lucretia gives in to the rape. The next day, she tells her father, husband and their friends of the disaster and they pardon her, pointing out that since she didn't want the rape she was blameless. But Lucretia realizes that her example might excuse the actions of women who could claim that a sexual encounter was a rape in order to escape punishment. Declaring that no 'unchaste woman' shall live through her example, Lucretia draws a knife and plunges it into her breast.

Lucretia's choice of death to defend a principle found extended political application. Her suicide, according to Livy, led the Romans to replace the Tarquins' tyrannical monarchy with a republican government, and Lucretia was thereafter extolled as a symbol of political freedom, by both Renaissance Florentine humanists and leaders of the French Revolution.[31] For early Christian writers, on the other hand, Lucretia was a model of religious martyrdom because she inspired Christian women to die to preserve their virginity. The causes Lucretia might support could vary, yet her decision was universally endorsed for its prioritizing of a principle over the actual woman's life. The story was nuanced by St Augustine, who recognized the conflict of Roman and Christian values, body vs soul, in Lucretia's dilemma: 'If she was adulterous, why praise her? If chaste, why slay her?' Many subsequent writers framed Lucretia's story in the terms of Augustine's dilemma, down to Artemisia's contemporary the poet Giambattista Marino,[32] and like Augustine they were content to leave Lucretia with her impossible decision.

The feminist writers looked at it differently, and they were aghast at Lucretia's violent self-destruction in the face of an inhuman expectation. Christine de Pizan includes Lucretia's agonizing choice in her discussion of Susanna, who had the same dilemma. When the elders threatened her, Christine's Susanna cried: 'if I do not do what these men require of me, I risk the death of my body, and if I do it, I will sin before my Creator. However, it is far better for me, in my innocence, to die than to incur the wrath of God because of sin.'[33] In this echo of Augustine's body–soul dilemma, the terms are subtly adjusted. Whereas Augustine was addressing the judges

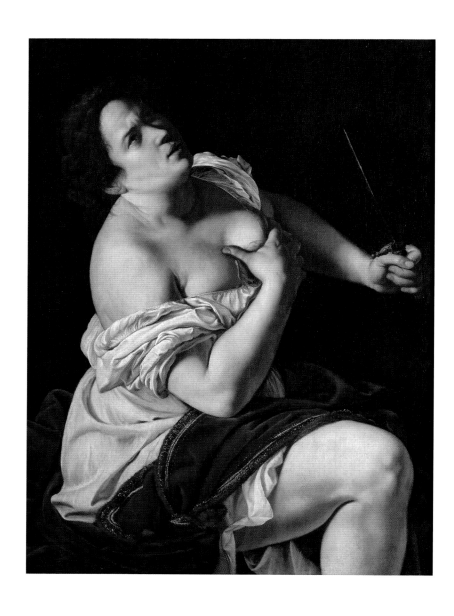

18 Artemisia Gentilesci, *Lucretia, c.* 1612–13 or 1621–5, oil on canvas. Gerolamo Etro, Milan.

and legal systems obliged to navigate the horns of the metaphoric Lucretia's dilemma, Christine considers the decision the woman's personal problem, a drastic situation where no action is without penalty.

Like Christine, Artemisia focuses on Lucretia's moment of decision (illus. 18).[34] The heroine is seated in a dark space, implicitly her bedchamber. Her naked shoulders, breasts and knee, exposed by a strong light, and the disarray of her clothing indicate that the rape has occurred. Grasping a dagger in one hand and a breast in the other, she gazes upward as if to seek God's help, yet it is not a posture of rhetorical piety, for this Lucretia is filled with physical and emotional tension. Her intensely knotted brow, her speaking lips and the stiff anxiety of her body suggest that she does not so much invite divine intervention as *demand* that God help her with a difficult decision she faces in the here and now. She even appears to be speaking – in stark contrast to traditional and contemporary admonitions to women to be silent.[35]

Unlike many Lucretias of the period, Artemisia's character is not shown stabbing her breast, nor is she heroically posed to carry out the sacrificial act with stoic resignation, nor is the theme taken as a pretext for exposing naked female breasts to the art connoisseur.[36] Instead, she holds the dagger nearly upright, as if to question the necessity of the act. In her hesitation and anguish, Artemisia's heroine seems to ask how she could have been put in a situation in which she will be damnably blamed unless she's willing to die. In this she brings a distinctly modern perspective (modern in her day) to a dilemma that would have resonated for Artemisia, and the many women like her who were expected to sacrifice because

they had been raped – shamed by a sexual taint, 'spoiled' for marriage to anyone other than the rapist, their social identities dramatically altered. The voices of such women, victimized not only by their assailants but by the aunts and even mothers who acted as procuresses, can be heard in the testimonies of rape victims preserved in the Roman trial proceedings of 1602–4 (the same set of records included the Gentileschi–Tassi trial).[37] As the testimonies show, many of these women did not 'play the victim' and stood up for themselves in court just as Artemisia did. But Artemisia painted a Lucretia who protests the injustice of such victimization, and her outrage could stand for them all.

One small detail brings another dimension to Lucretia's choice. Artemisia's figure grasps a breast with her right hand (presuming right-handedness, this is a subtle way to prioritize the gesture's importance). Two fingers press the flesh to push the nipple forward, palpating the breast like a nursing mother. Long ago, I interpreted this curious interpolation to mean that the protagonist is weighing her options within a broader framework: the nurturing gesture, representing female fecundity in nature's ongoing cycle, is juxtaposed with the sword, agent of the suicide that would interrupt the natural cycle.[38] In these terms, the decision to live might be better than to choose to die. This still seems to me the most likely meaning of that detail, planted by Artemisia to enlarge the character's dilemma in human terms. Yet, as I subsequently learned, an emphasis on Lucretia's nurturing breast was not unique to Artemisia's painting.

The female breast plays a central symbolic role in the writing of the fifteenth-century humanist Laura Cereta. In

her letter to a young man on the brink of marriage, Cereta catalogues the exemplary strengths of legendary women such as Lucretia, Judith, Dido, Agrippina and Semiramis, whose maternal breasts symbolize their loyalty, strength and heroic actions on behalf of their people and posterity.[39] Cereta barely mentions Lucretia's rape, focusing instead on her legacy: 'Lucretia cut her bleeding breast with a sword and her innocent blood washed away the outrageous crime of Sextus Superbus, causing his everlasting exile.' As Diana Robin points out, in Cereta's entirely original adjustment of the paradigm, 'it is the nurturing female breast and not male vengeance that washes away monarchy and enables the birth of the republic.'[40] Over a century later, Arcangela Tarabotti again invoked the female breast in telling the Lucretia story. She recounts the plot, then adds: 'One could weave story upon story about deceived, raped, and abandoned women who would rather die than live once they were dishonoured. Decent people confirm that the proper abode of chastity is a woman's breast.'[41] Tarabotti echoes Cereta in this slightly strained figure of speech, but given Artemisia's presence in Venice in the years she was writing *Paternal Tyranny*, the nun could have known a version of Artemisia's memorable visual image.

In her letter to the young Pietro Zecchi, Laura Cereta names the great women famous for defending their chastity and, like Christine de Pizan, she subtly reworked Boccaccio's biographies of famous women, *De mulieribus claris*, to present women in a more favourable and plausible light. She describes Dido's suicide from Dido's point of view. Whereas Boccaccio states simply that Dido mounted the pyre, announced her

action, fell on her knife and died, Cereta dwells for a poignant moment on the dying heroine's emotional distress: 'As she lay on her funeral pyre while the Africans pressed around her menacingly, she repeatedly called out in an imploring tone the name Sychaeus, the husband she had longed for most.'[42] Cereta was vigilant in rescuing the legendary women from gratuitous blame. She emphasizes Penelope's 'pure and unbending' conduct in rejecting the suitors' proposals during her twenty-year wait for Odysseus' return. Boccaccio also praises Penelope's marital fidelity, yet he abruptly ends the narrative with the rumour that, according to a Greek poet, Penelope had committed adultery with one of the suitors after all. 'Far be it from me to believe that Penelope . . . was anything but chaste, just because one writer states the opposite,' he states sententiously.[43] But it's too late; the word is out.

The agenda for Laura Cereta and other feminist writers was to overwrite such sexist tainting of women, which appeared even in a genre intended to celebrate the exceptional ones. One of Boccaccio's purposes was to expose the generic deficiencies of most women by highlighting the rare exempla of special ones.[44] Like Christine de Pizan before her, Cereta rejected Boccaccio's premise that women displayed exceptional abilities only rarely. She addressed this directly to her own contemporary, a certain Bibolo Semproni:

> You are not only surprised but pained that I am said to show this extraordinary intellect of the sort one would have thought nature would give [only] to the most learned of men – as if you had reached the conclusion, on the facts of the case, that a similar girl had

seldom been seen among the peoples of the world. You
are wrong on both counts, Semproni![45]

To paraphrase: not only has nature given me an intellect just
like that given to men, but girls the world over are similarly
endowed.

Cereta further argues that women have a universal right to
be educated, a viewpoint unheard of in her time, then launches
an encomium to educated and learned women, whose 'noble
lineage I carry in my own breast'. Again the metaphoric breast
appears, now to harbour her almost mystical vision of a family
tree of learned women (see Chapter One). Cereta precedes
her encomium to women with a furious invective aimed at
men's uninterrupted denunciation and degrading of women,
her own cohort, whom she protectively celebrates in explicit
defiance.

I am angry and my disgust overflows. Why should the
condition of our sex be shamed by your little attacks?
Because of this, a mind thirsting for revenge is set
afire; because of this, a sleeping pen is wakened for
insomniac writing. Because of this, red-hot anger lays
bare a heart and mind long muzzled by silence.[46]

Cereta's outburst, apparently triggered by some final insult,
is understandable and appropriate considering women's
long-standing mistreatment and misrepresentation by men.
It's as if she suddenly woke up to see it, like the proverbial
'click' of recognition in 1970s feminism; and as in January
2017, when the inauguration of a self-proclaimed sexual

abuser as president of the United States was protested in Washington, DC, and around the globe by millions of women who wore pink hand-knitted 'pussy hats' to decry, among other things, the gender insult. A modern feminist, the artist May Stevens, once said to me, 'There are times when anger is the only appropriate response.' Laura Cereta's anger, like that of Artemisia's Lucretia, was an existential human reaction to gender injustice, whose validity must be acknowledged before change can come.

The Fictive Self: Musicians and Magdalenes

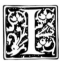 n 1998 an unusual painting turned up on the art market (illus. 19). A woman in an elegant blue gown and fancy headdress, playing a precisely depicted lute, turns to meet the viewer's gaze. Documents indicate that the *Self-portrait as a Lute Player* was painted by Artemisia Gentileschi during her Florentine years, in connection with her service to the Medici.[1] When the painting first came to light, it seemed unlikely to be a self-portrait, since Artemisia is not known to have played the lute, and considering the musician's rather provocative display of her highlighted breasts – suggestive enough for one writer to have identified her as a prostitute.[2] It was an implausible self-image, some thought (myself included), for the artist who had so recently experienced rape, and whose anger at sexual violation is mirrored in her *Lucretia.*

But an explanation lay at hand. Artemisia might have presented herself in this portrait playing a role, such as one that she likely played on 24 February 1615, as the 'Artemisia' who sang in a performance of Francesca Caccini's *Ballo delle zingare* (Dance of the Gypsy Women), along with Caccini herself.[3] It was not a straightforward self-image, we could thus believe; she was merely assuming a theatrical identity.

My own discomfort remained, since Artemisia could have depicted herself as a musical gypsy without an erotic component. Why would a woman whose life and options had been circumscribed by sexual shaming choose to further sexualize herself?

The question is relevant today, when many women wonder why their daughters or friends choose to dress provocatively in this post-feminist era, eroticizing themselves when they are theoretically free to dress any way they like. One obvious answer, the desire to be sexually attractive, might be said to beg the question since it identifies that image as one's chosen primary identity. But it is not a new question. In a harsh attack on her own contemporaries, Laura Cereta bemoaned women's obsession with fashion to please men: 'Some wind strings of pearls around their throats, as though they were captives proud of being owned by free men . . . One woman walks with a limping gait, her belt loosened from her attempts at popularity. Another woman's breasts become larger when she wears a tighter sash.'[4] A century later, the women in Moderata Fonte's Socratic garden discussed the extravagant dress of patrician Venetian women and offered an opposite conclusion, calling the 'pastime' of dress and adornment a matter of their independent personal choice: 'What on earth has it got to do with men . . . if we do what we can to look beautiful, and do what we like with our hair?'[5] This is a bold claim for women's freedom to choose.

Artemisia's self-portrait as a lutenist offers another kind of answer. In presenting herself as a theatrical character, the artist is role-playing and, like an actress, she assumes a temporary identity. For the artist, as for well-known actresses,

the role-playing bears some relationship to the real-life self; there is some overlap of identity. Yet because they are not identical, a tension between the real and the fictive self is built into the image. We postmoderns understand this as 'performing identity', as Judith Butler termed it.[6] But what is the relationship between these performances and one's 'real' identity? Are we only a composite of the identities we perform, or is there some stable, essential self?

19 Artemisia Gentileschi, *Self-portrait as a Lute Player*, c. 1615, oil on canvas, 77.5 x 71.8 cm.

Children practise role-playing from an early age. Some little girls rehearse being mothers; others pretend they are doctors or nurses, cowboys or superheroes, or they pull some old clothes or a cape out of the attic and put on a show. They try on a known identity before their own is formed, perhaps to enlarge and empower themselves at an age when they are small and vulnerable. Children know that they are pretending, yet their driving urge to 'play like' so frequently suggests that at this critical stage of self-formation, the play-acting game might have firmer roots in the psyche than does mundane life. When children grow up, girls in particular, role-playing may support identity in subtle and complicated ways. But, as a further look at Artemisia's painting will suggest, play-acting can serve as it did in childhood – drawing on the imagination to expand the self.

The *Lute Player* ripples with overlapping associations that were current in Artemisia's time. A bosomy female musician could represent music as the food of love, or sex on offer, as could a lute-playing seductive boy such as those Caravaggio depicted. Gypsy fortune-tellers are often depicted with turban-like headdresses and sometimes low-cut dresses. The gypsy sorceress, *zingara maga*, was a stock figure in popular theatre, and Artemisia herself was later described by a poet as a benevolent sorceress, a *maga innocente*.[7] Sibyls also wear turbans in Baroque paintings, and like gypsies, sibyls foretell the future. All these associations circulate in Artemisia's *Lute Player*, and all enrich its meaning. But another connection is perhaps the most relevant: the lute player's headdress also resembles the folded turban that signifies the artist identity in Renaissance art. Michelangelo was thus identified as a

20 Florentine artist, *Portrait Drawing of Michelangelo*, c. 1520–22, pen and ink.

sculptor in a much-copied lost portrait drawing, which Artemisia could have seen in a copy at Casa Buonarroti (illus. 20).[8] The gypsy sorceress and artist merge to a degree, for in Renaissance tradition an artist is a magician, a *magus*, who gives physical form to divine ideas or, more mundanely, who tricks the viewer into believing the image she has created is real.[9]

The turban is a prominent feature in a set of images that resemble the *Lute Player*. One painting, wrongly ascribed to Artemisia in my opinion, presents a face that echoes the lute player's (illus. 21); its head is almost identically positioned and the subject wears a blue, turban-like headdress and holds a martyr's palm. On the grounds of style, this small painting – the whole picture is not much larger than the lute player's head – cannot have been executed by Artemisia herself, but might be another artist's copy of an Artemisian original.[10] In 2017, a picture surfaced at auction that could have been its model: the *Self-portrait as St Catherine of Alexandria*, now in the National Gallery, London (illus. 22). This painting, virtually the same size as the *Lute Player*,[11] shares with the little *Female Martyr* the folded headdress and martyr's palm, here developed into St Catherine and her torture wheel.

The London *Self-portrait as St Catherine* exhibits the strength and finesse of Artemisia's best Florentine paintings, and is a welcome addition to her *oeuvre*. It is a missing link between two pictures: the *Lute Player* and the Uffizi *St Catherine of Alexandria* (illus. 23), which has also been interpreted as a self-portrait.[12] All three paintings show the same distinctive physiognomy – the mouth is telling – and a nearly identical positioning of the body and angle of the head. In this grouping, we watch Artemisia explore the possibilities of pictorial role-playing. She

doesn't start from scratch and paint herself anew each time. (In fact, she probably transferred the outlines of the figure from one picture to the next, since the three figures are identical in size.) Instead, she produces facsimiles of the same person in different guises, like a paper doll with changing outfits, the better to underline the constant that is Artemisia the painter.

21 Florentine artist, *Artemisia Gentileschi as a Female Martyr*, c. 1615–20, oil on canvas, 31.75 x 24.76 cm.

The relationship of these paintings has recently been clarified by an X-ray of the Uffizi *St Catherine* (illus. 24), which shows that another figure lay beneath the saint, one virtually identical to the National Gallery self-portrait.[13] The Uffizi painting evidently started out as a self-portrait in a turban, but Artemisia decided to convert the canvas into a St Catherine, probably on receiving a commission for one,[14] and to develop the first idea on a new canvas. Given the prominence of the turban and its resemblance to Michelangelo's

22 Artemisia Gentileschi, *Self-portrait as St Catherine of Alexandria*, c. 1615, oil on canvas, 71 x 71 cm. The National Gallery, London.

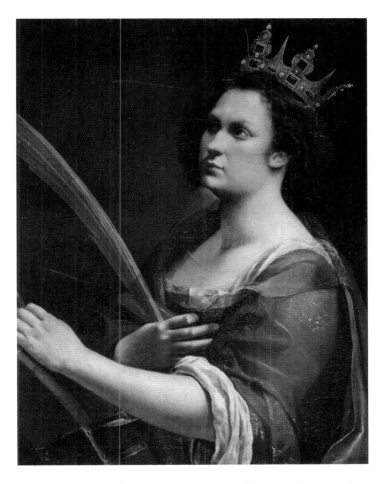

model, we may infer that in her initial self-image (perhaps her first ever), Artemisia claimed the identity of artist in the vein of Michelangelo. But having converted the first canvas into a saint, Artemisia then brought the doubled identity into the London version, where the turban is rather illogically draped over a now-minimized martyr's crown and halo.

23 Artemisia Gentileschi, *St Catherine of Alexandria*, c. 1614–15, oil on canvas, 77 x 62 cm. Gallerie degli Uffizi, Florence.

In the London *Self-portrait as St Catherine*, Artemisia created
an image that merges the identities of artist and saint, and
that can only be understood as an autobiographical riff. First
she transformed her natural self, an artist, into a pious virgin
saint; and now she enacts that transformation in reverse, pre-
senting her artist-self as having overtaken the martyred saint.
With the Uffizi *St Catherine* as a referent, the London picture

24 Artemisia Gentileschi, *St Catherine of Alexandria*, Uffizi, X-ray.

speaks in its formal language of a self-confident artist coming out of victimhood (the rape trial is only one reason Artemisia might have felt victimized). Artemisia/Catherine directly engages the viewer, a hint of determination on her brow. Her left hand is gracefully mobile, and with her right fingertips she holds the slender palm of victory almost upright, as if it were a painter's brush. The torture wheel, repositioned and enlarged, takes a more prominent role. Its metal spikes are conspicuous and sharp, but the wheel itself is broken, a reminder that Catherine of Alexandria was saved from death when her touch broke the torture wheel. Artemisia/Catherine commandingly touches the wheel, as if to change her own luck, and we might think of it as a wheel of fortune, studded with adversities she will overcome. Artemisia clearly thought in such terms, for the pseudonym she adopted in correspondence with her Florentine lover was Fortunio Fortuni.[15]

The *Lute Player* (see illus. 19) probably came last in the sequence. Now, the artist yields to the performer, and the picture is revealed to be a highly theatrical self-fashioning. The sitter is bathed in a strong light, a spotlight-like effect before its time. She wears an elegant blue dress and gold-bordered turban; her hair is tightly coiffed. She is heavily rouged, and her sexuality is exaggerated. As if to distinguish the worldly gypsy from the ascetic saint and the agonistic artist, Artemisia's lute player lightly embraces life's sensuous and tactile pleasures: the smooth rounded wooden box, the taut strings that vibrate to her touch, the viewer's receptive gaze. In this self-image that sprang from her performance in Caccini's gypsy *ballo*, Artemisia presents herself as a virtuoso merger of artist—magician—musician—seductress, a *maga* who

controls the show.[16] While serving the Medici court, Artemisia painted herself in another role. The inventory that names the *Lute Player* also lists a self-portrait of Artemisia as an Amazon with a helmet, shield and curved sword. This self-portrait was probably connected with another performance, and it points to the interests of Grand Duchess Maria Maddalena, who cultivated the image of herself as a woman warrior and was described by a biographer as 'a new Amazon in Tuscany'.[17]

Artemisia's play-acting self-portraits were attuned to theatrical performances that were a particular feature of this and other Medici courts, in which fiction was the coin of the realm. The court performance was a multimedia art form in which music, visual imagery and dance interpenetrated – and composers, librettists, artists and dancers collaborated – to create what the Germans later called a *Gesamtkunstwerk*. A famous court ballet performed in 1615 at the French court of Queen Marie de' Medici was described to Marie's aunt, the dowager grand duchess Christine of Lorraine, by a Florentine in Paris.[18] Luca degli Asini Fabbroni marvelled at the extravagance of the productions and the experience of such a spectacle. Supported by hidden machinery, the elaborate stage sets produced dynamic effects: clouds that moved, changing their size, shape and even density; mountain scenes that morphed into forests and seascapes. Engravings of these performances belie their very nature, for contrary to the engravers' dry, static record, everything was in motion, dancers and scenery alike.

Caccini's *Ballo delle zíngare*, a spectacle with similar special effects, was performed in Florence the same year. Cesare Tinghi, the Medici court diarist, described the event, and like Fabbroni he devoted particular attention to the costumes of

the gypsies and nymphs, which consisted of luxury textiles shot with gold and silver thread.[19] The eyewitnesses would have been sensitive to nuances of quality and cost in fabrics, for silk and wool were Florentine industries, and Florentines knew cloth well. During her eight years in the city, Artemisia developed an eye for quality materials and, indeed, she traded in the very fabrics she painted. She owned silk dresses, satin skirts and a purple satin fur-lined overcoat, which she used in the studio but also wore, presenting herself as an extension of her paintings, and positioning herself in social networks that included wealthy silk merchants and Medici court nobility.[20] These strategically purposed dresses were, effectively, costumes, and might have been made by the very tailors who created costumes for the Medici court.

The lute player wears such a dress – shiny blue satin, sparkling with gold bands and edging that are repeated in the fine gold borders of her headdress. Through the filter of the Florentine eye, and aided by the visual particularity of the *Lute Player*, we can sense how the qualities of a particular fabric – its texture, colour, the way it drapes and responds to light – could augment the illusion of reality in the court performance, lending material ballast to the pyrotechnics of motion. And, because wearing a costume could heighten a performer's sense of identity with her fictional character, Artemisia's *Lute Player* may have resulted from the experience of playing a gypsy. The painting gives us a sense of an uninterrupted flow between real and performative lives, and the magic that results when the material and the fictive converge.

A fluid interchange between real and fictive identities could also support the use of role-playing for strategic

purposes. Artemisia might have reasoned that it was safe to present a sexualized self-image – a dangerous choice for a woman who had been sexually branded by others – if it were only one of several play-acting images to be launched. After all, if you present yourself in multiple roles, you can't be pinned down to any one of them. Such a gesture would also have the effect of belittling the roles themselves, gently mocking the stereotypes of buxom lutenist and pious virgin.

There is an analogy (though without the mocking) in the strategies used by Grand Duchess Maria Maddalena to offset the perception that she and Christine of Lorraine had transgressed traditional female roles in their assumption of power at court. Maria Maddalena assumed the mantle of religious devotion, identifying with her namesake saint who had renounced sexuality for a spiritual life, and she commissioned numerous visual and dramatic works about virgin martyrs, apparently believing that virginity effectively symbolized a woman's legitimate exercise of power.[21] The grand duchess deployed virginal purity to sidestep the sexualization that can befall a powerful woman, a self-definition she put out to balance the Amazonian huntress. The example is a reminder that all women faced the problematic conflation of self with stereotype; anyone, from queen to artisan, could be brought down by assimilation to an unfavourable type. Both Artemisia and Maria Maddalena resorted to a quintessentially feminine strategy, playing one female stereotype against another to mitigate the essentialist typecasting used to define and constrict women.

Francesca Caccini also struggled to escape the limitations imposed on female identity. 'La Cecchina', as she was called

in her native Florence, was a composer, singer, lutenist and music teacher who joined the Medici court in 1607, having been trained by her musician father Giulio Caccini. In an important study of Caccini at the Florentine court, Suzanne Cusick examined the musician's negotiation of her social circumstances as a creative woman constrained by gender norms. Like Artemisia, Francesca tried for more than professional survival; she too attempted to give voice to the self through types constructed by men. Cusick discusses Caccini's aria 'Lasciatemi qui solo', from her *Primo libro delle musiche* of 1618, as an open challenge to its model, Monteverdi's lament for Ariadne in his opera *L'Arianna* (1608) and its libretto by Ottavio Rinuccini.

The lament was by tradition a female-gendered genre, both in the ancient Mediterranean world and in its modern musical form.[22] In 'Lasciatemi qui solo', Caccini uses the conventional framework of the lament to challenge its constraints. The genre is feminine, and Ariadne is female, but in Rinuccini's libretto the poetic speaker is a fictive male. Rhetorical priority is given to the departing Theseus, the focus of Ariadne's pleading and vengeful lament. Caccini's improvised deviations in both music and text give emotional focus instead to Ariadne's overwhelming desire for death, a private anguish that is voiced by a female singer ('Leave me here alone . . . Alone I wish to end my sufferings'). As Cusick explains, Monteverdi appropriated the fictional Ariadne for his own purposes. But in Caccini's version, Ariadne's voice is subsumed in her own voice, 'the once-living Francesca, not a fiction'. Caccini makes use of the lament, broadening its conventions and composing its elements differently, so as to

challenge the authenticity of Monteverdi's version and, through female singers, 'to bring one's several selves into being again and again'.[23]

This is a useful way to think about the relationship of Artemisia-the-artist and the performing subject of the *Lute Player*. In Caccini's music, the female singer reanimates the female composer, giving new life to the composer's creative self through performance. Similarly, the lute player performs the painter who made her, the once-living Artemisia, yet in a very specific artificial guise chosen to bring forth elements, but not the whole, of the artist's creative self. She could present herself in other guises, but they would be equally artificial, not to be mistaken for the artist per se. For both Artemisia and Francesca, the projection of a fictive self was self-protective, for to amplify the fiction is to obscure the real, leaving the world in some doubt about the artist's true identity. The artist herself might wonder whether she is anything more than her composite of roles – a fundamental predicament of a woman in a man's world. Considering the rhetoric of role-playing that the lutenist invokes, it may seem that she poses this very question to the viewer she engages with her eyes.

In their creation of artifices, Francesca and Artemisia unmasked something even more artificial – the masculine construction of femininity. In her groundbreaking *balletto*, *The Liberation of Ruggiero* (1625), Caccini exposed the masculinism of its model, Ariosto's *Orlando furioso*. Her distinctive female characters include Alcina, Ruggiero's sorceress captor; Melissa/ Atlante, his bi-gendered liberator; and some enchanted plants that were once humans. In scenes that ridicule poetic tropes of seductive sirens and feminine wiles, Caccini departs from

Ariosto to suggest that Ruggiero is trapped not by sexual allure, but by the spell of his own fantasies about women. His liberation by Melissa (according to Cusick, a figure for the virago-like Maria Maddalena) metaphorically freed both women and men from masculinist conventions and 'gyno-phobic fantasies',[24] with the added potential to dispel fears about a gynocratic regime under the grand duchess who, after Cosimo II's death, now ruled Tuscany.

A similar manipulation of Ariosto's urtext had been carried out earlier by Moderata Fonte. In her chivalric romance *Floridoro* (1581), Fonte rewrote the identities of some stock characters and invented others, such as the delightful Circetta, the imaginary daughter of the sorceress Circe and her captive Ulysses, who is a blend of Ariosto's Alcina and Melissa. Like Circe, Circetta has magical powers but in this revisionist tale, the two women are not sorceresses who seduce men; they are *maga*s who use magic to discover the secrets of nature for social good. As Valeria Finucci explained, 'by taking away from Circetta any suspicion of sexuality, the author shows that the Circe stereotype is a fantasy created by men for men.'[25] Such texts, or at the least their stories, must have circulated quickly in the cultural bubble of Italian courts, so the Venetian writer's *Floridoro* was likely known in Caccini's Florence.

But women who shared the constraints of gender did not need 'sources' to invent ways to escape them. If Moderata Fonte could convert a seductive sorceress into a natural philosopher, and Caccini could change the sorceress Melissa into a woman warrior, then it is not surprising that Artemisia would turn a saint into an artist and a gypsy. Or that Virginia Woolf would convert Ariosto's *Orlando* into the playful gallop

of her own bi-gendered Orlando across centuries.[26] Through
the magic of imagination, these female characters and their
authors are empowered to act on the world beyond their
socially defined limits. By comparison, the male heroes cre-
ated by men more closely mirror men's actual agency in
social life.

By the time that Maria Maddalena built her gynocentric
retreat at Villa Imperiale, where *The Liberation of Ruggiero* was
performed, Artemisia Gentileschi had left Florence to seek
new opportunity in Rome. She took with her, thanks to her
participation in Florentine cultural life, an acutely sophisti-
cated perspective on gender conventions, both as a prevailing
condition and a theme to be addressed in art. All the pictures
she painted thereafter must be understood in the light of that
perspective.

The grand duchess's enthusiasm for her namesake saint may
account for several Mary Magdalenes painted by Artemisia
during or soon after her residence in Florence. The penitent
Magdalene of 1617–20 in Palazzo Pitti (illus. 25) was probably a
grand-ducal commission.[27] Consistent with the image of reli-
gious piety the grand duchess liked to project, the Magdalene
appears here as a fervent convert to the spiritual life. She
gazes heavenward with sober intensity. One hand touches her
breast in a gesture of devotion; the other pushes away the mir-
ror that symbolizes earthly vanity, juxtaposed with the skull
of death that accompanies a penitent saint. But although the
Magdalene is said to have renounced the luxuries of earthly
pleasures, she seems not yet to have put them aside, dressed
as she is in an elegant golden silk gown and seated on a plush

red velvet chair, both of which are trimmed, *alla fiorentina*, with fine metallic ornament.

When I first wrote about this picture, I complained that the Magdalene's 'over-dramatization lacks credibility', and I found the painting to be disappointingly deficient in feminist expression.[28] My latter suggestion was rightly challenged, not

25 Artemisia Gentileschi, *Mary Magdalene*, 1617–20, oil on canvas. Galleria Palatina, Palazzo Pitti, Florence.

because feminism was irrelevant to the picture (as my critic argued), but because I did not yet understand that feminist expression could involve not only overt protests against gender inequality but the subversive strategies women adopted to compensate. Reflecting now on Artemisia's riff on feminine typology in the *Lute Player*, I suggest we understand the *Magdalene* as an intentional mocking of rhetorically dramatic conventions, rather than as a naive and ingenuous reinscription of them.

Like the *Lute Player*, the *Magdalene* is infused with qualities of the author's experience. Artemisia was well aware, and savvy Florentines could also have known, that Mary Magdalene's story broadly matched her own: a woman whose identity is stamped by a sexualized past turns a corner and takes up a new,

26 Detail of head from Artemisia Gentileschi, *Allegory of Inclination* (illus. 62), 1615–17, oil on canvas.

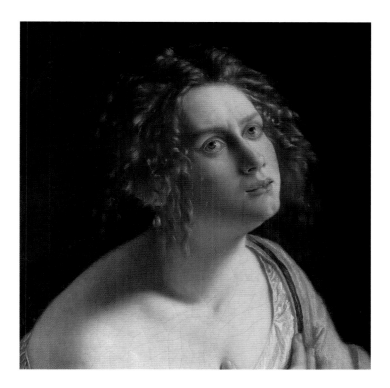

respectable life. But this picture is not openly a self-portrait. As with the *Lute Player*, the protagonist's face is a slightly older version of another fictional Artemisia, in this case the *Inclination* (illus. 26 and 27), an allegory recognized at the time to be tinged with the young artist's aspirations (see Chapter Six). In the Pitti *Magdalene*, Artemisia is subtextually playing herself, again in the guise of a performance. By projecting multiple images of her fictive selves, she was playing with her audience as well.

She pits this *Magdalene* against stereotype by exaggerating the features of the saint as she was commonly imaged – the

27 Detail of head from Artemisia Gentileschi, *Mary Magdalene*, Palazzo Pitti.

upward gaze of glistening eyes, the devotional gesture, the luxuriant golden hair – but now in a slightly awkward form, as if a real woman had suddenly come to inhabit a style-shaped body. Mary's coiffure alludes to the abundant, slightly unruly hair of the *Inclination*, but it is now a disarranged mess, like a wig that has slipped: tight corkscrew locks sit atop wispy, disobedient strands that are not quite contained by the coiffure. Her long fingers enact a penitent's gesture, yet unlike the smooth boneless hands of aristocratic women in Florentine art, these are clumsily jointed. Also overjointed is the bare (and slightly hammer-toed) foot, pertinent to the saint's life in the wilderness, but iconographically peculiar in this aristocratic chamber. The effect is comical, and I believe it is meant to be, as is the lachrymose gaze of her large shiny eyes. By overstating the signifiers of a conventional weeping saint, Artemisia undermines the stereotype, as if an actress were to play Mary Magdalene for laughs.

The notion that these characters are like actresses is not just a simile. Emily Wilbourne connects Artemisia with Virginia Ramponi Andreini, a *commedia dell'arte* actress and troupe leader who specialized in playing the stock character of the seduced and abandoned *donna innamorata*.[29] Andreini performed Arianna in Monteverdi's opera of 1608 at the Mantuan ducal court, and she often presented both comic and sacred versions of the same basic character. She played Mary Magdalene in sacred dramas written by her husband Giovan Battista Andreini, one of which is likely to have been performed in Florence in 1617.[30] Noting that it was common for actors to serve as painters' models, and that Virginia and Artemisia are likely to have known each other in Florence,

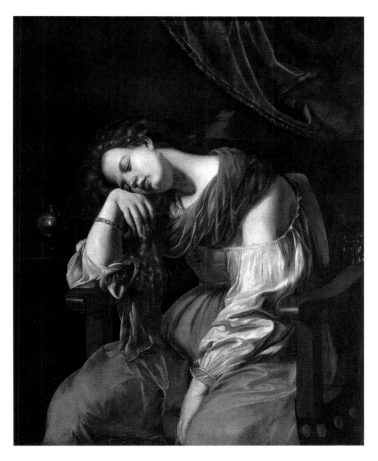

Wilbourne proposed that Virginia was the model for another
of Artemisia's Magdalenes, a picture now in Seville (illus.
28). It is difficult to be certain that the Seville *Magdalene*'s
face is the same as that of Virginia Andreini, whose general
features were recorded by Domenico Fetti, but they are not
dissimilar, and the circumstantial evidence is compelling.[31]
Giovan Battista Andreini himself commented that many

28 Artemisia Gentileschi, *Mary Magdalene*, c. 1615–25, oil on canvas.
Sala del Tesoro, Catedral de Sevilla.

people wanted 'painted images of actors in the guise of various gods'.[32]

The Seville *Magdalene*'s expressive allusions also point elsewhere.[33] The sitter's distinctive pose, her head resting on a sharply bent wrist, refers to a print that represents Michelangelo in the 'cheek on the hand' pose that is the iconographic sign of melancholy.[34] Michelangelo had come to personify the melancholic or saturnine genius, linked in Renaissance thought with artistic creativity. In the Seville painting, Artemisia embeds the Michelangelo allusion in the image of Mary Magdalene, a saint who is typologically identified with the contemplative life (versus the active Martha). By association, Artemisia connects herself with Michelangelo as a creative artist (not for the first time), even though the saint's face is not her own.

Like other *commedia dell'arte* performers, Virginia Andreini struck poses on stage that were artfully composed to express identity through body language.[35] Did Andreini take this pose when performing the melancholic Magdalene, and prompt Artemisia's recollection of the melancholic Michelangelo? Or did the artist ask the actress to strike a pose that would evoke Michelangelo in her Magdalene? However it came into being, the collaboration could hold enhanced meaning for both artists. Giovan Battista Andreini's affair with another actress in their troupe was common knowledge and a matter of disgrace for Virginia.[36] By casting Virginia as the Magdalene – her pose might hint at seduction and abandonment, but actually has elevated associations with artistic creativity – Artemisia allowed the actress to inhabit a permanent image of the saint's character that was independent

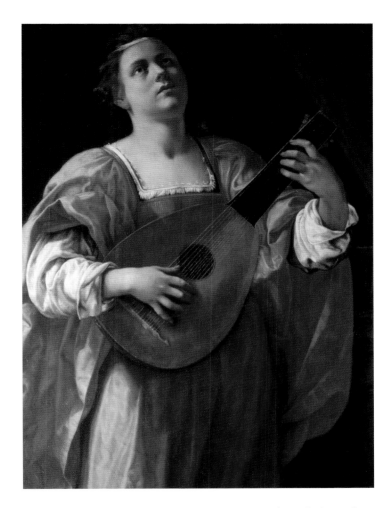

of her husband's play, and perhaps more dignified. In fact, none of Artemisia's Magdalenes is sexualized, in contrast to the many eroticized Magdalenes by artists of the period, and even Fonte and Marinella sustained her sexual identity in their religious poetry.[37]

29 Artemisia Gentileschi, *St Cecilia Playing the Lute (Francesca Caccini?)*, c. 1615–19, oil on canvas. Galleria Spaola, Rome.

The idea that the performer Virginia Andreini inhabited the identity of Artemisia's *Magdalene* opens new interpretative possibilities for other pictures. Artemisia's painting of *St Cecilia Playing the Lute* (illus. 29) might represent Francesca Caccini, a celebrated lutenist, or perhaps another musician at the Florentine court.[38] The lute, a peculiar attribute for St Cecilia, is redundant here since the saint's usual organ appears behind her. The figure's trance-like expression (and her

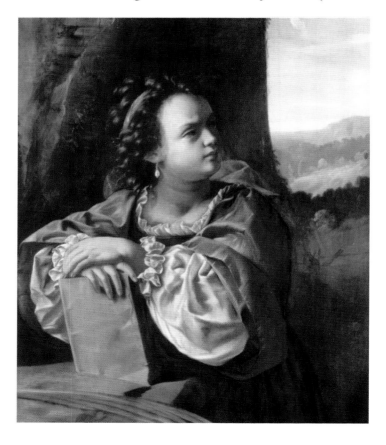

30 Artemisia Gentileschi, *St Catherine of Alexandria*, here identified as a portrait of Adriana Basile, *c.* 1615–20, oil on canvas. Private collection.

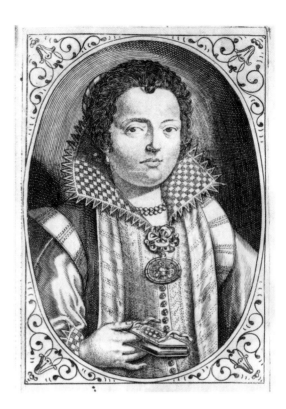

mysteriously rising sleeve) might be understood to connote
the musician's realization of celestial harmonies through a
modern instrument distinctively her own.

More securely, Artemisia's portrait of an unidentified
woman as St Catherine of Alexandria (illus. 30) closely res-
embles an engraved portrait of Adriana Basile (illus. 31), and
probably represents the celebrated singer who came from
Mantua to perform at the Medici court in the 1610s.[39]
Artemisia painted a portrait of Adriana Basile, which the
Neapolitan poet Girolamo Fontanella described as showing

31 Portrait of Adriana Basile by Nicolas Pirrey, frontispiece to
Il teatro delle glorie della signora Adriana Basile (Naples, 1628).

her touching the strings of a harp.[40] The extant *St Catherine* might be this portrait of Basile, if Fontanella's description was inaccurate, or a second portrait in which the singer played the role of St Catherine. Basile and Francesca Caccini shared patrons and interlocking circles with Artemisia in Florence, and the singers' merits were often compared.[41] Artemisia continued her close connections with musicians and performers in Venice, where she was associated with the performance-oriented academies of the Desiosi and Incogniti, and may herself have sung or recited poetry at one of their gatherings (see Chapter One).

Artemisia's third *Magdalene* from this period (illus. 32), a painting discovered only recently, departs sharply from the other two versions.[42] A woman is seen semi-reclining in a dark, virtually empty space, her head thrown back, her eyes closed, and a hint of a smile on her lips. She could be asleep, or meditating, or dreaming. None of Mary Magdalene's attributes – skull, mirror, ointment jar, cross – is present, not a single one. Were it not for her telltale off-the-shoulder chemise, we would not know who she is. She might even be Ariadne as Caccini envisioned her, alone in her dream of a blissful death, sounding an expressive note of rich solitude. Indeed, her dreamy facial expression resembles that of a famous Roman *Sleeping Ariadne* in the Medici collections (now on display in the Uffizi Gallery).[43]

She is more likely the Magdalene, however, for the picture also resembles an influential (lost) *Magdalene* by Caravaggio, its probable point of departure.[44] Artemisia eliminates all signs of the saint's anguish in her moment of spiritual crisis,

presenting instead an image of complete inner absorption. Even a kind of contentment is hinted at in the facial expression and the hands locked around a knee. It is at such a point, when the story virtually disappears but the emotion remains, that the author invests the character with a grain of lived experience. This very plain, almost homely, Magdalene does not look like other images of Artemisia, yet many autobiographical analogues suggest themselves in this narrative void: the seduced and abandoned rape victim, the young wife who began a love affair in Florence, the woman who fled Florence to escape gossip.[45]

I hesitate to mention such romanticizing possibilities, knowing well the scholarly scolding that has followed every writer's attempt to connect Artemisia's dramatic pictures with her colourful life; we are constantly cautioning one another about the danger of the biographical fallacy. Yet Artemisia

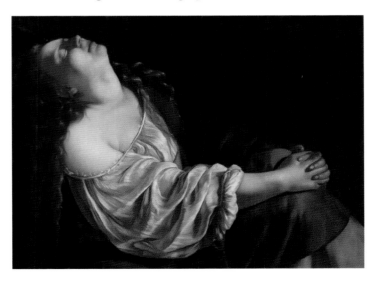

32 Artemisia Gentileschi, *Mary Magdalene*, c. 1620–25, oil on canvas. Private collection, Europe.

plays games with her own history. As the *Lute Player* and Pitti *Magdalene* show, she insisted that her audience recognize her presence in the paintings, so as to relish her role-playing and appreciate her wit and daring in creating images that might satisfy patrons even as they threw winking asides to others. The pictures are always about her, even when they ostensibly concern an archetypal female character, and the relationship between the two, the type and the artist's fictive self, is the major discourse of Artemisia's art.

The three *Magdalene* pictures differ distinctly in expression and style, yet their dating remains uncertain. Scholars have been unable to agree on dates for many of Artemisia's paintings because their developmental sequence is unclear: no sequential order can be postulated for the Florentine works that yields a clear stylistic development. As one who has long engaged in that effort, I now believe that the traditional art-historical concept of stylistic progression may not apply to Artemisia, because very early on she developed an ability to paint in more than one style, something she changed freely to suit a particular expressive purpose.

The three *Magdalene*s that come out of the painter's immersion in the Florentine world of music and theatre suggest an even more specific intention. Their differences are very much like the modes of music, whose expressive distinctions were employed by Renaissance composers. Caccini's songs were cast in particular modes. Cristofano Bronzini praised her Phrygian mode, which could make her listeners 'pliant, agreeable, or many other things by turn'; her Dorian music as 'elevating the low and earthbound in human minds

to the level of sublime contemplation'; and her Lydian song as wrapped 'in the sadness of melancholy and the denseness of dark clouds'.[46]

The idea that a song, or a painting, could be set in a particular expressive register would have been obvious to Artemisia from Caccini's example. Bronzini only vaguely describes the modes he names, but musical modes were characterized by other early modern writers in distinct expressive terms that suggest a rough analogy with Artemisia's *Magdalenes*: the playfully over-dramatic Pitti painting might be thought of as a light parody of the Hypolydian mode (devout, pious, tearful); the serious and intellectually subtle Seville version as Hypodorian (sad, serious, tearful); and the absorbed intensity of the third picture as Mixolydian (youthful, uniting pleasure and sadness).[47] The dominant emotional character of each of the paintings is calibrated through style. The fastidiously ornamental Pitti *Magdalene* is theatrically lighted, defined by hard contours, bright colours and sharp, sometimes fussy detail. The austere and introspective Seville *Magdalene* is more intimate, softer-edged, and virtually monochromatic, with more fluid brushstrokes and darker shadows. In the third *Magdalene*, the singular focus on the subject's state of mind is supported by a combination of sharp edges and painterly brushstrokes, with an intense contrast of light and dark that, as in the *Lute Player*, is almost like a spotlight.

The sequence in which these pictures were painted and their dating remain anybody's guess. Yet it might not matter so much. Artemisia's virtuosity confounds traditional art-historical practice, for in her art, style differences were a consequence not of her evolving artistic identity, but of the

artist's adjustments to the expressive challenge of her subjects. Style, in this way of thinking, is a function of role-playing, a question of the right costume for the character, and one style, like one size, does not fit all. Artemisia's radically feminist expression similarly confounded our discipline, and helped add the dimension of gender to the practice of connoisseurship.[48] The example of her art has challenged art history, its methods and standards, and it might please her to know that she has upended them all.

FOUR

Women and Political Power: Judith

o you think of Judith as a queenly warrior? Moderata Fonte did. On the first day of the women's dialogue in the garden, Leonora names Judith among the warrior queens of antiquity.[1] The only biblical character in this group of heroic leaders, Judith, is linked with them by a brave political act: she killed the tyrant Holofernes in defence of the Israelites. Thamiris killed the Persian king Cyrus on behalf of the Massagetae. Zenobia of Palmyra defeated the Persian king Sapor in battle. Semiramis ruled Babylon after her husband's death, regaining territories and building cities. Christine de Pizan, too, praised these paragons of female martial power for their courage, magnanimity and strength, and she extolled Judith and Esther in similar terms: as bold and fearless women who saved the Jews.[2]

This chapter concerns the biblical Judith, so forcefully depicted by Artemisia Gentileschi, from the viewpoint of her political agency. I use the term 'political' in the sense of its root definition (from the Greek *polis*, city-state), to mean an action taken that affects one's country or people. Women writers emphasized Judith's patriotic tyrannicide, and Arcangela Tarabotti states it precisely: 'With striking fearlessness, she severed the head of Holofernes and freed her country from

a deadly siege.'[3] It might seem obvious that this heroic deed defined Judith's identity. But, over time, the Judith story had taken on other meanings. In medieval Christianity, she became an emblem of Chastity and Humility, typologically linked with the Virgin Mary, and during the Counter-Reformation she came to embody the Church Militant and the victory of Truth over Heresy.[4]

Judith's identification with chastity contradicted the facts of the story. She was a beautiful widow who saved the Israelites by a trick, seducing Holofernes with her beauty and some wine, then chopping off his head. Moreover, this took place in a bedroom. The early Church fathers' insistent praise of Judith's purity and chastity was undoubtedly meant to offset the plot's erotic innuendoes. But the Judith story was too rich to be controlled by patristic moralists, and the protagonist also fitted another gender stereotype: a deceptive woman who trapped and endangered men through her sexual allure and 'feminine wiles' – what would later be called a femme fatale. Renaissance artists imaged her as an erotic seductress, especially in northern Europe, where she was linked with other 'devious' women, such as Salome, Delilah and Jael, under the topos of *Weibermacht*, or 'the Pernicious Power of Women'.[5]

Eroticizing Judith had the effect of neutralizing her threatening agency. Like Semiramis, Zenobia and Artemisia of Caria, Judith was a widow, a dangerously independent category of woman. In antiquity and in early modern Europe, widows held significant economic and social power, free of reproductive obligation and a husband's control.[6] The ancient widow queens pushed back military foes, built cities and monuments, and exercised power well beyond the female

norm. For this they paid a price. Their legendary achievements were minimized, or else joined by rumours of sexual misbehaviour. Boccaccio praised Semiramis for her courageous 'manly spirit', but, he adds, she was 'constantly burning with carnal desire'; she had many lovers and even slept with her son.[7] For her reputed lust and incest, Semiramis was consigned by Dante to the second circle of Inferno; and her sexual tarnishing was gleefully repeated by Artemisia Gentileschi's contemporary Giuseppe Passi.[8] The eroticizing of powerful women in history – think too of Cleopatra, who stood next to Semiramis in Dante's *Inferno* – is so common that it could almost become an indicator: the more eroticized, the more threateningly transgressive.

Judith's depiction as a temptress at least had a basis in the original story. She *did* sexually tempt the enemy general, and it is a paradox that Judith's seductive behaviour was essential to her achievement. Yet its magnification by artists and mythmakers helped obscure the political significance of the act for, despite its occurrence in an intimate setting, Judith's seduction of Holofernes was a civic deed. When the commentators sought to sanctify Judith by describing her as an instrument of God's will, they obscured her political acumen – she invented a strategy in which seduction was merely a tactical tool, such as a general might use to exploit a weakness of the enemy.

One type of woman warrior resisted eroticization: the semi-legendary Amazons of antiquity, who, in renouncing marriage and raising their female children independently, challenged patriarchal convention.[9] Their model was the virgin goddess Artemis and her female entourage, whose chastity was an

emblem of their independent power. This lineage was invoked centuries later to describe the French peasant girl Jeanne la Pucelle, who became the inspirational military leader Joan of Arc. When Joan broke the English siege at Orléans and led the dauphin to be crowned king of France at Reims, contemporaries compared her to the Amazons.[10] In her first known depiction, Joan was also paired with the biblical Judith, another siege-breaker, and Judith's sword was rhymed with Joan's martial spear (illus. 33). Christine de Pizan wrote a poem to celebrate Joan of Arc, whose military triumph occurred near the end of her own life – the first theorist of feminism was reportedly thrilled to see her claim for women's potential confirmed in 'a modern Amazon capable of performing wonders' – and she too named the biblical Judith as the French heroine's prototype.[11]

The analogy between Joan of Arc and Judith of Bethulia underlines the political basis of Judith's story. Like Joan, Judith was the de facto leader of a besieged nation, a female avatar of her government who, against all expectations, led her people to victory over a wicked enemy. Judith too was cast as an Amazon, in visual images that presented an alternative to the erotic versions. In an example by Fede Galizia (illus. 34), Judith's courageous deed is celebrated, and sex has nothing to do with it. Indeed, her sexual purity is implicitly the source of her strength, for Galizia presents Judith wearing a metallic bodice that resembles an armoured breastplate, a conflation of Amazonian militancy and Christian purity.[12]

In many respects, the story of Judith fits a masculine model of heroism. Her action was courageous and self-initiated, a responsible sacrifice for a larger cause. But Judith never

became that kind of hero because her story was counter-
cultural. Unlike her biblical counterpart, David, who displaces
his father Saul to become king, Judith cannot become a patri-
arch, and her deed brings her neither power nor reward. She
thus 'slips out' of the patriarchal order, escaping its moral pro-
tection.[13] But, at the same time, Judith's identity as a rebellious,
counter-cultural heroine gave her new life as a touchstone
for iconoclastic political challengers. The Huguenot leader
Jeanne, Queen of Navarre, was described as a Protestant
Judith in the French Wars of Religion. Protestantism's prime
advocate, Queen Elizabeth I, was characterized by herself and

33 French School, *Judith and Holofernes and Joan of Arc*, 15th century, vellum.

others as an anti-patriarchal Judith pitted against a metaphoric Holofernes, who represented both papal decadence and the threat from Philip II of Spain.[14]

From a patriarchal point of view, Judith's very deed was questionable. For one thing, her power was not legitimate. She nominated herself to save the Israelites, inventing a strategy and putting it into action without consulting the rulers of

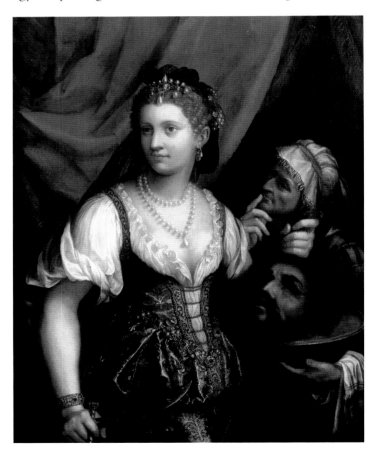

34 Fede Galizia, *Judith with the Head of Holofernes*, 1596, oil on canvas. The John and Mable Ringling Museum of Art, Sarasota, Florida.

Bethulia.[15] This directly challenged the code that public action was a male prerogative. As a female, Judith could not act in public, for while men gained prestige and honour from their public roles, 'public woman' was another name for whore.[16] Moreover, Judith accomplished her secret, politically illegitimate deed through deception. She tricked Holofernes with words, telling him that God had chosen her to accomplish a great deed, which he took to mean she would support his cause. In the Hebrew tradition, Judith is cast in the lineage of Eve; like Esther and Jael, she serves God by using stereotypically feminine tricks and doubletalk.[17]

Looming larger than these social transgressions is the belief that it is unspeakable for a woman to kill a man. A classic example is found in the Florentine debate of 1504, about the relocation of Donatello's statue of *Judith* (illus. 35) in the Piazza Signoria, to make room for Michelangelo's *David*. Francesco Filarete argued that the image of a woman killing a man was a deadly symbol, inappropriate for Florence, an omen of evil that had brought only bad luck to the city.[18] Ironically, forty years earlier, Judith's androcide was considered a highly appropriate emblem for the city. In the mid-1460s, Piero de' Medici, son of the family dynasty's founder, brought Donatello's statues of Judith and David to stand in the Medici Palace, to express the idea that the Medici family, like Old Testament saviours of Israel, were slayers of tyrants and protectors of Florentine liberty.

In this statue, the most monumental Judith yet created, Donatello underlines the gory reality of her deed. The assassin stands over her victim, sword raised. She has already delivered the first blow; the gash is visible in Holofernes' neck, and his

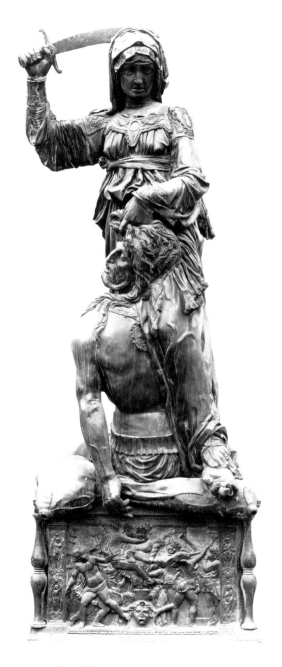

35 Donatello, *Judith and Holofernes*, c. 1455, bronze, 236 cm.

head lolls to one side. The meaning of her shockingly brutal action was made clear by an inscription on the base: 'Kingdoms fall through luxury, cities rise through virtues. Behold the neck of pride severed by the hand of humility.' A second inscription brought the message home to Medicean Florence, stating that this statue is dedicated to liberty and fortitude, and represents the health and well-being of the state.[19]

The Medici family's use of Donatello's statue to serve a modern political situation drew on Judith's history as a civic emblem in Tuscany. Petrarch had expressed admiration for Judith's intervention in political history, and in the Sienese town hall and other Tuscan frescoes Judith was conflated with Justice to represent good government.[20] Humanist and patristic thinkers defined Judith as an exceptional woman who performed 'manly exploits', and she thus acquired a kind of honorary virility that allowed her entry into public spaces.[21] The concept of masculine courage in a female body is made plausible in Donatello's remarkable image. Diminutive in her modest gown and widow's cowl, Judith lifts the sword decisively with her *manu forti*, the strong right arm of God and justice. She is virile but no virago; womanly yet untouched by gratuitous feminizing. In these terms, Donatello's powerful embodiment of civic humanism could be admired by men and women alike.

Yet this Judith did not represent women at all, for Florentine women were not citizens of the republic. A woman wasn't supposed to be able to wield such power, but somehow Judith did. Her story is a parable of the miraculous power of virtue to conquer vice, all the more miraculous when virtue is championed by an improbable political agent, a member

of the sex on the sinister side of 'right'. Judith was utilized allegorically as an exception to her sex, and then tainted, for Filarete and his ilk, by her association with it.

What did Florentine women think of Donatello's *Judith*? Situated in a garden courtyard of the Medici Palace, where brides and young unmarried women gathered, the statue would certainly have gained their attention. Yet, as Kelley Harness has aptly noted, Judith was a role model for chastity, not for tyrannicide.[22] One female author hints at the statue's subversive potential. Lucrezia Tornabuoni, the wife of Donatello's patron Piero de' Medici, was a woman who exercised matriarchal power within a patriarchal structure, an important patron of art, poet and educator of her sons Lorenzo and Giuliano de' Medici. Tornabuoni composed a poem on the theme of Judith and Holofernes, in which she takes up the theme of humility conquering pride, a concept inscribed on Donatello's statue standing in her household.[23] She embellishes the definition of pride (*superbia*) to include 'sensuality, anger, the urge to dominate others', displays that women were likely to have experienced at the hands of their husbands.[24] Donatello's statue potentially held a different kind of political meaning for women, an inspirational sign of what might be possible should the concept of Florentine *libertas* be extended to include them. Some Florentine wives might have seen in Judith's decapitation of Holofernes a fantasy solution for their own domestic confinement.

In time, *Judith* became a flexible civic emblem for Florence. Donatello's statue stood in the Medici Palace for thirty years, until the Medici were expelled from Florence in 1495. It then came to the Piazza Signoria, in front of the town hall, where

it continued to represent Florentine liberty, now championed by the anti-Medici, republican government. Displaced by Michelangelo's *David* in 1504, Donatello's *Judith* was moved to an arch of the Loggia dei Lanzi. Over the sixteenth century, as Quattrocento humanist republicanism became a distant memory with the return of a new Medici ruler, the authoritarian Grand Duke Cosimo I, there developed an open gender hostility. The deadly symbolism of Judith's androcide – for beneath Filarete's unease about Donatello's statue surely lay castration anxiety – was countered by Benvenuto Cellini's even more brutal gynocide, *Perseus Slaying Medusa* (1545–54), and the *Judith* was further displaced to a shadowy corner, with a misogynistic flourish, by Giambologna's *Rape of the Sabine Women* (1581–3; see illus. 40).[25]

Over the century following its creation, Donatello's *Judith* was turned from an emblem of political idealism into a relic of atavistic beliefs, yet it remained a dangerous reminder of women's potential power and men's need to control it. In the sober example of the statue's relocation, like the heroine's story itself, Judith's political agency is delegitimized. She is disdained for her usurping of male power and intrusion into a masculine space. This brings us to another usurper, Artemisia Gentileschi, who arrived in Florence thirty years after *Judith*'s last relocation, when its history was still within the living memory of Florentines.

In painting Judith (illus. 36), Artemisia picked up where Donatello left off, and took decapitation to a new level of gory detail. Judith slices off Holofernes' head with her sword, blood spurts from the almost completely separated head and

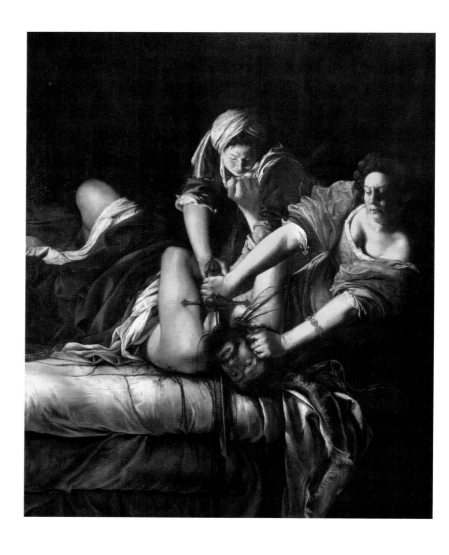

36 Artemisia Gentileschi, *Judith Slaying Holofernes*, c. 1618–20, oil on canvas. Gallerie degli Uffizi, Florence.

neck, and the maidservant Abra holds down the body of the still-struggling victim. Artemisia's expansion of the theme was supported by the narrative-friendly genre of painting (sculpture is better at consolidating ideas), yet the two works share a vision of Judith as intent on her mission and more than capable of carrying it out.

The depiction of Judith as a heroic defender was unusual in early seventeenth-century Florence, where the theme had largely been returned to its religious context.[26] Judith was also used for eroticized personal expression, as seen in a painting by Artemisia's friend Cristofano Allori, in which the beautiful heroine cruelly displays the decapitated head of the artist himself, the victim of emotional torture by his domineering mistress.[27] Artemisia's interpretation of the Judith theme, first realized in the version now in Naples,[28] sharply contrasts with Allori's picture. She countered Allori's self-pitying conceit of Judith the man-killer with the image of a heroine engaged in the bloody work of decapitation, a conception formally rooted in her memory of Caravaggio's *Judith Slaying Holofernes* (illus. 37). Here I concentrate on the Uffizi version, which was made as a variant of the Naples picture, probably at the request of Grand Duke Cosimo II.

Artemisia strengthened her Caravaggian prototype in this sharply focused, centralized composition, where hands, head, sword and blood converge as the dramatic climax. The Uffizi *Judith* is explosively dynamic, energized by the thrust of the women's arms and the pressure at Judith's wrists. A young and vigorous maidservant Abra replaces Caravaggio's passive, crone-like bystander. Where Caravaggio's maidenly Judith seems to cringe from her task in revulsion, Artemisia's mature

Judith concentrates on the job impassively, her facial features distorted by the physical strain. Blood, depicted by Caravaggio as neat parallel ribbons, runs everywhere in Artemisia's version, staining the bed, dripping down the sheets and spurting in arcs from the victim's neck, even spotting the executioner's lovely dress. As many have noted, this is a typically Baroque *contrapposto*, or contrast of opposites, beauty juxtaposed with horror. Yet the juxtaposition effectively underlines the chilling point of the story: the awful suddenness of Judith's attack, and the victim's shocked realization that things were not as they seemed. Artemisia seems to challenge Caravaggio retroactively, showing him up with a tougher and more credible Judith.

The relationship of this violent image to the artist's experience of rape has been much discussed. Psychological interpretations of the Uffizi *Judith* may have exaggerated its importance, but critics of those interpretations have unduly minimized it.[29] It is important to remember that this is art, not psychotherapy. The pictorial revenge that Artemisia took on her rapist was not a defensive psychological reaction by a female victim, but might better be understood as poetic justice – a playful, imaginative expression of retribution she was due. Italian epic poetry and Elizabethan drama often hinged on avenging a wrong (*Hamlet* and *Orlando furioso*, for example); and in Renaissance Italy, honour killings and crimes of passion were considered justifiable homicide. The theme of female vengeance has not much resonated in literature and drama (one jumps quickly from Medea and Clytemnestra to Thelma and Louise). Yet when Artemisia took this ancient right for herself, embedding in her *Judith Slaying Holofernes* the subtextual

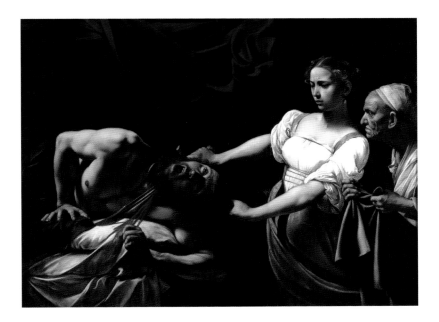

theme of the artist's visual punishment of her sexual assailant,
she might have done it, and it might have been recognized, as
a witty and apt payback carried out in good biblical style – a
symbolic castration for a phallic assault.

But while the subtheme of pretend vengeance floats lightly
over the surface, the deeper effect of this painting is of hor-
ror and shock. The image frightens because it appears to be
amoral: two women coldly execute a screaming man in a dark
space, a murder framed by no obvious religious or political
message. This violent and bloody decapitation, verging on
Grand Guignol sensationalism, has disturbed many viewers.
The seventeenth-century biographer Filippo Baldinucci said
that the picture caused 'not a little terror', and in 1791 it was
reported that the painting had been put in a remote corner

37 Michelangelo da Caravaggio, *Judith Slaying Holofernes, c.* 1598–9,
oil on canvas.

of the gallery (Uffizi), 'since the grand duchess did not wish
to be subjected to such horror'.[30] Part of that terror was
surely the threatening gender reversal in this deadly serious
image: a man struggles helplessly at the hands of two pow-
erful women. The picture that projected such *terríbilità* was
subsequently hung, and remained for decades, in a stairwell
of the museum inaccessible to the public. Suffering the same
fate that befell Donatello's *Judith*, banishment from public
spaces, Artemisia's *Judith* was unmistakably indicted for the
same crime: the illegitimate usurping of male power.

 Perhaps justifiably so, for the fact that the execution is
performed by two women, not one (virtually no other image
of the slaying shows this), makes it a political action. One
assassin is a person with a private grievance or mission; two
assassins can represent a community, like the ancient Greek
tyrannicides Harmodius and Aristogeiton, who delivered
Athens from tyranny, named by Pliny and Alberti as exemplars
of civic virtue.[31] Judith's execution of Holofernes is a political
act on behalf of her people but, in Artemisia's version, the
community is cast as the female sex. And because the agents
are physically strong women who overpower a man, the image
rises to a metaphoric level to symbolize female defiance of
male power. It is useful to recall that what Kate Millett called
'sexual politics' (or as we say today, the politics of gender) is a
form of political conflict as deep and fundamental as wars or
elections. In gender as in statecraft, political strife arises from
divergent points of view on basic issues, and gender attitudes
have diverged for a very long time.

 The issue of women's physical and political capability
was much contested in early modern Europe. Writers of

both sexes took the position that if properly trained, women could acquire the same physical strength as men. Boccaccio noted that Penthesilea, Queen of the Amazons, overcame her woman's body to become a manly fighter.[32] Veronica Franco observed that women are no less agile by nature than men and, when trained and armed, will prove their equal abilities. Both Boccaccio and Franco point out that men are not universally capable either (she says some are delicate and others are cowards, while he faults those who exhibit 'womanly' sybaritic idleness). But Franco ups the ante, claiming that when women receive training and weapons, 'I will show you how much the female sex / excels your own.'[33] Lucrezia Marinella similarly argued that if a girl and boy of similar intelligence were given equal training, the girl would become expert sooner and surpass the boy completely.[34] Moderata Fonte cited the Amazons and Judith as models of female fortitude and strength, and, like Franco and Marinella, she claimed women's superior leadership, arguing that women 'have turned out to excel in valor and skill, aided by that peculiarly feminine talent of quick thinking, which has often led them to outshine men in the field'. As proof, she names Camilla, Penthesilea 'and all those other warlike women whose memory not even the history written by men has been able to suppress'.[35]

While the women writers claimed equality and more, men tended to hedge their bets. Boccaccio explains that when women displayed fortitude and intelligence, it was an exception to their 'soft, frail bodies and sluggish minds'.[36] The Quattrocento humanists Agostino Strozzi and Bartolommeo Goggio allowed that women were equal to men in ability and suited for active public roles, but for society's restraints

– which they didn't suggest removing.[37] Theoretical arguments for women's equality were buried under the crushing weight of custom. Castiglione argued that women are capable of doing everything men do (ride, hunt, play ball, handle arms, lead armies, govern cities and make laws), but should not do so, because these masculine activities are not appropriate to his idea of the feminine, which, he explains, is needed by society.[38]

In the decades that followed Castiglione's fairly balanced assessment of women's capacity to lead and rule, the appearance of powerful, real female sovereigns provoked violent misogynist reaction. Female rulers in France (Catherine de' Medici) and England (Mary Tudor) were attacked by John Knox, in *The First Blast of the Trumpet against the Monstrous Regiment of Women* (1558) – a thrust parried by the ascent to the throne of Elizabeth I. At the beginning of her reign, Elizabeth's fitness as a woman to be England's supreme ruler and head of the Church was questioned, a problem solved by applying the medieval principle of the 'king's two bodies', the body politic and the body natural, so that the queen could act as a male through her political body, rather than through her weak female body.[39] Yet Elizabeth's all-male parliament was openly hostile to the idea of a female monarch, and masculine outrage was expressed as far away as Italy, where Giulio Cesare Capaccio wrote of 'that wretched Queen Elizabeth of England' as a horrible example of what happens when women put their hands into government, and cause great damage and disorder.[40]

The cultural belief that women were incapable of political leadership, a belief as old as Aristotle, was now being vigorously challenged by female rulers and writers. Artemisia's

Uffizi *Judith* shows us what the feminists' fantasy might look like: two strong, physically fit women overpower a clueless, sybaritically soft man, whose arms lack muscle tone. Their expertly executed beheading of a ruler's agent figures the removal, and perhaps replacement, of a male head of state. It is pointless to ask whether Artemisia Gentileschi was 'really' a feminist or just getting back at the man who wronged her. Her crucial decision to depict two assassins, not one, might have been prompted by something in her own life,[41] but she recognized the larger scope of her experience when she put it to use in the picture. 'The personal is political' is an ever-applicable feminist slogan, yet the slogan is also reversible, for an effective political gesture can be personally empowering. Like Veronica Franco, who turned her self-defence against a man who had defamed her into a defence of all women,[42] Artemisia turned her personal experience of injustice into the image of an anti-patriarchal action that continues to resonate.

The Uffizi *Judith* has had a political afterlife all of its own, as the iconic centrepiece of Artemisia's twentieth-century resurgence as a feminist hero, and countless works of fiction, drama and art have flowed from her example.[43] Judith's adaptable story has embraced many binary oppositions – chastity vs luxury, Protestant vs Catholic, truth vs heresy – but most of these constructions became dated over time. The binary of gender is different, for it involves a continuing social reality, the imbalance of power between the sexes, and the oppression of one by the other. Judith's decapitation of Holofernes – woman's metaphoric vengeance against her social oppressor – will be a meaningful metaphor for as long as gender inequity continues.

Artemisia could not have imagined the future reception of her Judith as the heroic protagonist of an anti-patriarchal challenge, yet she demonstrably understood its ancestry. In each of her three versions of the Judith theme, the artist planted a sign that she was aware of the convergence of Judith's story with those of the Amazons, the goddess Artemis, the ancient Near Eastern queens, and even Donatello's *Judith* – all challengers of men. In the Uffizi picture, Judith's bracelet bears two discernible images, which I have read as references to Artemis the archer with her bow and stag, expressively fused with its echo in the artist's name.[44] Beyond this is an exceptionally subtle reference to the Amazons, whose legendary strength is already invoked in the physically powerful heroine. Judith's partly exposed breasts are defined by a cast shadow that shapes her right breast as rounded and the left one as flattened, bringing to mind the one-breasted Amazonian identity that joins and supports her own. Indeed, things are not what they seemed to Holofernes: Judith's sexually tempting dress and adornment turn out to be signs, illegible to him but clear to us, of the power and purpose concealed by the disguise.

In this remarkable visual pun, Artemisia sculpts Judith's décolletage so as to evoke simultaneously her seductive charm and her Amazonian ferocity. She is thus true to the Hebrew text as many other artists had not been for, as we have seen, Judith was historically bifurcated into the virago and the femme fatale, two negative stereotypes not easily combined. Artemisia's solution is to embrace them both, as an indivisible whole that is the crux of the plot. Through a single signifier with a double meaning, she presents a Judith who credibly uses her sex to disarm her mark and her strength to destroy him.

In the Pitti *Judith*, her second version of the theme (illus. 38),[45] Artemisia continued to emphasize the political nature of the action. We now see the aftermath of the decapitation: as Judith and Abra begin to leave Holofernes' tent with his head in a basket, they turn together and look to the right, signalling that their escape may be hazardous. The women stand face to face, forming a tight, closed unit against the black ground, a pictorial design that is less narrative than iconic, and approaches sculpture's unchanging monumentality.[46] Their solidarity and unanimity of purpose are reinforced by Judith's gently protective hand on Abra's shoulder, a gesture that bridges the class difference between the noblewoman and her servant. As in the Uffizi *Judith*, Abra is given equivalent weight. Judith's face is prominently spotlighted, but Abra's body, seen from the back, occupies more of the picture's surface. Judith holds the sword of justice on her shoulder; Abra holds the trophy of victory at her side. Set in dynamic equilibrium, they are equal partners in the defence of their people.

Through its referential imagery, the Pitti picture joined a specifically Florentine political discourse. Judith projects an aura of heroic watchfulness, which is reinforced by Artemisia's subtle incorporation of Judith's biblical counterpart, David, into her own identity. The heroine's strong, faintly classicized profile, her upturned bulging eyes, and the weapon held close to the head bring to mind Michelangelo's *David* – an allusion that permits Artemisia to claim comparable agency and importance for Judith. She also appropriates a secondary meaning that Michelangelo's *David* had acquired, as guardian and protector of the Florentine republic from its enemies.

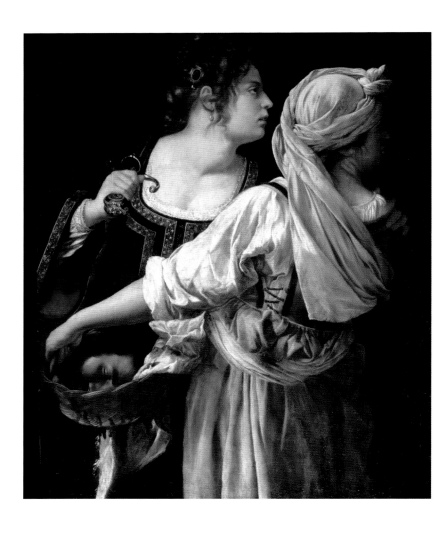

38 Artemisia Gentileschi, *Judith and her Maidservant*, c. 1618–19, oil on canvas. Galleria Palatina, Palazzo Pitti, Florence.

The concept of political liberty as a fragile asset to be zealously protected was a strong element in Florentine political thought, and the idea of a heroic civic guardian was expressed in statues such as Donatello's *St George* and Michelangelo's *David*.[47] Artemisia's Judith takes this role for herself, as we are told by an emblem in her hair, a small but prominent image of an armed male figure holding a lance and shield, as Donatello's *St George* once did, as if to reiterate the original civic role of Donatello's now-demoted *Judith*.[48]

Memory of Donatello's *Judith* enters the painting in another way. The curiously prominent drapery on Abra's backside can be understood as a tribute to Donatello's characteristically expressive drapery, seen especially on the back and sides of his *Judith* (illus. 39). Artemisia replicates Donatello's dynamic combination of twisted bands and binding straps with bunched and flowing folds, to instil her figure with psychological tension. Her homage to Donatello takes on larger meaning if we imagine her standing at the far end of the Loggia dei Lanzi to examine the *Judith*'s backside. From that position, as we see in a nineteenth-century painting (illus. 40), one would also see Michelangelo's *David* in front of the Palazzo Vecchio, and in other arches of the loggia, Cellini's *Perseus Slaying Medusa* and Giambologna's *Rape of the Sabines*. The Pitti *Judith* references them all: David the heroic guardian, Donatello's *Judith* and, on the pommel of Judith's sword, a Medusa head that brings in Cellini's statue.

In this corner of the city's main square, statues act out an agonistic battle of the sexes, in which Judith's androcide is trumped by Perseus' gynocide and Giambologna's rape scene. The gender dynamic in Piazza Signoria could hardly

39 Donatello, *Judith and Holofernes* (illus. 35), rear view.

have escaped Artemisia's attention. As the next move in the game, the Pitti *Judith* resoundingly trumps Cellini and redeems Donatello. The power structure has changed completely, and ironic reversal is salient. An emblematic Medusa screams mockingly at the severed head of Holofernes, a boastful oppressor who has met an ignominious end. Judith and Abra have replaced David as heroic civic guardians and defenders of their people, a people who can metaphorically be imagined as a republic of women.

Such a gynocracy was close at hand in Florence during Artemisia's sojourn. As we have seen, Grand Duchess Maria Maddalena and her mother-in-law Christine of Lorraine held effective political power in the years of Grand Duke Cosimo II's declining health. When Cosimo died in 1621, Maria Maddalena gained official power, as regent for her ten-year-old son Ferdinando II. A year later, she purchased the Villa del Poggio Imperiale in Arcetri, which became a gynocentric power base. Over the next few years, Maria

40 Italian painter, *View from the Loggia dei Lanzi*, 19th century, oil on canvas.

Maddalena commissioned three rooms of frescoes that represented exemplary women, saints, biblical and historical figures.[49] Among the ten biblical paragons, Judith appears as a civic heroine, with sword held high (illus. 41), whose triumphant return is welcomed by a crowd of Israelites. In another room, ten historical female rulers provide models of women's heroic leadership and their legitimate exercise of government. Judith was further singled out for political allegory when Maria Maddalena needed the support of Pope Urban VIII. In preparation for the 1626 Florentine visit of the pope's nephew Cardinal Francesco Barberini, the grand duchess commissioned Andrea Salvadori to create an opera, *La Giuditta*, whose allegorical relevance to Maria Maddalena was supported by Judith's history as a symbol of Florentine political agency.[50] This time, the allegorical and real came together, and Judith could represent a living female ruler of Florence.

41 Matteo Rosselli, *Triumph of Judith*, 1624, fresco. Villa del Poggio Imperiale, Arcetri.

One imagines that Artemisia's Uffizi and Pitti *Judith*s played a part in this scenario, given their early presence in Medici collections, yet no evidence connects either painting with the grand duchess and her feminist interests. Artemisia did not participate directly in the Villa Imperiale decorations, having left Florence before the grand duke died. Yet a heroic image such as the Pitti *Judith* would surely have been welcome at the Villa Imperiale, where easel paintings of Judith and other female paragons were hung in addition to the frescoes.[51] One can only speculate about this baffling missing link. Artemisia's *Judith*s might have been too bold for Maria Maddalena's tastes; alternatively, one or both of the pictures may once have been displayed at the Villa Imperiale. But whether or not they were deployed by Maria Maddalena, Artemisia's Uffizi and Pitti *Judith*s were created at a time when feminist ideas ruled at the Florentine court, and in one way or another they must have shaped and strengthened the political imagery of Florence's most powerful female ruler.

Artemisia's third *Judith* composition is, like her third *Magdalene*, in yet another mode and presents a different expressive key. Artemisia painted the Detroit *Judith* (illus. 42) in Rome, where Caravaggism still prevailed, and she redoubled her use of its vocabulary. A strong external light casts Judith and Abra into bold chiaroscuro and modulates the luminous shadows, while a lighted candle, a cliché of Caravaggism by now, illuminates the objects on the table. The image projects a certain theatricality, as if this were a stage performance, and the heavy red curtain of Holofernes' tent were part of its machinery.

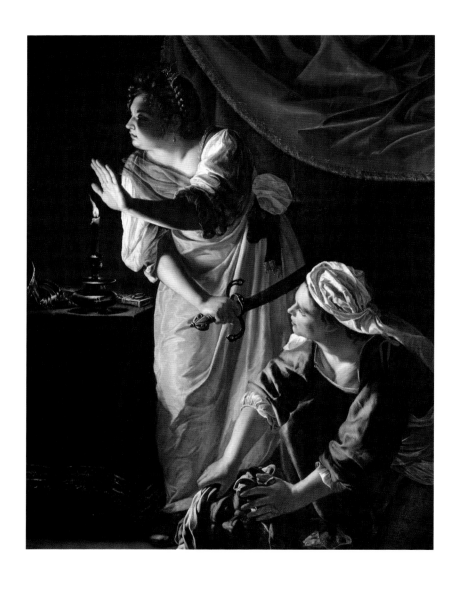

42 Artemisia Gentileschi, *Judith and her Maidservant*, 1625–7, oil on canvas. Detroit Institute of Arts, USA.

Judith is seen at full length, a mature woman who moves heavily, with operatic presence and bearing.

It is minutes after the decapitation. Judith still holds the tyrant's sword and Abra is just gathering the head in a cloth. At the sound of approaching danger, dramatically signalled by the flickering candlelight, they freeze: Abra looks up and Judith lifts an imposing hand. Their capability is demonstrated, not through action, but in having acted: they are not slaying, they have slain, and the tyrant's body is not to be seen. Remnants of his former power, the metal scabbard and gauntlet, are visible on the table, and Judith's appropriation of that power is signalled in her strong right hand, shaped to echo the empty glove, that grips the unsheathed phallic sword. So clearly has she usurped his virile agency, one reaches for a gloss: the king is dead, long live the queen.

Indeed, Judith even wears a crown (see illus. 10).[52] But the biblical Judith was never a queen, and she was rarely if ever shown crowned. Judith's honorary queenship carries two allusions, I would suggest, first to the artist's namesake, the ancient queen of Caria, Artemisia II, with whom she clearly identified. We are told so in Vouet's portrait, in which Artemisia Gentileschi wears a medallion bearing an image of the Mausoleum of Halicarnassus, Queen Artemisia's magnificent architectural achievement – an emblematic linkage that the sitter herself most likely prompted. Queen Artemisia's construction of her husband's tomb, the third wonder of the ancient world, is a subject that Vouet also depicted (illus. 43), perhaps as a nod to his friend and her *Judith*.[53] In 1624, around the time that Vouet painted Artemisia, Cristofano Bronzini published his treatise on women (see Chapter One), with

a long section on Hellenistic queens that included Zenobia of Palmyra and Artemisia of Caria, dwelling at length on the latter. And in annual Roman census reports of the early 1620s, Artemisia's daughter Prudentia was renamed Palmira – perhaps in homage to the Hellenistic queen.[54]

Moreover, as proposed in Chapter One, the queenly heroine of the Detroit *Judith* may also pay homage to a living queen, Marie de' Medici, whom Artemisia later served. The identification of Artemisia's crowned Judith with the queens of both Caria and France can be placed in a broader context. Shortly before Artemisia painted the Detroit *Judith*, Marie de' Medici filled the Luxembourg Palace with Rubens's images of her own heroic queenship. She later commissioned eight statues of legendary queens and *femmes fortes* for the drum of the dome over the entrance. In Marie's Luxembourg Palace, Judith and Esther rubbed elbows with ancient queens and modern rulers, as they did at Maria Maddalena's Villa Imperiale, and in the later cycles of Women Worthies and *femmes fortes* commissioned by Anne of Austria.[55]

Like Maria Maddalena of Tuscany, Queen Marie de' Medici of France put forth an Amazonian identity, and she claimed Judith as an antecedent, as Queen Catherine de' Medici had embraced Artemisia of Caria.[56] In such a tradition, and in its spirit of gender pride, Artemisia's crowned Judith could seamlessly join Hellenistic queens, similarly endowed with the physical strength that was associated with courageous female leadership.

Through artfully embedded allusions, Artemisia's Judith is simultaneously the biblical heroine, Queen Artemisia II, Queen Marie de' Medici and the artist herself. In the Detroit

picture, we see the consolidation of one strain of women's
political history in a single compact image. The biblical Judith,
like the ancient queens and even Artemisia Gentileschi, was
a victim of cultural diminishment, her power weakened by
sexualization, her narrative co-opted, her trajectory inter-
rupted. Yet despite all this, she prevails. If Artemisia's Judiths

43 Simon Vouet, *Queen Artemisia Building the Mausoleum*, early 1640s,
oil on canvas.

have a particular resonance for women, it is perhaps because they embrace the heroine's vulnerability as well as her power. Each of the three Judiths is individualized; no two look alike, and their faces were based on different models, perhaps even actresses. It is their individual specificity that makes them credible, and the embedded identities of artist and queens that give them real-world meaning, capable of speaking honestly to other women who have been damaged by sexism. As wounded warriors, they can be personally relevant, not just blandly rhetorical.

The ancient warrior-queen Artemisia was acclaimed for her masculine powers. Boccaccio explained her as an androgynous accident, nature's erroneous blend of a female body and a virile spirit.[57] Artemisia Gentileschi echoed Boccaccio's description of her namesake in her proud assertion to her patron Don Antonio Ruffo: 'You will find the spirit of Caesar in this soul of a woman.'[58] Indeed the idea of a male spirit in a female body was a common trope, sometimes claimed by female rulers. Queen Elizabeth I said to her troops at Tilbury, 'I know I have the body of a weak and feeble woman, but I have the heart and stomach of a king.'[59] In what spirit did Artemisia pronounce herself a Caesar? She seems to embrace her own exceptionality, her difference from ordinary women, and in another letter to Ruffo she deprecates the 'womanly chatter' of her sex.[60] Artemisia is not known to have been a champion of women's rights, as was the socially active Veronica Franco, or literary advocates like Arcangela Tarabotti and Lucrezia Marinella.

But, as she said in the same letter, 'the art will speak for itself.' Art speaks in a different voice, and in an important

sense has an edge on verbal media. In the biblical account and other narratives, Judith returns to private life after executing the tyrant, for she cannot sustain the power she briefly demonstrated.[61] Something has to happen next. In the Detroit *Judith*, the triumphant moment looks like a precise instant, yet it will last forever – the image of a victorious woman is frozen in time. In this way, Artemisia's *Judith*s take the battle to another conceptual plane, where exceptionally strong women overthrow exceptionally powerful men, and demonstrate endlessly to the masculine world – again, Artemisia's words – 'what a woman can do'.[62]

Battle of the Sexes: Women on Top

n the midst of her Judiths, Artemisia depicted another biblical androcide (illus. 44). Like Judith, Jael tricked and killed an unsuspecting man, though her motive for murder is less clear. When Sisera, a Canaanite defeated by the Israelites, sought protection from a Canaanite ally, his wife Jael welcomed him into her tent. But once Sisera was asleep, she drove a tent peg through his temple. Since Jael had no obvious reason to kill an ally, some rabbinical commentators suggested that 'letting him into her tent' implied sexual intercourse, her strategy to carry out a (mysteriously) righteous deed.[1] Jael was, like Judith and Esther, a biblical 'woman worthy', yet she appears in *Weibermacht* (Power of Women) print cycles as a seductive man-killer.[2]

Artemisia painted *Jael and Sisera* soon after her return to Rome in 1620.[3] Though thematically related to the Uffizi *Judith*, its expressive tone differs considerably. It is a much smaller picture, lighter in both tonality and intensity. The sleeping general offers no struggle, and Jael places the nail with calm precision. It is an execution drained of passion, which is perhaps why, as one writer observed, 'no one loves this picture.'[4] But we may have missed the point. The heroine's moral rectitude, underlined by the austere architectural

44 Artemisia Gentileschi, *Jael and Sisera*, signed and dated 1620, oil on canvas.

plinth behind her, distracts us from the picture's comic undertone. While Jael is a strong-armed virago, Sisera is outlandishly de-virilized, with a bright pink doublet, a stumpy body and chubby midriff, indecorously exposed thighs and a forearm whose soft flesh is indicated by the tapered, womanish fingers that press it. The picture's expressive key is confirmed by the smiling animal-human head on the sword pommel, who gazes up at this figure of ridicule.[5] In this gender-role inversion, Artemisia subtly invokes the theme of woman-on-top, which ran through power-of-women imagery prevalent in widely circulated northern European woodcuts and engravings (illus. 45).

What animated the woman-on-top topos was the laughable absurdity of a woman making a fool of a man by appropriating his power. This topos partook of the larger theme of the world turned upside down, ritually enacted in carnivals, when power roles were reversed and the low held temporary sway over the high. Anthropologists have deemed that ritual gender-role inversion reinforces and stabilizes a social hierarchy by providing safety valves for conflicts within the system. But as Natalie Zemon Davis showed, such comic inversions could also undermine the social order, since images of disorderly women might offer 'behavioural options' for women, including innovative political behaviour and challenges to social hierarchies.[6] If the image of a woman besting a man, even in a world-upside-down context, carries a latent threat to the social order, we must consider that gender competition is a basic underlying issue.

Real-life gender battles were conducted in the seventeenth century through more sinister imagery. Images of militant

women were popular in mid-century France, some inspired by the noblewomen who led a revolt against the monarchy called the Fronde. The duchesses of Montpensier, Chevreuse, Condé and others commanded armies and directed battles, then went on to write and hold literary salons.[7] Avowedly modelled on his militant female contemporaries, Pierre Le Moyne's *Galerie des femmes fortes* (1647) contains graphically detailed imagery of female homicide. These representations of Amazonian *femmes fortes* were followed by a 'reign of terror' conducted in texts and images, which chillingly called for

45 Peter Flötner, 'Four of Bells', from *The Playing Cards of Peter Flötner: Suit of Bells*, c. 1540, woodcut featuring a man receiving a thrashing with a faggot wielded by his wife.

violence against the 'new Amazons', who must be controlled by 'debraining'. An engraving of the period plays off this idea (illus. 46): a well-dressed executioner presents a decapitated woman to a crowd; floating above is the prominent inscription, as if she were meat in a butcher shop, *'femme sans teste tout en est bon'* ('on a woman without a head, every part is good [to eat]').[8] In both engravings and satirical literature, it was put forth that 'women's capacity for violence posed a widespread threat that could only be stopped if all French women's heads could be "corrected".'[9]

46 Anonymous, *Il est brave comme un boureaux qui faict ses pasques*, 1660?, engraving.

The French image wars point to men's fear of competition in the traditionally masculine spheres of military leadership and intellectual brilliance. The militant women's prominence could not be explained by the 'exceptional woman' defence, for the multiple exceptions threatened the rule (of men's innate superiority). As the seventeenth-century feminist writer Marie de Gournay observed, when men compare the two sexes, 'in their opinion, the supreme excellence women may achieve is to resemble ordinary men.'[10] For the sex accustomed to experiencing dominance as normal, even rough equality would feel like reversal and abject loss. To men of this mindset, an image of gender roles reversed carries disturbing affective force: a nightmare vision of what happens when the exceptional woman gains actual power.

Early modern feminist writers did not press the issue of competition. Instead, they compared the relative merits of men and women, offering essentializing generalizations about gender differences, or compensatory assertions of human commonality. A good example of the latter is found in Moderata Fonte's *Floridoro*:

Women in every age were by nature
Endowed with great judgment and spirit,
Nor are they born less apt than men to demonstrate
(with study and care) their wisdom and valor.
And why, if their bodily form is the same,
If their substances are not varied,
If they have the same food and speech, must they
Have then different courage and wisdom?[11]

Here, in terms that Shakespeare's Shylock would also employ, Fonte makes a bold, commonsensical claim for absolute equality based on the common human physical features of the sexes. Arcangela Tarabotti argues similarly from Genesis, pointing out that God gave Adam and Eve equal free will: 'He did not tell Adam, "You will rule over woman".'[12] In another text, Tarabotti was obliged to insist that women were human beings, refuting a certain Orazio Plata, who claimed they were not of the same species as men.[13] The species commonality of the two sexes is a long-settled issue, yet the scientific analysis of biological differences between the sexes has often been weighted by gender bias. In the nineteenth century, Charles Darwin wrote that women are biologically inferior to men, with underdeveloped brains, which led to the inference that evolution, having given women smaller bones and brains than men, made them weaker and stupider.[14]

Some feminist writers postulated a separate-but-equal kind of equality, arguing, as had Castiglione, that the two sexes had complementary strengths. Moderata Fonte and Cristofano Bronzini each envisioned an ideal society in which feminine values (compassion, charity and temperance) held equal status with masculine values (rationality, courage and justice).[15] Others made a case for female superiority. Veronica Franco said that women are smarter, and also more adaptive; she proclaimed woman's superior wisdom while acknowledging her strategic need to conceal it for the sake of social harmony.[16] Lucrezia Marinella claimed that women are more excellent than men, with the same reasoning skills but nobler souls, and they are better at learning the arts and sciences.[17] Marinella may have believed in female superiority (she couldn't

yet see the danger of putting woman on a pedestal), but the claim that women were better human beings could also have been a rhetorical strategy, a philosophical gambit that followed logically from her cataloguing of men's deficiencies.

But what if the challenge is personal? It is one thing for women to claim generic equality with men, and another to demonstrate that in particular instances they are better. And a win for one is a win for all. A memorable example in the modern era was the Billie Jean King vs Bobby Riggs tennis match of 1973, described in advance as 'the battle of the sexes'. The young King's easy win over a 55-year-old male opponent was not surprising, but it was widely considered a gender triumph, one of the many small triumphs that propelled the women's movement of that decade. Early modern Europe saw similar challenges by individual women to advocates of male superiority. When Isotta Nogarola publicly debated her protector Ludovico Foscarini, when Veronica Franco confronted Maffeo Venier through duelling poetry, and when Arcangela Tarabotti challenged her patron Gian Francesco Loredan's interpretation of Genesis, each woman waged a battle on behalf of her sex, against a man who spoke for his own.[18]

In *Jael and Sisera*, Artemisia Gentileschi challenged her own role model, Caravaggio, dead though he was. She had earlier pitted her conception of Judith against Caravaggio's, and she now takes him on in a fantasy encounter. Artemisia's identification with Jael is signalled by the juxtaposition of the strong, hammer-swinging arm with her comically pompous claim on the plinth, in (inaccurate) Latin and Roman numerals, that she had done it ('Artemitia Lomi facibat MDXX') – ambiguously referring to the execution of the painting, or of Sisera,

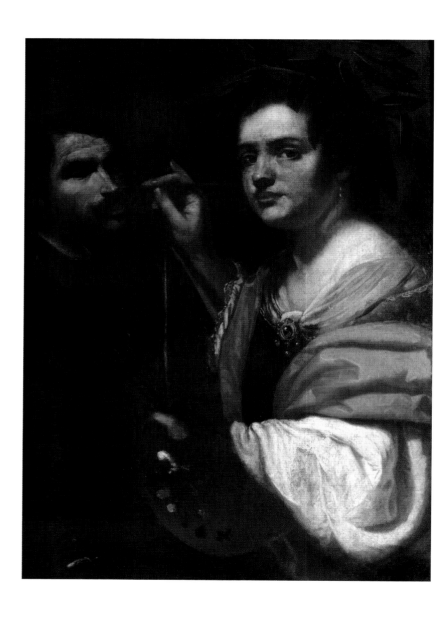

47 Artemisia Gentileschi or another artist, *Artemisia Gentileschi as
the Allegory of Painting*, c. 1630, oil on canvas. Palazzo Barberini, Rome.

or both. She signed the Uffizi *Judith* similarly.[19] Scholars have advanced various candidates for Sisera's unusually specific face, but surely the closest analogy is that of Caravaggio.[20] Artemisia's immediate audience would have recognized the allusion, and perhaps savoured this light-hearted contemporary twist on a biblical theme, as the woman artist figuratively skewers her famous rival.

By the evidence of art, Artemisia was highly competitive. In a picture that portrays Artemisia as the allegory of painting (illus. 47), the artist gazes provocatively at the viewer, holding her paintbrush with the little finger raised or extended. In the gestural language of the period, a lifted little finger was the sign of a dare or challenge.[21] Its appearance in these paintings suggests that she was known as – or put herself forward as – a competitive artist who challenges the painter depicting her and, by extension, all her male peers. Artemisia asks to be considered their equal, and because she is a woman, equality would signify defeat for the male artist she challenges.

Epitomizing the shame of defeat by a woman is the story of Hercules and Omphale. The Delphic Oracle punished the Greek hero for an accidental murder by sentencing him to a year in slavery to the Lydian queen Omphale. Artemisia painted two pictures of this subject, both unfortunately lost today. The theme was quite popular in early modern European art: artists often fastened on the comic, erotically titillating, inversion of gender roles: a man is humiliated by role reversal, obliged to play female to his masculinized mistress. Hercules is shown wearing women's clothing and holding icons of women's work, the distaff and spindle of

spinning, while his masculine attributes, the wooden club and skin of the Nemean Lion, are transferred to Omphale.

During her stay in Venice (1627–30), Artemisia painted a Hercules and Omphale for King Philip IV of Spain, which hung in the Alcazar in Madrid, as a pendant to Rubens's *Achilles Discovered by Ulysses and Diomedes* (1617–18), a pairing of two virile heroes who once assumed female clothing. Artemisia's picture disappeared sometime after 1636, perhaps removed because its demeaning imagery was found unsuitable for a programme celebrating the heroic Hercules, legendary ancestor of the Spanish kings.[22] An image of Hercules in thrall to Omphale could elevate gender anxiety, raising disturbing questions about effeminacy in men, cross-dressing and power. In Florence, on the approaching performance of Salvadori's *Iole et Ercole* at a Medici wedding, Francesca Caccini warned that the image of a feminized Hercules enslaved among women might be taken as insulting to the bridegroom.[23] Cross-dressing was an especially volatile issue in England, where women who adopted masculine attire were seen to threaten social stability (see Chapter One). King James I himself declared that the very sight of cross-dressing women indicated 'a world very far out of order'.[24]

In 1646 a Venetian writer, Padre Angelico Aprosio, expressed a similar anxiety. Aprosio warned that dressing like the opposite sex will put men's superiority to women at risk: 'women in masculine clothing will acquire that which man has lost through his vanity with female ornaments.'[25] The Hercules and Omphale theme offers a doubly threatening combination: a man disempowered by mandatory feminizing and a woman empowered by possession of his weapons. She is

a liberated marvel, freed from the dreary and petty attributes of her sex (as spinning was regarded by men), while he is burdened with them, an object of humiliation and shame. Women, on the other hand, might find the theme inspiring. Lucrezia Marinella cites approvingly the practice of the Amazons, who kept their men at home and required them to sew and weave.[26]

The city of Venice was the birthplace of opera, an art form in which the themes of gender role reversal and transvestism abounded.[27] One of the earliest operas, *Ercole in Lidia* (1645), was based on the Hercules and Omphale story.[28] Noting that the first librettists and composers of opera came from the circle of Gian Francesco Loredan, which included Artemisia (see Chapter One), Jesse Locker speculated that Artemisia might have influenced the development of Venetian opera. He pointed to the overlapping imagery of Artemisia's heroic women and operas sponsored by Loredan's Accademia degli Incogniti.[29] Wendy Heller had earlier observed that the escalating debate about women paralleled the emergence of opera in Venice. At a time when basic ideas about women and sexuality were in flux, Heller argued, images of women (unnamed) served to navigate these waters. Like the images, opera presented women as complex, nuanced characters, rather than as conventional stereotypes of good and evil.[30]

It is plausible that Artemisia's heroines influenced the deepening of female characters in opera, since no other paintings of the period match them in complexity and subtlety.[31] The majestic heroine of Artemisia's painting *Esther before Ahasuerus* (illus. 48) satisfyingly corresponds, *avant la lettre*, to our modern idea of an operatic grand diva. Other Incogniti

artists depicted powerful women, *donne forti*, at just this time, most prominently Padovanino (Alessandro Varotari), whose virtuous heroines have been connected with the Incogniti debates about women and the texts of Marinella and Tarabotti.[32] Padovanino's determination to honour lesser-known women of antiquity, such as Berenice, Cratesiclea and Theoxene, through images of stoic resolve was, however, a somewhat academic response to the Venetian intellectual milieu that was brimming with ideas about gender.

In the *Esther before Ahasuerus*, most likely painted during her Venetian years, Artemisia gave the popular biblical heroine a human dimension not previously developed in art. First, the story. After the Babylonian king Ahasuerus chooses Esther for his wife, not knowing she is a Jew, the king's lieutenant

48 Artemisia Gentileschi, *Esther before Ahasuerus*, c. 1627–30, oil on canvas.

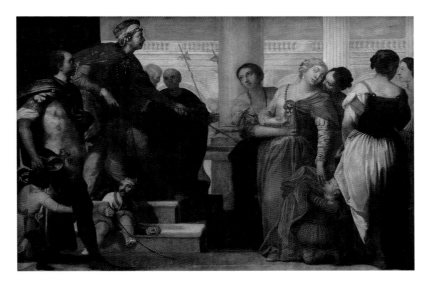

Haman convinces him to exterminate all the Jews in his empire. Queen Esther, distressed at the prospect of her people's slaughter, goes to the king dressed in her finest royal robes and begs him for mercy. Persuaded by Esther's plea, Ahasuerus orders the execution of Haman. Like Judith, Esther plays a decisive role in defence of her people, but unlike Judith, she did not herself take forceful action; her sole achievement was to persuade her husband to do justice.

The biblical narrative takes many twists and turns – there is the king's first wife, Vashti; there are banquets – but Renaissance and Baroque artists favoured the moment when Esther appears before Ahasuerus. Overcome by emotion and hunger, because she was required to fast before entering the king's presence, she begins to faint and collapse. In many versions, including that of Padovanino (illus. 49), the event occurs in a palatial setting, divided into two gendered halves:

49 Il Padovanino (Alessandro Varotari), *Esther before Ahasuerus*, 1620s?, oil on canvas.

the (emotional) feminine side, occupied by the fainting Esther and two women who support her, and the (judicious and rational) masculine side, where Ahasuerus, seated high on a throne, is flanked by several adjutants. Padovanino presents the theme with classicizing restraint and dignity; no figure shows much emotion, least of all Esther. The queen's face is a lifeless mask, and her body is rigid. She could as well be dead, a corpse or mannequin propped up by servants. There is no hint that the queen has confronted the imperious king with a problem.

Artemisia strips the composition of staffage and leaves the protagonists virtually alone onstage, the better to dramatize their encounter. X-rays of the painting show that she eliminated a page boy restraining a snarling dog, which she may have considered a distraction. She gives the queen and king nearly equal height and positional status for, unlike most depictions of the theme, Esther's head rises almost as high as his and Ahasuerus gazes at her laterally rather than from above.[33] Through these and other means, Artemisia subtly changes the power dynamic. Ahasuerus is nervously reactive rather than overbearing, and the shift underlines Esther's intrusion into a masculine space and his defensive response. As the initiating agent of the narrative, the queen drives the plot.

Esther's fainting is required by the story, but it is a classic sign of female emotionality, and for that reason, she is a difficult female hero to represent. Artemisia chose to magnify the simple act of falling. As in opera, Artemisia's luxurious dramatization of the heroine's faint eclipses the bare bones of the story and, like a dying diva, Artemisia's Esther takes her

time. *Contrapposto* is used to embrace the conflicting psychological dimensions of Esther's situation. As the queen's body rotates slowly to initiate the fall (we infer this from the trail of blue drapery that winds around her dress), her projecting right knee continues to confront the king. The maidservants deepen the image's expressive range, providing the queen, through their sympathetic attention, a support more emotional than physical. Artemisia's conjoining of Esther's virile strength with her emotional passion merges two iconographic modes of depicting the Virgin Mary, Esther's typological counterpart: the *mater dolorosa*, an image of the Virgin collapsing in grief over Christ's dead body, and the *stabat mater*, who stands tall at the foot of the cross.[34] The two types are combined in this image of a queen who, like her divine counterpart, was equipped with both fortitude and compassion.

In contrast to the stately Esther, Ahasuerus is distinctly unheroic. Noting the comic tone set in the laughing mask above the king's heel, Locker described the king's extravagant outfit – his crown perched on a plumed hat, his jewel-encrusted boots, puffed sleeves and superabundant filigreed scarf – as 'foppish, outmoded' dress that was ridiculed in the period.[35] Locker connected Artemisia's depiction of Ahasuerus with Marinella's critique of men who 'adorn themselves excessively', spending their money on silk clothing, medallions, pearls and plumes, observing that both Artemisia and Marinella juxtapose men's and women's dress in an ironic inversion of expected gender roles.[36] Artemisia's Ahasuerus is more subtle than a simple caricature, however, for one could read sympathy as well as wariness in his expression. Her gentle ridicule was perhaps aimed at men's conceit more generally,

matching Marinella's critique of swaggering male vanity that centred on men's dress and adornment.

Arcangela Tarabotti similarly commented on the foppery of men's dress, inverting, as had Marinella, the stereotype of women's vanity and excessive adornment. Tarabotti's comment was prompted by the publication in 1639 of a satirical critique of female luxury, *Contro 'l lusso donnesco* by Francesco Buoninsegna.[37] Buoninsegna's arguments centred on the dangerous seductive power of women's adornments, including the charge that women used jewels and gold as weapons to compensate for their lack of a penis. He even demonized the fabric of silk, 'a vomit of nature' produced by worms, which is somehow poisonous when worn by women.[38] Tarabotti refuted his points one by one, matching his satirical tone. And she defended with passion – from inside a convent – women's right to choose fashion and ornament to adorn their natural beauty, skewering men's hypocrisy in criticizing women for the same vain excesses and luxuries in dress that they indulge in themselves.

The issue of dress was a surrogate for underlying issues of power. Artemisia's juxtaposition of the heroic Esther and the foppish Ahasuerus reminds us of the pairing in the pamphlet of the 'Man-Woman' and the 'Womanish Man' (see illus. 13), in which women's masculine dress, perceived in England as an attempt to usurp male authority, is contrasted with a foppishly dressed male, to point up their common absurdity. In Italy the issue was not female cross-dressing but men's hypocrisy regarding feminine adornment. In both juxtapositions, however, the feminized man's weakness enlarges the woman's power. In her *Esther* Artemisia subtly brings out this

dimension of the pairing. She gave Ahasuerus a fine silk and filigree outfit that is inappropriately dandyish for a king, and the queen an elegant yet appropriately restrained costume that befits her royal status and regal heroism. Esther's splendid golden gown is quite simple in its lines, with swelling puffed sleeves that enlarge her stature. Ornament is limited to strong silver-and-gold patterned borders, a small pearl belt and one brooch. With a sure knowledge of nuances in dress, Artemisia gives dignified elegance a powerful expressive role.

The *Hercules and Omphale* and *Esther before Ahasuerus* were painted at the height of the gender debates in Venice. One might expect them to be noted by Gian Francesco Loredan in his poems on Artemisia's paintings published in 1627–8.[39] If Loredan didn't know these works, he surely knew by reputation her incendiary Judiths. Yet he singles out for mention only a Lucretia, a Susanna and a Sleeping Child, which he describes with effusive conventional praise – he admires Lucretia for dying well, and Susanna for her modesty. In one of two letters to Artemisia, Loredan extravagantly praises her beauty, using one of masculinism's most effective defensive strategies against a threatening woman. After a brief nod to the vitality of Artemisia's mind, he composes a paean to her physical beauty, counting the ways that her *bellezza* inflames and stimulates him, torments him and ties him in knots.[40]

Did this sophisticated and powerful man who presided over the Incogniti's debates about the nature of woman have nothing to say about Artemisia's pictures that heroized women and deheroized men? Apparently not, but he did react obliquely. Loredan held forth on women at length in his *Bizzarrie academiche* (1654), offering a traditional misogynist

view of their dangerous sexuality, inherently evil nature and inability to appreciate reason or justice. He concludes with the hope not to have offended any women, but to have 'satisfied his obligation', which has suggested to some that he might jokingly have adopted a misogynist voice in an academic debate.[41] Yet as much as humour might mask and defuse a harsh position, the attitudes Loredan expresses were obviously his own, because Tarabotti confronted his arguments seriously in *Paternal Tyranny*. The Venetian patriarchal institutions she attacked were vigorously defended by Loredan, who cruelly supported the sentencing of women to convents. Moreover, it was probably Loredan who arranged the suppression of Tarabotti's *Paternal Tyranny*, forcing as a condition of its publication the change in title to *Innocence Betrayed*, so that the treatise no longer appeared to be a critique of patriarchal control of women, but a discussion of women as innocent victims who are destined to suffer.[42]

The belief that women are men's inferiors, says Moderata Fonte, 'is an abuse that men have introduced into the world and that men have then, over time, gradually translated into law and custom; and it has become so entrenched that they claim (and even actually believe) that the status they have gained through their bullying is theirs by right'.[43] Renaissance men perhaps needed to justify their unnatural social dominion over women by saying and believing outrageously implausible things about them, fanning the ancient flames of woman's evil nature and deficiency of intellect. Yet the obvious untruth that women were stupid was wielded to counter the growing evidence of their equal capacity to enrich and use their minds. 'Woe to men if women did possess brains!' exclaims the god

Apollo, in a fictional response to a fictional plea for gender equality by Arcangela Tarabotti and other educated women. Apollo (in reality, one of the Incogniti, Antonio Santacroce) allows for a few exceptional intelligent women, but insists that women on the whole lack brains.[44] Gian Francesco Loredan, obliged by reality to acknowledge the quality and importance of Arcangela Tarabotti's writings and Artemisia Gentileschi's paintings, did so with as much grace and flourish as he could muster, while simultaneously doing all he could to deflect their threateningly incisive power by defining them down.

Over decades, Artemisia painted a number of 'women on top' pictures, images that consistently diminish the male and empower the female. They began with the Naples and Uffizi *Judith*s, and continue in *Joseph and Potiphar's Wife* (illus. 50), whose attribution to Artemisia I would restore, though other writers have disagreed.[45] The painting's present ascription to Paolo Finoglia is unconvincing. The structure of drapery folds and the turnings of delicate lace edges are hallmarks of Artemisia's brushwork, while the seducer's head, with energized chestnut-red hair and shadows that irregularly break the features, is pure Artemisia. Another sign of her hand is the interpretation of the theme. When the biblical hero Joseph is taken to Egypt as a household slave of Potiphar, the captain's wife with no name (later commentators call her Zuleikha)[46] attempts to seduce the handsome young man. As he tries to escape, she grasps and keeps his cloak. The story is a delicious inversion of the Susanna story, for when the virtuous Joseph has escaped, No-name falsely claims that he tried to seduce her, producing the cloak as her evidence.

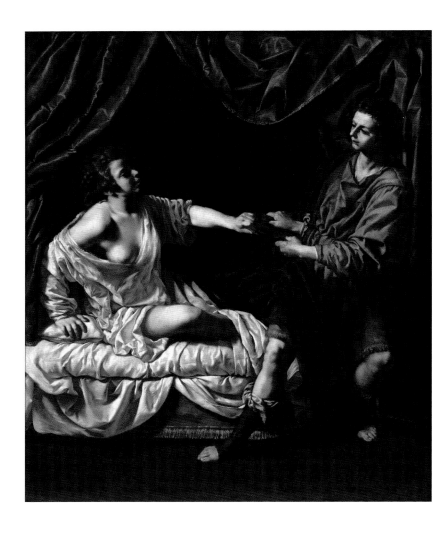

50 Artemisia Gentileschi, here attributed, *Joseph and Potiphar's Wife*, 1620s?, oil on canvas.

If you examine Paolo Finoglia's best effort to depict a seductress and her mark, a painting that shows the sorceress Armida tempting the virtuous Rinaldo (illus. 51), in which the virile muscular hero lolls in the lap of a rather prissy aristocrat with a chaste décolletage, it seems clear that the Fogg picture's genuinely erotic, really slutty, temptress would have been beyond him. Her dishevelled hair and crumpled gown establish a bedroom intimacy, while the exposure of her luscious single breast gives us a taste of what Joseph is missing – along with the messy sheets that hint at the anticipated activity. When Artemisia painted this subject again for Don Antonio Ruffo, she described it as having a 'bellissimo leto di drappi', just what we see here.[47] No-name – shall we call her Zuleikha? – sits in graceful equipoise on her bed; her stable body has a centre of gravity. Zuleikha's calm self-confidence is contrasted with Joseph's uneasy resistance, a contrast of temperament that is echoed and heightened in the drapery folds above their heads, her side smoothly curvilinear, his side agitated and angular. With a commanding grip on Joseph's cloak, Zuleikha initiates a power struggle she will win against the hapless, chinless young man who braces his stance, yet is enfeebled by inept arms.

The Joseph and Zuleikha story was played straight by Artemisia's male contemporaries. Orazio Gentileschi cast Joseph as elegantly noble and Zuleikha as forlorn; Cigoli showed a blowsy wench reaching for a shocked young resister; and Guercino similarly made it a contest of virtue and vice.[48] In each of these versions celebrating Joseph's virtue, Zuleikha's body is positioned eccentrically against a stable male body. None of the three male artists was able to depict a genuinely

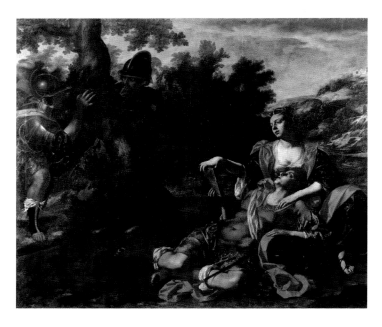

seductive female beyond the stereotyped conventions of the
female nude. Artemisia did it, and she may have gone too far
– for weren't men always warning about women's dangerous
sexuality? But she must have delighted in the possibility of
playing on the side of vice and not virtue for a change, creating
an honest-to-goodness, down-to-earth bad girl, armed with
all the sexual power and know-how that poor Susanna and
Lucretia had been denied.

Artemisia's *Joseph and Potiphar's Wife* is a feminist inversion
of the woman-on-top prints, which were cautionary tales
about female power. For Artemisia and certain other women
artists, presenting women on top was an act of gender pride,
and they juxtaposed strong women with dysfunctional men
to show what female empowerment might look like. When,

51 Paolo Finoglia, *Rinaldo and Armida in the Enchanted Garden*, from cycle
of paintings illustrating Torquato Tasso's *Gerusalemme Liberata*, 1640–45,
oil on canvas.

much earlier, the Bolognese sculptor Properzia de' Rossi
depicted the theme, she too gave Zuleikha strong arms and
hands, and a bracing, self-sufficient pose.[49] Elisabetta Sirani
painted the unforgettable Timoclea pushing an unnamed
Thracian captain into a well (illus. 52), and I have no doubt
that Sirani relished a story in which it is he who has no name

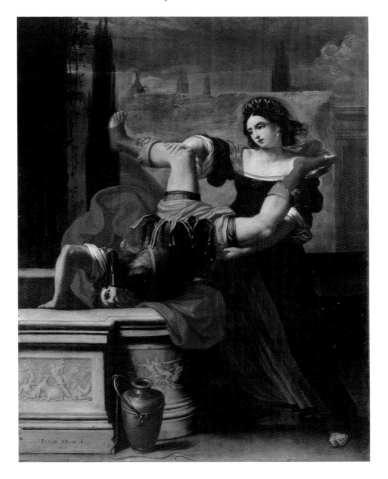

52 Elisabetta Sirani, *Timoclea Killing the Thracian Captain*, 1659, oil on canvas.

for a change, not to mention the delight of depicting the humiliating inversion of the captain's ungainly body by an upright, strong-handed woman.[50] A similar relish in turning the tables is hinted at by Artemisia in her last preserved letter. Describing a painting she has promised to Ruffo, along with the *Joseph* and its beautiful bedclothes, she says that this one represents 'Andromeda when she was freed by a certain knight on the flying horse Pegasus, who killed the monster that wanted to devour that woman'. Every character is named but the great Greek hero Perseus, who is just *un tal cavaliere.*

Artemisia clearly liked to depict bad girls. Potiphar's wife was followed by Medea, Delilah and the nymph Corisca, each traditionally considered to be tainted or evil to the core. In the parlance of the day, these were the *donne infame*, mirror opposites of the heroic *donne forti* – infamous women who disarmed and emasculated unsuspecting men.[51] Artemisia painted Medea in the act of killing one of her children (illus. 53), an unspeakable deed that made her the quintessential wicked mother. This episode was rarely depicted by early modern artists, who instead emphasized Medea's malevolent concoction of poisons. But Medea's magic, as Christine de Pizan expounded, also enabled her to move the winds, stop the flow of rivers and start fires.[52] Christine linked Medea and Circe as two sorceresses empowered by their magical arts, countering the negative stereotype of enchantresses who used magic to destroy men (Boccaccio called Medea 'the cruelest example of ancient treachery', with 'shameless eyes'[53]).

After Medea helped Jason win the Golden Fleece, he abandoned her for Glauce. Medea took revenge by killing Glauce, and then she killed the children she and Jason had

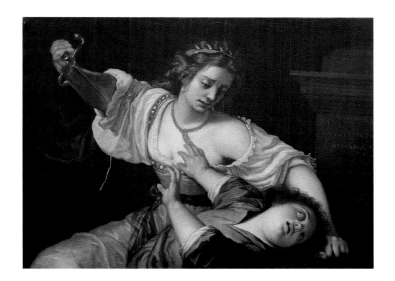

produced – his children, in the patriarchal order – an act of
vengeance that would destroy his family line.[54] The child-
murder ending of this story was invented by Euripides, who
exonerated Medea as the agent of Zeus' revenge on Jason
for his disloyalty. Yet Medea's action was problematic, both
within the play and for Euripides' Athenian contemporaries,
and continued to be so in later centuries.[55] Seeking to burnish
her 'good wife' image, Christine de Pizan, Vittoria Colonna
and other writers simply eliminated Medea's murder of her
children when telling the story.[56]

Artemisia's surprising depiction of this shocking moment
was ascribed by Judith Mann to the artist's marketing strategy,
a bold and outrageous move by a celebrity woman painter
who was herself a mother.[57] Locker read the painting in a
comic spirit, in which the juxtaposition of the 'elegant knife-
wielding young woman and the obese, porcine child' becomes

53 Artemisia Gentileschi (by or after), *Medea*, c. 1627–30, oil on canvas.

an impudent variation on a tragic theme.[58] Locker connected
Artemisia's *Medea* with Gian Francesco Loredan's *Scherzi geniali*
(1626), a collection of playfully irreverent versions of stories
from ancient history. In these *scherzi*, gender attitudes abound,
but from an ambiguously ironic position. Loredan puts the
stories in the mouths of the protagonists, sometimes with
sympathy, but often with disdain. Lucretia's anguish is com-
ically exaggerated as taking her to the brink of madness – a
cheeky irreverence, yet at the cost of the woman's dignity.
Misogynist views are ascribed to the women themselves.
Helen states that 'Paris wouldn't have abducted me if I hadn't
wanted it . . . women can only be raped by their own caprices.'[59]

 It is unlikely that Artemisia fully shared the sensibili-
ties of Loredan and the Incogniti circle, but their satirical
iconoclasm might have encouraged her to take on so edgy
a character as Medea. As that rare breed, an artist-mother,
Artemisia might have playfully identified with Medea, an iden-
tification enriched by the picture's echo of Artemisia's earlier
paintings of women (on top) who pull weapons on supine,
helpless males. Unlike the *Scherzi geniali*, however, Artemisia's
self-referential irony always involved female empowerment;
never are the women diminished. Artemisia may also have
enjoyed giving Medea an amoral agency. This anti-heroine
acts decisively with the hint of a smile, and whether the killing
is a fantasy punishment of a bratty child or an extreme form
of marital revenge, the point is that Medea takes control of
her own life and that of her children – perhaps a comment on
mother-right by a single mother? In the classical Greek view,
Medea kills Jason's children as the agent of divine justice, but
in more ancient myth, she was one of many avatars of woman's

control of life and death.[60] In this way of thinking, Medea's action needed no social justification.

Artemisia similarly inverts traditional values in her depiction of Delilah (illus. 54). Perhaps the most infamous of evil women, Delilah betrayed Samson, and was paid to do so.[61] Yet Samson was hardly a saint – his exploits were brutal and vengeful – and Delilah's 'betrayal' of this man amounted to taking advantage of his susceptibility to drink and seduction, cutting a lock of his hair, the secret source of his strength, and delivering him to her fellow Philistines. Artemisia treated this subject quite differently than did most male artists. Rubens's muscular hero sprawls drunkenly on the lap of a bosomy

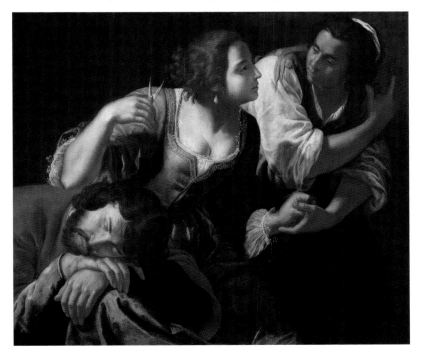

54 Artemisia Gentileschi, *Samson and Delilah*, c. 1635, oil on canvas.

Delilah, whose diabolically intimate gaze (and the crossed arms of the hair-snipper) inform us that this sexy scene is in fact a treacherous double-cross (illus. 55).[62] Artemisia gives us instead a Samson dozing peacefully on the knee of a centrally positioned Delilah who brandishes the scissors (she's another of Artemisia's blade-wielding women on top), and hands the lock of hair to a female adjutant. The maidservant in turn points up and out, a reminder that Delilah's action will lead to the Philistine's arrest and blinding of Samson.

By comparison with Rubens's bare-bosomed Delilah, Artemisia's heroine is only mildly sensual, and her tresses are properly bound as a young matron's should be. Like Artemisia's

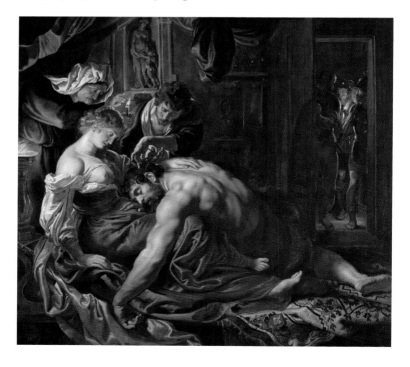

55 Peter Paul Rubens, *Samson and Delilah*, c. 1610, oil on wood.

Judiths, she is assisted by a working-class helper, whose support is here registered in the women's exchange of gazes and hands that touch. The women's collaborative intimacy recalls that of Artemisia's Pitti Judith and Abra, partners in political agency, and Delilah's dignified profile faintly recalls that of Judith. Samson was as much a wicked bully as Holofernes (at least from the Philistines' point of view), yet in this picture his calm slumber suggests he's not a villain. Samson's emotional neutrality might instead indicate his fatal gullibility in trusting Delilah. Arcangela Tarabotti used this story to deliver a disturbing message to men:

> When you think women adore you, their laughter and glances are meant to mock, and they marvel at your vain conceit. Samson, all too gullible, was proof, just like all men deluding themselves too easily about their own supposed merits . . . If Samson had not presumed Delilah's love, he would not have perished so wretchedly.[63]

If Artemisia's sensibility was similarly honed, as seems likely, she made a picture that is not about the danger evil women pose to men, but about women's greater acuity, and their ability to operate in tandem underneath the crude male radar. Samson was dumb, Delilah was clever, and she manipulated him into causing his own destruction.

As deceivers of men, Medea and Delilah were associated with Circe, Homer's sorceress with magical powers. Those untrustworthy women were joined by Corisca, a crafty nymph

who tricks a satyr in Giovanni Battista Guarini's pastoral drama, *Il pastor fido*. Artemisia painted this rarely depicted scene (illus. 56), drawn perhaps to its anti-heroine, whom even Lucrezia Marinella described as a 'bad and wicked woman'.[64] Artemisia took her Corisca directly from Guarini's *Il pastor fido*, a widely read and influential play written in the 1580s and published in Venice in 1590. But while in Venice, she could have seen a now-lost cycle of paintings in the cortile of Palazzo Mocenigo that featured a grouping of Medea, Circe, Corisca and some witches – all 'malevolent women', according to Marco Boschini[65] – and that too might have sparked her interest in Medea and Corisca.

With *Corisca and the Satyr*, we enter the world of the pastoral. Dramas such as Torquato Tasso's *Aminta* (1580) and Guarini's

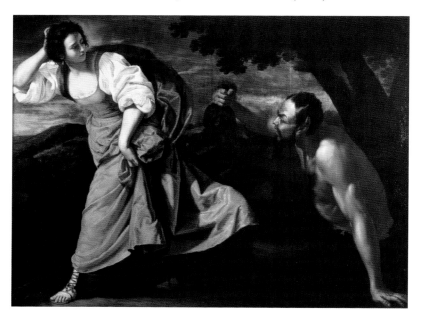

56 Artemisia Gentileschi, *Corisca and the Satyr*, c. 1635–7, oil on canvas.

Il pastor fido featured complicated love stories and characters both refined (shepherds and nymphs) and rough (satyrs and fauns). The plot of *Il pastor fido* involves the 'faithful shepherd' Mirtillo and his beloved, the nymph Amarilli. Amarilli is, however, betrothed to Silvio (who is loved by the nymph Dorinda), while Mirtillo is loved by the 'faithless nymph' Corisca (who is loved by a lustful satyr). Corisca's scheme to compromise Amarilli goes awry, but in the end, with the happy marriages of Mirtillo and Amarilli, and Silvio and Dorinda, Corisca repents and is forgiven. Conventional gender roles are largely respected, except for the unusually proactive Corisca, whose manoeuvrings drive the plot. In the episode depicted by Artemisia, the lustful satyr, having twice failed to capture and ravish Corisca, has now caught her by the hair.[66] After a contest of wills, she pulls away, leaving the wig he thought was her hair hanging empty in the hand of the befuddled, thwarted satyr.

In annotations to the play, Guarini said that he treated this scene comically so that the villainous characters would not give the play a tragic tone. There was a risk, for Guarini's Corisca is a more complex figure than the heroines.[67] Witty and ironic, she asks the satyr why she'd be attracted to someone who is 'half-man, half-goat, and all beast', with a greasy beard, an ugly mug and a toothless, dribbling mouth.[68] Corisca is duplicitous and manipulative and, like other literary villains, driven by a worldly cynicism. A female Don Juan, she boasts of having had many lovers, though none will have her heart and, completely unsentimental about romantic love in a play that is predicated on it, she describes fidelity as a foolish female virtue.[69] Guarini gave his villainess a masculine ego

for comic effect, yet he also described her misogynistically as 'lustful and impudent, wicked and cruel', and modern commentators sustained the link between her wickedness and her lust.[70] As even the author seems to need reminding, Corisca's interaction with the satyr is not about her sexual appetite but his. It was a contest of wits, and she won.

Artemisia eschews Corisca's wicked identity to present her as beautiful, bold and strong. The satyr looks suspiciously like a fully human male, despite the textual Corisca's ridicule of his goatlike appearance, a deviation that suggests metaphoric meaning. From a female point of view, Corisca's foiling of the satyr is a triumph over the kind of man who ascribes his own lust to the object of his prey and describes all women as evil temptresses. Guarini's satyr rails against female artifice, their make-up and hair colouring, yet he was undone by his stereotypical attraction to Corisca's hair, that 'glowing amber and gold that drives poets mad'.[71] Corisca exploited his weakness, and tricked him with a simulacrum he could not distinguish from the real thing. Shedding her artificial hair, Corisca figuratively liberates herself from masculinist values and the artificiality they impose on women's lives.

Perhaps even sweeter than victory in this story is the anti-heroine's freedom to act and move – precisely what the average woman in Seicento Italy lacked – and this is the feature Artemisia emphasizes. Corisca speeds away from the satyr, her airborne legerity indicated by a billowing rose-violet cape and flying skirt hem, while the satyr seems rooted to the ground like the tree behind him, its shape-echo of his arm signalling his bestial earth-boundedness. As if to document

Corisca's victory, and perhaps her own identification with her, Artemisia signed her name on the tree.

Pastoral dramas by women often featured the outwitting of satyrs by nymphs. Part of pastoral's appeal for women writers was the freedom of movement and speech allowed to nymphs who, as Virginia Cox observes, were 'transparent figures for contemporary upper-class women'.[72] In her pastoral *Flori* (1588), for which Guarini's *Il pastor fido* was also a point of departure, Maddalena Campiglia explored the possibilities of female autonomy. These included a female–female love theme, and the nymph-protagonist's unorthodox rejection of marriage as a plot resolution.[73] Nearer in spirit to Artemisia's *Corisca* is Isabella Andreini's pastoral drama, *La mirtilla* (1588). In this play, Andreini reversed the model of Tasso's *Aminta*, in which the nymph Silvia had to be rescued from a rapacious satyr by the hero. Andreini's own nymph, Filli, outmanoeuvres a satyr by tying him to a tree, a bondage he mistakes for erotic foreplay. As she escapes, Filli mocks the gullible satyr: 'Have you at last understood that I am making fun of you?'[74] Trees figure again in the play when the shepherd Igilio carves a poem addressed to Filli on a tree trunk, echoing a familiar incident in Ariosto's *Orlando furioso*.[75]

Artemisia's signature on the tree in *Corisca and the Satyr* (a witty touch, since the tree has been inscribed both by and to herself) indicates that she was familiar with both the topos of tree inscription and the nymph and satyr episodes in *La mirtilla*. She playfully engages the intertextual motif – her satyr seems almost tied to his tree – as if she were merging the stories of Corisca and Filli in a gesture of nymph solidarity.[76] Artemisia plucked the spunky anti-heroine out of Guarini's

relatively conservative *Il pastor fido* to plant her flag in the feminist camp of Andreini's *Mirtilla*. Isabella Andreini, who died in 1604, was still a presence when Artemisia lived in Florence, a celebrated actress, poet and playwright, whose virtuoso performance in her own play, *Pazzia d'Isabella*, at a Medici wedding in 1589 was long remembered.[77] And in Florence, Artemisia may have collaborated with Andreini's daughter-in-law, the actress Virginia Ramponi Andreini (see Chapter Three). In *Corisca and the Satyr*, perhaps more than in any other painting, Artemisia sings in unison with the feminist writers of her era.

We can only fully understand Artemisia Gentileschi's art by recognizing the subtle signals it emits from the raging feminist battlegrounds of her time. Like the writers, Artemisia sought fictional escape from constraints imposed on women, and she used similar aesthetic strategies to challenge cultural conditions. One strategy was to exaggerate a feminine stereotype, subverting it through ridicule. Artemisia's hyperbolically pious Pitti *Magdalene*, as discussed in Chapter Three, exemplifies this approach. Comparable is the character of Ardelia in Andreini's *Mirtilla*, whose extreme narcissism leads her to fall in love with herself – a play on the Narcissus myth that lampoons the stereotype of the Petrarchan beloved.[78] Another tactic was to defeat the oppressor in fantasized competitions, as when Artemisia used the murderous Judith and Jael to play-act vengeance, or when Artemisia and Andreini invent nymphs who outwit and escape their sexual aggressors. Still another strategy was the foregrounding of an amoral protagonist who breaks social rules to assert a woman's right to

independent agency, including sexual choice. In this respect,
Artemisia's characters – Zuleikha, Corisca, Medea, Delilah
– resemble Maddalena Campiglia's bisexual and starkly inde-
pendent nymph Flori, or the extraordinary, countercultural
Circetta in Moderata Fonte's *Floridoro*, who evades stereotype
by eschewing sexuality altogether and exercises her mother
Circe's magical powers to turn a man into a tree.[79]

In claiming the *donne infame* for her own, Artemisia was
playing a dangerous game, because these mythic characters,
invested with misogynist venom, carried more social fire-
power than the unproblematic *donne forti*. As Tarabotti's male
adversary, Ferrante Pallavicino, described them, Circe, Medea
and Medusa were mythological characters, yet they were 'true
likenesses of qualities proper to women'.[80] Every image of an
infamous woman was potentially an invitation to implicate
contemporary women in her guilt, all of them daughters of
Eve. Images of *donne infame* are scarce in this period, however,
and Artemisia's paintings stand out conspicuously. Who
commissioned or purchased these against-the-grain pictures?
No patrons or early owners are recorded for any of them.
Considering that Artemisia's male patrons are unlikely to
have loved these infamous women, we might hypothesize a
shadow female market or audience for 'Artemisias' that were
not the kind admired by male writers.

We have no evidence of such a clientele as yet, but the sort
of woman who read the women writers might have appreciated
these rebellious paintings. There were many such women. The
first chivalric romance written by a woman, Laura Terracina,
which challenges the masculine bias of *Orlando furioso*, was
reprinted thirteen times after the original edition of 1551.

Moderata Fonte's *Floridoro*, known and cited by Marinella and Tarabotti, achieved something like cult status in early modern Venice. Andreini's *Mirtilla* had seen nine editions by 1605. It has been reasonably concluded that female readers boosted the popularity of these works.[81] One imagines that Artemisia's radical pictures would have found a similar audience. There are differences between images and texts, of course, for printed books circulate more widely than privately owned paintings, and texts make explicit arguments while images don't make arguments at all. But an image of a woman on top, literally inverting the so-called natural order, is a clear and potent feminist metaphor. If even a handful of women writers and intellectuals saw Artemisia's pictures, we might expect some commentary in their writings. Yet I have found none, and instances of a woman's direct commission or ownership of Artemisia's paintings are quite rare.[82] Scholarly evidence of female art patronage in early modern Italy is growing, however, and may one day produce answers to the question of women's response to Artemisia's most challenging works.

The Divided Self: Allegorical and Real

e owe to the psychologist R. D. Laing the concept of 'the divided self': a conflict between our sense of an authentic identity and a false self that we present to the world. Laing used the phrase to explain schizophrenia as a state resulting when social expectations come to feel unnatural and conflict with one's inner nature and desires.[1] It sounds remarkably like the situation faced by women in early modern Europe, a peak period of patriarchal social repression. The women's experience of tension between their social and natural selves raises a question about the medical definition of schizophrenia as an individual's failure to adjust to the world: what if the social expectations imposed on her are, indeed, unnatural and inhuman?

This is precisely the question the early modern feminist writers asked of society. Recognizing the contradiction between the social female role and self-actualization, they turned their experience of this conflict into a political challenge. Countless women endured repressive conditions and the resulting psychological damage silently or unthinkingly. This chapter concerns the far fewer women who emerged within that unjust society, while equally conditioned by it, to point out its abnormality on behalf of them all. Because no

woman could entirely escape the sense of having a divided self, caught between 'I ought to be' and 'I want to be', each was obliged to shape her identity in response to conflicting demands – and for this purpose, women devised strategies for coping.

Woman's 'duplicity', much excoriated by misogynist writers, is perhaps a necessary coping device for women in patriarchal societies. Female duplicity (literally, twofold) involves compliance, or feigned compliance, with an unnatural social contract, while making simultaneous efforts to undermine and counter it. Penelope weaves her tapestry to appease the suitors, and unravels it nightly to thwart their efforts to claim her. Women may smile and agree, hiding anger and resentment behind a seemingly adoring compliance, yet their rage can come out sideways as treacherous deceit – which Arcangela Tarabotti justified as Samson's dangerously gullible belief that Delilah truly loved him (see Chapter Five). Duplicity may be morally lamentable, yet in the practical realm it is a viable path to agency and perhaps not even unethical when the social deck is stacked.

Another feminine strategy to satisfy the competing demands of self and society was to assume honorary virility, as an 'exception to her sex'. The archetypal patriarchal woman is the armed and helmeted Pallas Athena, literal offspring of father Zeus' brain (as the masculinist version had it). Honorary masculinity was granted to exceptional women who carried out a patriarchal agenda – Queen Elizabeth I is the outstanding example – yet pseudo-virility was deemed inferior to the real thing. Moreover, to accept honorary masculinity and its ascribed qualities of strength, self-reliance and rationality

was to eschew the feminized qualities of compassion, altru-
ism and emotional sensitivity. There were few models of a
coherent, whole woman equipped with both agency and fem-
ininity.[2] Artemisia's Esther (see illus. 48) exemplifies feminine
compassion combined with masculine courage, yet here the
two qualities oppose one another – her swoon neutralizes
her challenge. More accurately, Esther embodies the female
dilemma. Her self-paralysing torsion invites us to ask: must a
woman choose between a compassionate but ineffectual fem-
ininity and an empowered but heartless pseudo-masculinity?

Early modern writers were quick to proclaim woman's
sensitive and compassionate nature as the nobler one. On the
first day of the dialogue in Moderata Fonte's *Worth of Women*,
the women expound an Aristotelian theory of the humours
(men are hot and dry; women cold and moist), and they invert
its usual misogynist application to assign moral superiority
to their own sex: men's hot, choleric nature enslaves them
to their senses, which overpower their reason. The women
present arguments that modify the gender stereotypes, yet the
contradiction that the sex of greater worth holds an infer-
ior social position is left to stand. They had no solution for
women's social disempowerment, no alternative to the prison
they saw marriage to be, and its incompatibility with their
own desires and needs. According to the young wife Cornelia,
'women who are married – or martyred, more accurately –
have endless sources of misery,' inflicted by husbands 'who
keep their wives on so tight a leash that they almost object to
the air itself coming near them'; they are 'kept like animals
within four walls and subjected to a hateful guardian rather
than an affectionate husband'.[3]

Within the dialogue, the unmarried-by-choice Corinna comes the closest to being a clear-minded, whole person who transcends the limitations of 'femininity', unhobbled by its palliatives and rationalizations, yet her positions are challenged by the other women, who are also given sympathetic voices. There is no better text than Fonte's *Worth of Women* for a nuanced consideration of women's desires, the practical problems they faced within patriarchy and the considerable variety of female points of view on their common dilemma. Still, the treatises written by Fonte, Marinella, Tarabotti and others do not, and could not, offer a way out. It remained for fiction, the fictions of literature and art, to engage in the adventurous exploration of what might be possible.

The predicament of the divided self was dramatized by Fonte in her chivalric romance *Floridoro*. Two characters, identical twins who have experienced different upbringings, embody the twin horns of the female dilemma. Biondaura, raised conventionally, is beautiful, 'soft and delicate', while Risamante, kidnapped as a young child by a wizard who taught her martial arts, acquires masculine 'skill and valour'.[4] Fonte juxtaposes two kinds of female identity: Risamante goes on to heroic adventures, while Biondaura is cast as a representative of dated cultural values, first presented to us in the form of a painted portrait.[5] When Risamante fights and kills a ferocious giant, she is believed to be a male knight until she removes her helmet to uncover her female identity. Fonte even allows her to have feminine beauty. For Marinella, Tarabotti and other women writers, Fonte's Risamante became a model of female potential, a courageous, active and full-rounded

woman, thanks to her gender-neutral upbringing (by a wizard, necessarily, given its rarity in real life).

There is asymmetry in the Biondaura–Risamante pairing, yet the sisters are bound by their twinning. When the disinherited Risamante challenges their father's designation of Biondaura as his heir, each sister stakes a claim to the patriarchal legacy. Although Fonte the author openly supports the justice of Risamante's position, the twins' struggle over the patrimony, to which each is legitimately entitled, continues throughout the narrative. When Risamante finally defeats her sister's agent, she is moved by her 'soft and humane' woman's heart to take pity on her vanquished adversary and, implicitly, to share the inheritance with her sister. The twins are linked to the end by their contrast and affinity – joined, so to speak, at the hip.

Fonte's support of Risamante's claim was in part a feminist protest against the injustices of patriarchal primogeniture, which accorded sons but not daughters the right to inherit directly (daughters had only their dowries, which they could not claim legally). The author's resolution, in which the two sisters share their inheritance, puts forth a feminist model of political power-sharing.[6] Yet the twins' pairing has another metaphoric dimension: a woman might aspire to gender wholeness, but the dead stereotype continues to live in her psychic house, and retains a culturally sanctioned claim to its ownership. In retrospect, we may cheer Risamante for going rogue, then demanding her fair share of the establishment, yet for centuries to come, she would remain the madwoman in the attic of the 'sane' woman's house.[7]

Another division of the female self is that between allegorical figures and living women. Female allegories seemingly honour women, yet symbolically disable them. Women could embody justice but they could not be judges; they could represent liberty, as long as they didn't expect it for themselves.[8] It is the gap between the elevated female abstraction and cultural doubts about a woman's capabilities that makes an allegory work, signalling its unnaturalness and lifting the lofty concept above earth's gritty realities. (The necessity of a gap is revealed in the doomed efforts to honour male heroes allegorically, as in the disastrous instance of Canova's statue of a nude George Washington.) Allegorical images, nearly always female, are invariably represented in classicized form, elevated to a timeless ideal plane. Living women, whose faces rarely resemble the classical ideal, cannot measure up to the perfection of allegories. An allegorical identity that embodies absolute or unrealistic cultural expectations – chastity, modesty, fidelity – can be a typological trap.

Allegory could be empowering for women, however, if deployed strategically. A woman might join forces with the allegory, turning her two-folded nature into a double strength by blending the ideal with the real so as to bring both life and lift. In the *Book of the City of Ladies*, Christine de Pizan broke new ground when she joined a female allegory with a female author. In the famous opening passage, the author, sunk in despair and low self-esteem, is visited by three allegories who represent Reason, Justice and Fortitude. Lady Reason is linked with Wisdom (Sophia, Sapientia), which a woman could symbolize, yet was widely believed not to possess. But in Christine's narrative, Lady Reason counsels the author wisely and reasonably,

performing her identity with ease. She advises her not to believe men's lies about women's weaknesses. Holding up a mirror, Lady Reason explains that 'no one can look into this mirror without achieving self-knowledge', detaching the symbolic mirror from its association with female vanity and turning it into a metaphor for recognizing one's true nature – know thyself – which philosophers have called the deepest source of wisdom. Strengthened by Lady Reason's command, Christine goes on to build the city of women, with a self-possession that fortifies her sense of connection with all women.

Women writers took pains to associate their sex with reason and rationality because they were so often accused of lacking it. Moderata Fonte's scholarly Corinna urges her companions to escape the gender bind through their innate reasoning ability.[9] Lucrezia Marinella devoted an entire chapter of her treatise to proving the superiority of the female sex, 'by reasoning and example'. With penetrating insight, Marinella undermines the authority of 'our good friend' Aristotle, and his 'foolish' and 'cruel' opinion that women should obey men, cutting him down to size with the observation that 'we must excuse him because, being a man, it is only natural he should desire the greatness and superiority of men.'[10]

Marinella continues with a long litany of women learned in the arts and sciences, which runs from the ancient Greek Aspasia, who taught philosophy to Pericles, through Hildegard of Bingen, who wrote four books on nature, down to the modern scholar/writers Isotta Nogarola, Laura Cereta and Vittoria Colonna. Athena (Minerva) is recast as having been deified 'solely for the good arts she invented', and for her learning, 'which caused her to be named' the goddess of

wisdom and science. Marinella assigns Athena a historical identity and agency that precedes and forms the basis of her mythic identity. She gives the same historical reality to the Muses, claiming that Clio invented satire, and Erato invented geometry. With this canny adjustment, Marinella subordinates allegorical women to living ones whose intellectual achievements outshone their symbolic glorification. Christine de Pizan had similarly described Minerva as a highly intelligent Greek maiden who invented numbers and musical instruments, and was later made to represent wisdom; Ceres was a queen who invented the plough and discovered cultivation; Arachne was an Asian maiden who invented weaving.[11]

The Dutch feminist Anna van Schurman took ironic note of the discrepancy between women's allegorical power and their lack of it in the real world. When asked to recite her poems at the inauguration of Utrecht's new university, she called for its admission of women, pointing out to her audience that, after all, Minerva was a woman.[12] Van Schurman's remark challenged the permissible contradiction and, indeed, the misogynist view of women as intellectually deficient was disproved by her very existence. Other feminist writers emphatically refuted this view of women through historical exempla. Arcangela Tarabotti produced a long list of illustrious learned women, from Diotima, the wise female philosopher in Plato's *Symposium*, and Sappho of Lesbos, down to modern writers Maddalena Salviati, Isabella Andreini, Laura Terracina, Veronica Gambara, Vittoria Colonna and her own contemporary Lucrezia Marinella.[13] Laura Cereta ended her list with Isotta Nogarola and Cassandra Fedele; Marie de Gournay ended hers with Anna van Schurman.[14]

These writers were among the relatively rare European women whose intellects were supported by good education, for most women were woefully less educated than men. But, as Tarabotti pointed out, it was men who set the limits:

> Do not scorn the quality of women's intelligence, you malignant and evil-tongued men! Shut up in their rooms, denied access to books and teachers of any learning whatsoever, or any other grounding in letters, they cannot help being inept in making speeches and foolish in giving advice. Yours is the blame, for in your envy you deprive them of the means to acquire knowledge . . . So shameless are you that while reproaching women for stupidity you strive with all your power to bring them up and educate them as if they were witless and insensitive.[15]

Tarabotti laments that while men are given tutors, and are free to study at the famous universities of Padua, Bologna, Rome and Paris, 'we have never even been granted permission to attend lectures in Venice's state schools.'[16] The Venetian state schools provided humanist education to men of the citizen class as preparation for public service, which was also inaccessible to women. Tarabotti notes that 'women cannot be permitted to study grammar, rhetoric, logic, philosophy, theology, and the other sciences because by attending school they would easily lose their chastity'[17] – perhaps raising an eyebrow at this hoariest of excuses.

Nearer the truth was Marinella's assertion that men were hostile to female education for fear of losing their dominance

over women.[18] Rebutting the belief that women had never been allowed to study the liberal arts and sciences, Marinella cites numerous women in antiquity who were proficient and famous in the fields of philosophy, astronomy, poetry and languages, and she is careful to cite Pliny and Plutarch on these women, sources on whose accounts modern historians rely.[19] In England, the pseudonymous Mary Tattle-well would similarly observe that men limited women's education to keep them subordinate: '[we] have not that generous and liberal Education,' are not taught to read, except 'in the compass of our Mother Tongue', and they say we are weak by Nature, yet 'they strive to make us more weak by our Nurture.'[20]

Female education was restricted across Renaissance Europe. Poor women (and men) had no formal education at all; middle- and upper-class girls were taught domestic skills essential for marriage, primarily spinning and needlework, and patriarchal virtues such as chastity, obedience and silence. Girls of elite families were taught first to read, then (perhaps) to write, but only scriptures and devotional or morally instructive texts were permissible. Educated men pontificated on what women should read and learn. According to Juan Luis Vives, they could learn Latin, but not rhetoric, which they wouldn't need.[21] Lodovico Dolce stated that since women had no public role, they shouldn't be allowed to read Latin poets.[22] Despite this repeated patriarchal advice, female literacy in Europe rose to significant levels by the seventeenth century, and women increasingly acquired vernacular books of their own, including texts that partook of the *querelle des femmes.*[23]

Most of the female humanists and feminist writers came from educated families, who supported, or tolerated, their

intellectual development. Nogarola and Fedele were trained in Latin by private tutors and admired as learned women, yet their efforts to publish their work or speak publicly met resistance. Cereta received a piecemeal education: rudimentary Latin as a child in the convent, followed by self-schooling at home. Fonte learned Latin from her older brother, who showed her his daily lessons when he returned from school. Marinella's father was a noted physician who wrote books on medicine and natural philosophy, and she had access to a well-stocked library. Tarabotti's feminism was fuelled by the opposite experience; placed in a convent school by her father at the age of eleven, she raged against the poor education and social injustice she and girls like her experienced.

These writers' familiarity with the classics of ancient and modern literature is evident from the citations of Plato, Livy, Cato, Ariosto, Tasso et al. that fill their texts. If they seem to indulge in literary name-dropping to indicate their intellectual proficiency, we must remember that their opportunity even to know these names was hard won. A similar impulse to showcase her intellectual and cultural attainments is seen in Lavinia Fontana's *Self-portrait in the Studiolo* (illus. 57), in which this unusually well-educated artist situates herself at a writing desk, pen and paper at hand like a scholar, surrounded by statuettes and antique fragments, emblems of her erudition and art-world sophistication.[24] Such displays of learning constituted a quiet but steady defiance of the ongoing belief that women were intellectually inferior.

A humanist education also gave women access to the cultural discourse itself, and the feminist writers put their education to use by demanding more of it. Christine de Pizan

pointed out, as did Fonte and Marinella (see Chapter Five), that if daughters were taught the natural sciences and arts, they would learn 'as thoroughly and understand the subtleties' as well as sons and possibly better, since women 'have minds that are freer and sharper' than men's.[25] Marie de Gournay identified education as critically necessary for women to attain gender equality, while Anna van Schurman made the novel assertion that learning for women was an end in itself, not necessarily coupled with moral or domestic purpose. The English royal governess Bathsua Makin argued strongly for women's intellectual liberation from patriarchal enslavement through a thorough education in the liberal arts.[26]

Artists, who tended to be as uneducated as girls, gained access to cultural discourse through other avenues. Artemisia Gentileschi probably received an elementary education, for she stated in her rape trial testimony that she could read a little but could not write. Artemisia mastered writing, however, at least by 1620 when, in handwritten letters to her lover Francesco Maria Maringhi, she casually invoked Ovid, Petrarch and Ariosto through playful allusions to their writings; she commented, for example, on her body-changing weight gain by way of Ovid's *Metamorphoses*.[27] As Jesse Locker pointed out, Artemisia's knowledge of these writers did not necessarily come from books, but rather from oral culture, since cultural commonplaces circulated across social levels through songs, theatrical performances and poetry recitations.[28] Such performances, as we have seen, formed the core of Artemisia's cultural experience in Florence and Venice. Similarly, her familiarity with the concepts of art theory were

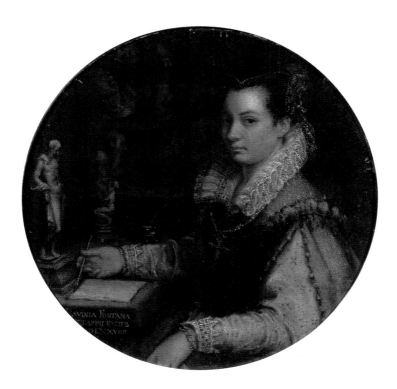

likely grounded in studio shop talk and conversations with the *culturati*.

If Artemisia was acquainted with the poetry and literature of her culture, Moderata Fonte was familiar with the visual arts. The women in Fonte's garden name as the best, most celebrated Venetian painters Paolo Veronese, Jacopo Tintoretto and Tintoretto's daughter Marietta Robusti, whom they describe as supremely talented.[29] They invoke two long-standing literary topoi: the idea of painting and poetry as sister arts, and the *paragone* (comparison) of the relative merits of painting and sculpture. These women are, naturally,

57 Lavinia Fontana, *Self-portrait in the Studiolo*, 1579, oil on copper.

partisans of the Venetian side of the *paragone*, as opposed to
the Florentine position, and the discussion tilts toward the
superiority of painting.[30] When Corinna says that painting,
though not sculpture, is a liberal art, she echoes Leonardo da
Vinci, who argued that painting (but not sculpture) should
be considered a liberal art and not a manual craft, because it
demands greater mental effort and painters get less dirty.[31]
The liberal arts, defined in antiquity as those arts and skills
a free (Latin: *liberalis*) person could enjoy, were canonized in
the Middle Ages as the Trivium (grammar, logic and rhetoric)
and Quadrivium (arithmetic, geometry, music and astron-
omy). At the beginning of the Renaissance, artists argued for
the inclusion of the visual arts among liberal arts, and they
sought a concomitant rise in their own social status, a struggle
that continued through the seventeenth century.[32] Like free
men, Fonte's women were empowered by class and education
to discuss such matters intelligently.

 Sensitive to art's metaphoric potential, Moderata Fonte
invoked salient images of Renaissance art through poetic
description, harnessing them for her feminist agenda. At
the centre of Fonte's imaginary garden stood a fountain
with a beautiful female statue at each of its four sides, from
whose breasts flowed 'streams of clear, fresh, sweet water'.[33]
She brings to mind the water-spouting breasts of female
fountain figures in real Renaissance gardens (illus. 58).
According to male writers and artists, such statues repre-
sented nature's (mere) procreativity, which they ranked
below their own creative powers.[34] A bare-breasted woman
might represent intellectual or creative fertility in general, as
in Cesare Ripa's allegory of poetry, but Ripa's allegory

58 Gillis van den Vliete, *Diana of Ephesus*, Fontana della Madre Natura, 1568–9, stone, tufa, water, vegetation. Villa d'Este, Tivoli.

symbolized the imaginative fertility of men, a point conveyed by the gender disjunction. Fonte blew this convention apart, setting the metaphoric figures in a garden of her invention, to be admired by women, in a story to be read by women, who would understand that the generative female fountain statue represented the author's own creative abundance – the same writer who had chosen 'Moderata Fonte', a good-sized fountain, as her metaphoric pseudonym.[35] Given Fonte's vision of a woman's inclusive (pro)creativity, it is tragic that her own career was terminated by death in childbirth at the age of 37.

In the masculinist perspective, woman's capacity to give birth was a marker of inferiority, linking her with physical nature and the body, while men claimed the superior realm of the spiritual and intellectual.[36] Praise of a woman artist could be loaded with this implicit distinction. When the Venetian writer Antonino Collurafi asked Artemisia Gentileschi for a drawing of a mother bear licking her cub, he invoked an ancient metaphor that likened the bear's maternal shaping of her newborn to artistic creativity, a conceit that the painter Titian had used for his personal emblem.[37] Because Titian's gender kept him removed from actual childbirth, his appropriation of female nature's creative power only enhanced his masculine genius. But to link a female artist (and mother) with the mother bear is potentially to reduce her to a performer of an instinctive maternal gesture.

In real life, the risks and responsibilities of motherhood prevented many women from fully developing their intellectual capabilities yet, despite that ongoing limitation, the Renaissance feminists fought to claim the higher ground. Their passionate demand for educational opportunity is an

obvious example. Less obvious was the creative ability of women writers and artists to turn the masculinist discourse against itself. In *Floridoro*, Fonte uses a sculptural metaphor to inscribe herself within the masculine literary canon. She situates a statue representing a female poet (transparently herself) among statues of male writers in the temple of Apollo at Delphi.[38] Describing herself as dressed in virginal white, too shy to come forward, Fonte contrasts her 'low and dull mind' with the statue's 'clear and sublime' design, and explains that hers is the only statue not given a caption because 'the sculptor did not wish that her name be known'. With deadly sarcasm, Fonte underlines the discrepancy between men's celebration of the symbolic feminine in marble or verse and their denigration and erasure of actual female achievement.

Her tactic resembles a similar manoeuvre by the painter Sofonisba Anguissola. In the double portrait, *Bernardino Campi Painting Sofonisba Anguissola* (illus. 59), Anguissola presents herself as a portrait being painted by her teacher, who glances over his shoulder inviting us to admire his handiwork. The image seemingly adheres to the trope of the woman artist as the product of a male artist's teaching – his creation, like that of Pygmalion, shaped from the raw material of her talent.[39] (An artist friend congratulated Campi for having 'created' the beautiful Cremonese artist, the product of his 'beautiful intellect'.) The fiction that Campi is real and active while Anguissola is frozen in paint is belied, however, by the fact that Sofonisba herself painted this double portrait, and only at first glance does it appear to be a tribute to his mentorship. Though she seems to have turned agency over to him, she has structured the composition so as to subordinate his image

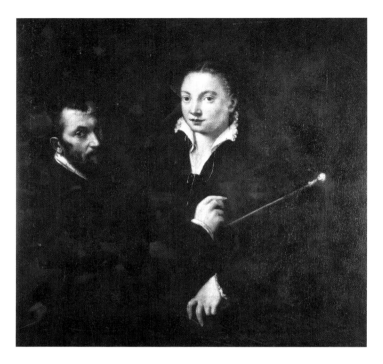

to her own: she is larger, she rises higher on the surface, and occupies the central axis. Moreover, Campi himself is merely a painted image. The real Sofonisba stands outside the picture space, triumphant creator of both portrait heads, which gaze at her obligingly.

By exaggerating the gender roles, Anguissola subverts them, exposing the duplicity of a male artist who pays symbolic homage to a creative woman while taking all the credit. She does this with a little duplicity of her own, seeming to have disappeared into his honorific portrait, yet controlling it all from the wings. Like Fonte, Anguissola plays with the viewer's expectation of female self-effacing modesty, only to

59 Sofonisba Anguissola, *Bernardino Campi Painting a Portrait of Sofonisba Anguissola*, late 1550s, oil on canvas.

insert a deeply disguised twist: the concealment of female
ambition and pride in achievement turns out to be a strategy
for asserting them. A woman could take gender pride in this
clever mockery, but the man whose gender is being skewered
might rightly feel he'd been had.

Artemisia Gentileschi constructed a similar fiction in her
painting of Clio, the muse of history (illus. 60). This hand-
some figure bears three identifying attributes: the crown of
laurel, the trumpet and the book of history. Inscribed on the
open book is the artist's signature, a simple 'Artemisia', and a
dedication to a deceased French nobleman named Rosières,
who is here commemorated. His specific identity has been
debated, but need not concern us overly because it barely
concerned Artemisia. Commissioned to memorialize a man
of putative historical importance, but personally important
to the patron, Artemisia deployed the allegorical Clio to do
the job.[40] Clio fills the space, striking a rather grand pose,
with one hand with an arched wrist resting on the trumpet,
and the other set akimbo on her hip. Her classicized face and
upward gaze, idealizing features, are animated by moist eyes
and warm red lips. The man who is recorded in Clio's book
of history has been reduced to a slightly cryptic inscription,
which threatens to disappear: his name is partly covered
by the trumpet's bend, while the lifted corner of the page
announces its imminent turning, and the inexorable turning
of the wheel of time (illus. 61).

Not quite so hidden is Artemisia's name, inscribed in block
letters above the lower-case dedication to Rosières, a sly
self-aggrandizing. With this, Artemisia establishes a relation-
ship between the unseen painter and the majestic allegory

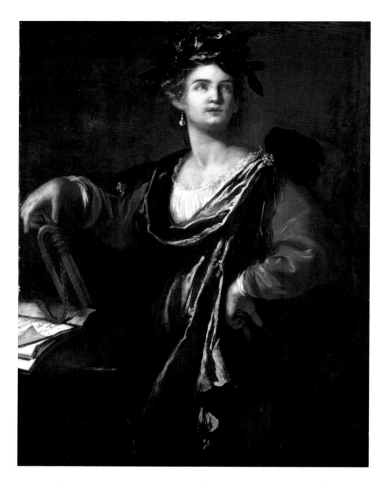

— a dialogue between the socially divided halves of herself. For Clio, in a particular way, *is* Artemisia, as she takes a pose that is virtually another form of the artist's signature. Clio's akimbo left arm echoes that of a woman holding a fan in Orazio Gentileschi's fresco of the Muses in Casino Rospigliosi, Rome, who has credibly been identified as modelled on the

60 Artemisia Gentileschi, *Clio, Muse of History*, signed and dated 1632, oil on canvas.

young Artemisia.[41] Projecting herself into the allegory, the artist becomes Clio, who will write Artemisia Gentileschi into the pages of history. This clever conceit, that the artist can simultaneously sign her product and declare her own historical fame, is made possible by the uniquely female capacity to blend the allegorical with the real: only a woman artist can make the muse of history her alter ego, and join with her to create history in living time. Artemisia's personal assertion is further indicated in the date above her name: 1632 is not the date of the dedicatee's death, but that of the picture's execution.

Artemisia's desire for recognition and fame, openly expressed in the *Clio*, was an aspiration manifested early in her career. She knew how to market herself, as the woman artist

61 Detail of inscription in Artemisia Gentileschi, *Clio, Muse of History*.

who specialized in images of women, and she built on the reputation this specialization brought her. She was a celebrity, an exceptional woman artist who successfully managed her own career and publicity, and was colourfully attractive as well. Yet celebrity was not her ultimate goal, only a condition of her unusual identity. She wanted to be famous because she considered herself to be a great artist, and she believed that her innate talent would empower her to rival the great male artists of history.

There are many signs that Artemisia guided the construction of her identity in this direction. As discussed in Chapter One, Cristofano Bronzini's biography of Artemisia contains deviations from fact that are likely to have been invented by Artemisia herself. One is that she was essentially self-taught, learning to paint while in a convent (that she never entered), and received no training from her father. In that convent, says Bronzini, Artemisia became more 'inclined' than ever towards the profession of painting, using a loaded word that evokes the concept of natural inclination, or inborn talent, accorded by Vasari only to great geniuses like Giotto and Michelangelo.[42] Shortly before Bronzini inserted her biography in his text, Artemisia connected herself with innate genius in the *Allegory of Inclination* she painted for the ceiling of the Galleria in Casa Buonarroti (illus. 62), within a programme commemorating the patron's uncle, the great Michelangelo Buonarroti.

The figure contributed by Artemisia was intended to symbolize Michelangelo's inclination for greatness through a female allegorical body. But she projected herself bodily into the allegory, giving the symbolic figure traces of her own appearance, such as the bushy, unruly hair that would become

62 Artemisia Gentileschi, *Allegory of Inclination*, 1615–17, oil on canvas. Casa Buonarroti, Florence.

her trademark. Her presence established, Artemisia then claimed personal identification with Michelangelo, taking the concept of precocious talent for herself: embedded in the *Inclination*'s grip on the compass is a figure quoted from Michelangelo's *Battle of the Centaurs* relief (which stood in the same room), in which the similarly young sculptor pronounced his destiny for greatness.[43] The quotation was perhaps also a bid to outdo Michelangelo, for there is a hint of the *paragone* in this contrived identification, in which Artemisia takes advantage of painting's edge over sculpture in the debate to underline her advantage.[44] Artemisia's self-identification with an allegory was picked up by other artists. Someone produced a small oval portrait of her as the allegory of painting, while another painted the *Allegory of Painting* as Artemisia herself (see illus. 47).[45]

Artemisia proclaimed her artistic genius once again in the lost self-portrait reflected in David's engraving (see illus. 11). Here she exaggerated her unruly, uncoiffed hair in probable reference to the iconographer Ripa's explanation that dishevelled hair was the sign of a powerful creative imagination.[46] Artemisia was evidently confident that she was destined to be one of the greats. Why would she think this way, considering that a female artist could expect at best to be praised for talent and achievement exceptional for a woman? My hunch is that Artemisia's sense of her own genius was embedded in every rule-breaking compositional decision she made, and in her every hijacking of a gender convention for personal use, and that she was fully aware that her female imagery was significantly original because it empowered women. Yet this must remain an inference drawn from the art itself because,

in her preserved writings, she never verbalized the grounds
on which she claimed greatness.

The Kensington Palace *Allegory of Painting* (illus. 63) was in part
Artemisia's response to a medal honouring Lavinia Fontana,
in which artist and allegory were implicitly joined.[47] Yet in
the *Allegory of Painting*, Artemisia did not depict herself as the
allegorical Pittura, even though other artists had shown her
in that role. Before any portraits of Artemisia were known,
scholars assumed that this was her self-portrait in the guise
of the allegory, yet the identification of Vouet's portrait of
Artemisia has cast doubt on this hypothesis.[48] Artemisia most
likely painted the *Pittura* in London, amidst a cluster of allegor-
ical works owned and commissioned by the English monarch
Charles I and his queen, Henrietta Maria. Some six to twelve
self-portraits are documented in Artemisia's *oeuvre*. One or
two of these, as well as two allegories of painting, appear in
the 1649 inventory of the English royal collections. Yet, as
Bissell noted, in none of the latter entries are they combined
as one image.[49] She is not known to have painted herself as
the allegory of painting.

 Artemisia may have felt that to associate directly with
the allegory would not elevate her identity, but diminish it.
Like Christine de Pizan and Lucrezia Marinella, who gave
muses and allegories historical identities the better to honour
actual female achievement, Artemisia may have wanted to
stake her claim as a living artist who could put meat on the
bones of an allegorical fiction men used to sideline women.
Like Marinella's Athena, who created a symbolic identity by
doing things she came to stand for, Artemisia's *Pittura* is a

living painter who practises the art she represents. Scholars have speculated that, if not Artemisia, then another specific female painter might be seen here. Yet the face is a familiar type in Artemisia's *oeuvre*, and though it might be based on a particular model, the figure is more plausibly a stand-in for women artists in general, a group that conspicuously includes herself. For all that her letters reveal pride in her connections with the kings and princes of Europe, Artemisia's affinity with working women is evident in her art – maidservants who perform their jobs with dignity and strength, or support their employers' heroic missions side by side.

The artist leans forward, with paintbrush poised before a blank canvas. Absorbed in the act of painting, she seems unaware of her appearance. Disorganized locks of hair fall around her face, and a gold chain bearing the allegorical mask of imitation (of nature) hangs slightly askew, like a forgotten medal bestowed in the last war. Subordinating the allegorical sign to her own agency, the painter diminishes the symbolic identity into which women had been frozen, rendering it incidental and secondary to the practice of painting. This stolen march on allegory distinguishes Gentileschi from Fonte and Anguissola, who exploited the disjunction between the real and iconic self, ironically concealing their authorial agency as an unseen presence behind the emblematic representation. By contrast, Artemisia includes the icon as a minimized referent within a real-world identity. In part, this difference resulted from changing aesthetic values, as cultural Europe turned in the seventeenth century from the intricate conceits of Mannerism, which delighted in complexity, paradox and layering of meaning, to the simplified

63 Artemisia Gentileschi, *Allegory of Painting (Pittura)*, 1638–40, oil on canvas.

and robust Baroque, which is all about fusion, synthesis and melting boundaries.

Yet in the *Allegory of Painting*, Artemisia propelled a shift in gender agency. Sharing with her female predecessors an awareness of creative possibilities within a divisive convention, Artemisia bridges the gap between real and ideal by endowing a real woman with iconic power. This important painting, central to women's history, presents a model of psychic integration within a social structure that dichotomized women – a healing fusion and reintegration of the divided halves of self.

The *Allegory of Painting*'s modelling of fusion and integration is also significant for the history of early modern art. This seemingly simple image incorporates many learned references and sophisticated ideas: the unruly hair alludes to artistic inspiration, the gold chain evokes prestigious chains rulers awarded to prominent artists, the colour changes in the drapery signify the painter's virtuosity, and the unmarked canvas evokes the *tabula rasa* of art theory.[50] But in engaging art's status symbols, Artemisia undermines their hierarchies, particularly the prioritizing of theory over practice. The blank canvas is prepared with an earthy reddish-brown ground, to remind us (as did Ripa) that, unlike poetry, the painter's art is rooted in material things. The aspirational elevated hand is balanced by the hand that holds the physical tools of painting, planted on a stable surface. The artist's hands, opposed by positioning, are connected by the sweeping curve of her arms, which is intersected by the painter's head, to suggest that her mind is the site of psychic integration.

Not incidentally, only a female artist could inhabit an allegory. To associate himself with art's nobler dimensions, a

male artist had to flash his credentials, point to his gold chain, or contrive to have a female allegory crown him. Simply by representing a woman painting, Artemisia could bring to mind the allegory, making a case for painting as a liberal art by physically enacting the concepts. Some twenty years later, Diego Velázquez would express the same idea in *Las Meninas* – that it is the practice of art, not the theory, that gives it dignity – and both painters added visual arguments to the rising debate in European courts about the nobility of artists and the art of painting. To make the point, however, Velázquez was obliged to ennoble himself with signs of his personal status at the Spanish court.[51] Artemisia could encode art's claim to elevated status as a liberal art in the image of a working female painter. It was a brilliant stroke of allegorical ju-jitsu, a triumph that holds particular meaning for the sex so long disparaged as dumb, the sex that was not permitted even to study the liberal arts.

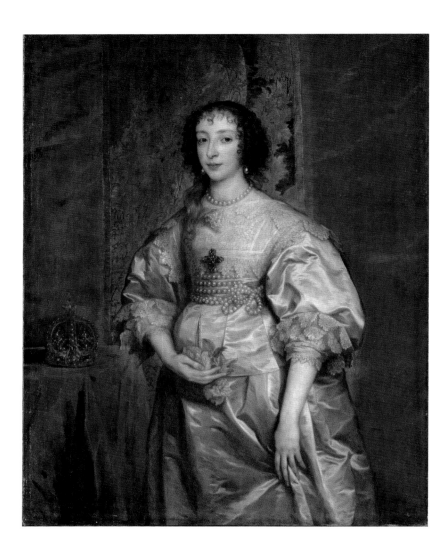

Matriarchal Succession: The Greenwich Ceiling

n the *Allegory of Painting* (see illus. 63), Artemisia drove home the point that living women are more real than allegories. A similar idea is expressed in the contemporaneous ceiling paintings for the Queen's House at Greenwich. Here, the allegorical figures contributed by Artemisia are distinct individuals who humanize the liberal arts and muses they represent. Moreover, they refer to living people.

In 1638, when Artemisia went to England at the invitation of King Charles I and his queen consort Henrietta Maria, she encountered her father Orazio, who had served the English court since 1626. After nearly two decades of estrangement, they would together produce a group of ceiling paintings for the Queen's House at Greenwich. But Artemisia did not go to help her ageing, ailing father complete this project, as was previously assumed. Charles had invited her to join his court repeatedly in the 1630s, and at first she put him off (see Chapter One). It was probably Henrietta Maria who instigated the invitations of both Gentileschi, encouraged by her mother, Marie de' Medici, whom Orazio had served in Paris in the 1620s, and who may have commissioned Artemisia's portrait of *Anne of Austria as Minerva* (see illus. 8).

64 Anthony van Dyck, *Henrietta Maria of France, Queen Consort of Charles I of England*, c. 1635, oil on canvas.

Charles I's vast collections of Italian art have been much studied, but Henrietta Maria was also a significant art patron, whose activity has been subsumed into that of her husband (illus. 64).[1] Like her mother, Henrietta Maria was Catholic and part Florentine. Thanks to her Italian connections, Henrietta Maria successfully attracted Italian art and artists to the English court.[2] She directed the acquisition of important Italian art, such as Bernini's marble bust of Charles I and a monumental *Bacchus and Ariadne* by Guido Reni. Several paintings by Artemisia Gentileschi entered the royal collections before Artemisia herself arrived, acquisitions that the queen is likely to have spearheaded.[3]

Henrietta Maria's signature achievement was the Queen's House, an architectural gem. The king's mother, Anne of Denmark, had commissioned Inigo Jones to build a country house as a retreat for the queen and her retinue. The house was unfinished at the time of Anne's death in 1619; Henrietta Maria took up the project in 1629, overseeing its completion and decoration.[4] In these years, the queen also tasked Inigo Jones to build a sumptuous Catholic chapel at Somerset House, where she sustained an autonomous female court. Henrietta Maria's female-headed court, like that of Anne of Denmark, was effectively a power base for women, enabling their political and cultural activities, and allowing them, as one scholar described it, 'to act like male courtiers and their queen to act as a prince'.[5] Revisionist analysis has uncovered the powerful, innovative cultural roles these two 'foreign' queens played: they commissioned art and architecture, wrote poetry and danced in masques, and brought new models for theatre and dance from the courts of their native lands – in

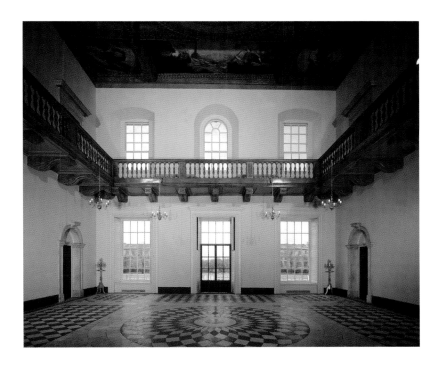

Henrietta Maria's case, France – setting and circulating new artistic trends.[6]

The Queen's House was completed in 1635, with a central hall that Henrietta Maria enlarged to embrace two storeys. The Great Hall was the centrepiece of this 'House of Delight', an elegant Palladian cube whose black and white floor tiles mirrored the pattern of panels in the ceiling (illus. 65).[7] In addition to the ceiling panels, decorations included ten marble statues, and four paintings hung on the east and west walls that were chosen or commissioned by the queen herself. They included a *Tarquin and Lucretia* by Artemisia Gentileschi and two or three works by Orazio Gentileschi: *The Finding of Moses*,

65 Inigo Jones, architect, Great Hall, Queen's House, Greenwich, 1616–35; interior, facing north wall, 1635–40. Ceiling: photo reproductions of original paintings.

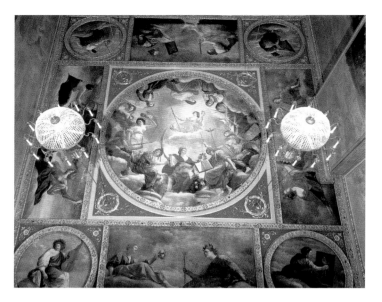

Joseph and Potiphar's Wife (or possibly *Lot and his Daughters*), and a painting of the 'Muses' that was either Orazio's lost *Apollo and the Nine Muses*, or Tintoretto's version of this theme now in Kensington Palace.[8]

Scholars have puzzled over the art Henrietta Maria chose to display at Greenwich, noting that the scenes named above, which feature rape, seduction and incest, seem odd for the devout Catholic queen. Yet the pictures have one simple thing in common: in each, women outnumber men and/or control the action, except for the *Lucretia*, which was painted by a woman. In the Greenwich version of Orazio's *Finding of Moses*, there are nine women (one more than in his Prado version), perhaps requested by the queen to match the nine Muses.

These scenes hung beneath a ceiling filled with female allegories, muses and personifications of the arts (illus. 66).

66 Orazio and Artemisia Gentileschi, *Allegory of Peace and the Arts under the English Crown*, with surrounding panels of Muses and Liberal Arts, 1638–9, oil on canvas, Marlborough House, Main Hall, London; ceiling paintings originally in Great Hall, Queen's House, Greenwich.

Henrietta Maria's enthusiasm for muses and the arts is indicated in her parallel commission of a ceiling painting for Somerset House, in which personifications of Architecture, Painting, Music and Poetry sat on clouds in the sky.[9] The queen's unusually vigorous devotion to female allegories may signal a belief that these images subtly strengthened the notion of women as an 'elevating force'.[10] In both houses, Henrietta Maria surrounded herself and her female courtiers with images that mirrored their gender, an ideal counterpart to the real women who moved through the spaces of the queen's residence. Moreover, the north gallery of the Great Hall connected the Queen's Bedchamber and her Withdrawing Room. When Henrietta Maria moved between these rooms, she walked through the gallery and viewed the ceiling at close range, thus experiencing the allegorical reflection from a private as well as public perspective.[11]

To paint the allegories of the Great Hall ceiling, Henrietta Maria tapped Orazio Gentileschi, who was known for an icily elegant and courtly, yet somewhat stilted, style that set him in contrast to Peter Paul Rubens, whose vigorous, dynamic style was prominent in the recently completed ceiling paintings at Inigo Jones's Banqueting House at Whitehall, commissioned by Charles I to allegorize the rule of his father, James I of England. It has been suggested that the two ceilings might reflect the king and queen's divergent tastes in painting,[12] yet the subjects chosen by each are perhaps more telling: the king moved to commemorate the patriarchal dynasty, while the queen chose to celebrate the liberal and visual arts through their female embodiments. In the four corner scenes of the Banqueting House ceiling, females appear as evil figures,

allegorical vices overcome by masculine virtues (illus. 66). The Queen's House ceiling is, in a sense, a feminist response, for every figure in it is a woman, and the 26 female arts and muses collectively represent the highest humanist virtues.

Henrietta Maria believed that, as queen, she had a special role in supporting the arts, as counterpoint to the king's management of war and politics. Drawing on Jacques Du Bosc's *L'Honnête femme* (1632–6), she introduced a concept of gender roles into England that was developed in the French salons and her mother's court circles.[13] Du Bosc assigned women responsibility for the harmonious running of society,

67 Peter Paul Rubens, *Apollo as Liberality Triumphing over Avarice*, installed 1636, oil on canvas. The Banqueting House, London, ceiling.

which included sustaining peace and cultural life; accordingly, he encouraged women to develop their knowledge of history and practice of the arts. Du Bosc's treatise, which has been described as 'conservative feminism', emphasizes women's duty and propriety, and effectively defines the key concept of *honnêteté* as things that women shouldn't do. Du Bosc even suggested that the purpose of women's education is to make themselves interesting conversationalists with men.[14] Yet, more progressively, he argued that women are as capable as men, and like Christine de Pizan and Lucrezia Marinella, he named Minerva as the inventor of learning and the Muses as the inventors of the arts.[15]

The Greenwich ceiling paintings are now preserved in Marlborough House, London, where they were moved in the eighteenth century. The ensemble consists of a central tondo, the *Allegory of Peace and the Arts under the English Crown*, in which Peace, at centre, is surrounded by other allegorical figures, including the seven liberal arts. Flanking the tondo are four rectangular panels in which the nine Muses are distributed; and in the corners, four round panels representing the arts of painting, sculpture, architecture, and poetry or music.[16] The programme is said to have been devised by Orazio Gentileschi with input from Inigo Jones,[17] yet the royals must have controlled the iconography, since the Greenwich ceiling took part in a propaganda campaign to promote the idea of a peaceful and benevolent Stuart monarchy.

The theme of peace was strongly sounded at the Caroline court. In reality, Charles's reign had been troubled since his marriage to a Catholic, and because of his firm belief in the divine right of kings. In the mid-1630s, he faced opposition

from the English Parliament and from Protestant groups in Scotland and England. In the ensuing civil war, Charles would be tried and beheaded in 1649, his monarchy replaced by the Commonwealth. Henrietta Maria's Catholicism made her anomalous – it prevented her being crowned in a Church of England service, so she never had a coronation – and she was widely unpopular in England. Yet her religion was also a political asset, providing a back-channel avenue to support from Pope Urban VIII, her godfather, and permitting her to operate on Charles's behalf through her Catholic networks. The Queen's House at Greenwich was, moreover, a useful site for political activity, where Henrietta Maria and her courtiers could mediate socially between opposing factions.

The theme of the ceiling is that in a harmonious and peaceful reign, such as that of Charles I and Henrietta Maria, the arts flourish. This message had earlier been delivered in court masques, and in paintings such as Gerard van Honthorst's 1628 painting of *Mercury Presenting the Liberal Arts to Apollo and Diana* (who resembled the king and queen).[18] Some masques gave the queen an acting role in fostering the arts. In Aurelian Townshend's *Tempe Restored* (1632), Henrietta Maria played the part of Divine Beauty, who turns herbs and flowers into 'the virtues and sciences', underlining the importance of the liberal arts for spiritual health. The Greenwich ceiling imagery embraces the same concepts, but in contrast to Honthorst's picture and the masques, the king and queen are not depicted as participants.

Yet if Henrietta Maria is nowhere depicted in the central scene (illus. 68), she is everywhere recalled. Peace (Pax), the central figure, holds the customary olive branch as attribute

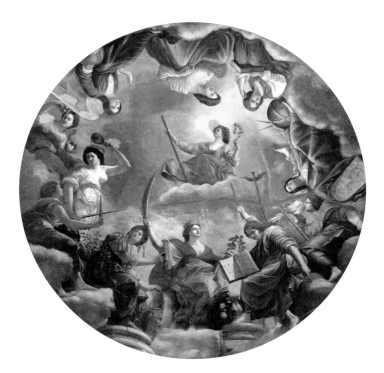

and, unusually, a staff that resembles a royal sceptre. We are to recognize that this female Peace surrounded by female liberal arts is an allegorical counterpart of the real woman who, with her court, exercises power to promote the arts and concord. Beneath Peace is a crowned woman holding a palm and a laurel wreath who has been identified as Victory, though Victory does not normally wear a crown. This allegorical Victory further incorporates the idea of Abundance, as her foot rests on an overturned container of fruit and flowers. Victory's unusual attributes, like Pax's sceptre, imply the presence of Henrietta Maria, the agent who sustains peace and political harmony, and who, as the bearer of royal children, is

68 Orazio and Artemisia Gentileschi, central tondo, *Allegory of Peace and the Arts under the English Crown*, 1638–9, oil on canvas. Marlborough House, London; originally Queen's House, Greenwich.

critical to monarchic succession.[19] Her importance is underlined by the adjacent figures, Reason and Astronomy, who point at her to focus our attention. With her other hand, Astronomy points to the Muses and visual arts scenes below, to indicate Henrietta Maria's connection with these arts.

The overarching message of the ceiling is pure propaganda, sugar-coating the Stuart monarchy that did in fact foster the arts but was far from peaceful and untroubled. It also presented Henrietta Maria in a particular light, as a benign arts overseer, that was intended to counter growing public antagonism towards her. For the English public, Henrietta Maria's Frenchness was as problematic as her Catholicism and these were inextricably linked, along with her gender, as her three pillars of otherness. Defiantly, the queen forged a political identity grounded in the merger of her three distinctive markers. She nurtured her French cultural connections, flaunted her Catholicism and supported embattled English Roman Catholics. She offered protection to converts, many of them women acting without their husbands' approval, whose profession of Catholicism was seen as a challenge to patriarchal authority. Much of this activity was clandestine, necessarily conducted undercover because it ran counter to her husband's agenda as king of a Protestant England.[20]

Henrietta Maria's work on behalf of women and Catholicism is shown in her support of a second book by Jacques Du Bosc, known in English translation as *The Secretary of Ladies, Or a New Collection of Letters and Answers Composed by Moderne Ladies and Gentlewomen*.[21] This collection of friendship letters, allegedly written by two anonymous aristocratic women, represents a genre of particular value for women.[22] Letter-writing gave

women informal access to the art of rhetoric (they were largely barred from public oratory), and fostered their participation in a political community. In England, *The Secretary of Ladies* served a group of French and English aristocratic women who were Catholics or supporters of Catholicism. Henrietta Maria was at the centre of this community and, with her support, Catholic books were published on clandestine presses, some encrypted to pass censorship – which fuelled suspicion about an 'encoded, invisible, secret Catholicism'.[23] Concomitantly, the threat of female subcultures produced anxiety about women's rising autonomy, an anxiety reflected in the misogynist and pro-female pamphlets discussed in Chapter One.

When Orazio Gentileschi died in February 1639, Artemisia had been at the English court for months, perhaps as much as a year.[24] She may have agreed to collaborate with her father on the ceiling commission he had begun in 1636, but more likely, she took over the unfinished project when poor health prevented him from continuing. Father and daughter had not been on speaking terms since 1620, and there is no evidence that they ever reconciled their differences.[25] Since work at Greenwich did not end until the summer of 1640, the ceiling paintings may not have been finished for some time after Orazio's death.[26] A logical terminus for Artemisia's participation was December 1639, when she wrote to the Duke of Modena to announce the end of her service to the English crown (see Chapter One).

Although some scholars have doubted Artemisia's participation in the ceiling, others, myself included, recognize her hand in major portions of the ceiling panels.[27] Key differences

between Artemisia and Orazio's painting styles are evident in three of the Muses panels, where figures by father and daughter are juxtaposed. For example, Euterpe was painted by Orazio, and her partner Polyhymnia was painted by Artemisia (illus. 69). In this and other pairings, Artemisia's figures are more animated.[28] They grip objects firmly, and their gazes are alert and focused. Orazio's figures gaze dreamily, and seem to lack inner life. Especially telling are their dissimilar depictions of draperies. Orazio's fabrics are arranged in smooth and placid convex folds, while Artemisia's draperies involve concavities and ridges; they are agitated and energized.

These distinctions continue in the central tondo (see illus. 68 and 69), where the seven liberal arts are given attributes according to Cesare Ripa's *Iconologia*. Clearly by Artemisia are the three figures to the left of Victory: Reason (with armour and shield); Grammar (in brown); and Rhetoric (in white). Rhetoric's fluid, translucent drapery and the rolled-up sleeve

69 Orazio and Artemisia Gentileschi, Greenwich Ceiling, Muses Euterpe (left, by Orazio) and Polyhymnia (right, by Artemisia), 1638–9. Marlborough House, London; originally Queen's House, Greenwich. Photo after cleaning, during restoration.

are Artemisian signatures, while the open-mouthed Medusa head on Reason's shield echoes that in Artemisia's painting of *Minerva* (see illus. 8). On the right side, I would give to Artemisia the figures of Astronomy (holding open book, points down) and Arithmetic (in green and violet, with a square tablet). Geometry (in a rose cloak, with compass, sphere and tablet) is the most Orazian figure among these liberal arts, and he may also have painted Logic on the left (with serpent and flowers).

Two figures, however, do not strictly conform to Ripan iconography, both painted by Artemisia (illus. 70). Logic is straightforward, with her serpent and flowers, as is Grammar, who pours water into a pot of plants (to indicate that correct grammar nurtures the growth of learning). But the woman in white between them, with mirror and sword, is more difficult to identify. She ought to be Rhetoric, to complete the Trivium, yet, in Ripa, Rhetoric holds a sceptre in one hand and a book in the other; neither sword nor mirror is mentioned. The allegorical figure who holds a mirror and wears a helmet is Prudence, but Prudence is not one of the liberal arts. And neither Rhetoric nor Prudence, nor any of the *artes liberales*, has one exposed bare breast, as does this figure. The seated woman in armour, helmeted and holding a shield and spear, has been identified as Reason, Ripa's *Ragione*.[29] But Reason is not a liberal art, and this figure more closely resembles Minerva, whose shield bears the Medusa head (Reason has a lion). Minerva is usually depicted with a spear, as here, while Reason holds a sword.

These anomalies can be explained, and the elements cohere, if we allow for the distribution of attributes across

figures, and for the possibility that they might evoke, rather than illustrate, secondary identities. The armoured, helmeted Minerva/Reason joins the one-bare-breasted Rhetoric with a feather-adorned helmet, to constitute an Amazonian reference that brings to mind Rubens's painting of Marie de' Medici as Bellona/Minerva (see illus. 7). Queen Mother Marie de' Medici, who resided at her daughter's court from 1638 to 1641, precisely when the ceiling paintings were executed, is thus pointedly included in the Greenwich ceiling.

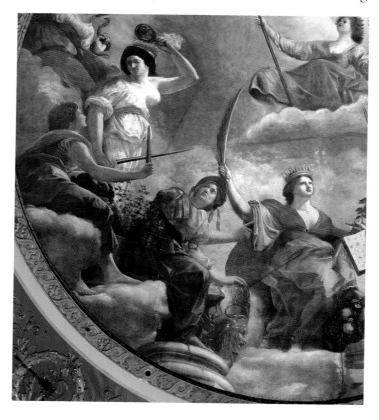

70 Orazio and Artemisia Gentileschi, central tondo, *Allegory of Peace and the Arts under the English Crown*, figures on lower left side.

Amazon iconography was central to Marie de' Medici's rule, and it was also adopted by Henrietta Maria, who performed as an Amazon in William Davenant's 1640 masque *Salmacida Spolia*. Like her mother, Henrietta Maria could assume masculine roles. When she raised money and armies and led troops during the Civil War, the English queen described herself as 'her she-majesty generalissima'.[30] The almost interchangeable iconographical identities of mother and daughter permeate the ceiling imagery allusively, yet on a subterranean level of meaning.

Fortifying Henrietta Maria's identity through that of Marie de' Medici had one obvious purpose, to reinforce her role as patron of the arts. Yet the Greenwich ceiling imagery is replete with allusions to Henrietta Maria's support of the arts. Why bring in her mother, and why indirectly? I propose that another line of dynastic succession is hinted at here, one not sanctioned by the Church of England, and unrelated to the ceiling's main theme. Henrietta Maria's political and cultural activity followed a pattern set by her mother, who in turn had imbibed it in her Medici upbringing. The English queen's female-centred court and her distinctive support of art and theatre echo key features of the Florentine court ruled by foreign-born Medici women, Maria Maddalena and Christine of Lorraine (see Chapter Three). Marie de' Medici was brought up at the court of Christine of Lorraine, her aunt by marriage, and when she assumed power in France after the death of her husband Henri IV, she initiated a formidable campaign of art patronage best known for Rubens's cycle in the Luxembourg Palace. Henrietta Maria, who spent her childhood in the Louvre, brought many French features into the Greenwich

house, just as her mother had imported Florentine ideas and iconography into France.[31]

This mother and daughter had a great deal in common. Culturally displaced, as queens exchanged in dynastic marriage always were, each inventively created cultural and political power for herself in a new foreign land, the mother presenting a model for her daughter. Excluded from royal succession, it was natural for them to value matriarchal succession. Marie de' Medici held direct power only intermittently, yet she exercised considerable indirect power, arranging the marriage of another daughter, Elisabeth, to the future king of Spain (Philip IV), and of her son, Louis XIII, to the future queen of France (Anne of Austria).[32] The management of dynastic marriages had a dimension of gender pride for Marie de' Medici, as she encouraged and cultivated the independent agency of her daughters and daughter-in-law. Since neither France nor England permitted female succession to the crown, unless by default (if the king died, for example), no ruling queen had ever been followed on the throne by a daughter in either country. This dream lived only in women's imaginations.

Through their successive cultural legacies, the queen of France and her daughter the queen of England established a female form of dynastic continuity. Continuity was sustained by this mother and daughter through their shared identification with the Virgin Mary, a powerful figure in the Catholic imagination, and their use of Marian imagery to underline the ideals of chastity and motherhood.[33] Female procreative power was further mystified by the concept of queenship – a queen's ability to pass along royal blood through her

children – and this power could be manifested in matriar-
chal as well as royal succession.[34] Marie de' Medici had filled
the Luxembourg Palace with images of ancient and modern
queens, as if to establish a mythic genealogy of queenship
(see Chapter Four). Following the lead of her mother-in-
law, Anne of Austria ordered a series of illustrious women
for her Palais Royal apartments, and numerous pictures of
empresses and queens for her rooms in the Val de Grâce.[35]
And on her mother's model, Henrietta Maria filled the ceil-
ing panels of the Greenwich Queen's House with images of
female arts and muses.

 In the Greenwich ceiling, the idea of mythic female suc-
cession is poetically evoked through the interactions of female
allegories. Reason/Minerva, a figure for Marie de' Medici,
points to Victory, a figure for Henrietta Maria, to hint at the
generational continuity between them. The pairing could
also allude to Henrietta Maria and her own eldest daughter,
Mary Henrietta, who was being groomed for queenship at
that time.[36] Since neither Reason nor Victory has a program-
matic reason to be here, their insertion seems openly political.
Multiple real-life identities are invoked to convey a powerful
key idea: the wise mother instructs or counsels the daughter,
whose attribute of fertility (the cornucopia) brings to mind
the generations, and matriarchal genealogies, to follow.

 The liberal arts Rhetoric and Grammar engage one
another directly, more explicitly resembling a mother and
daughter. The youthful figure of Grammar, her flowing hair
and cloak connoting a yet-unformed identity, looks up to the
more mature Rhetoric, who gazes down at the young woman
and holds a mirror before her. Their interdependence is

suggested in the crossing metal tools they hold. The pairing of Grammar's rasp and Rhetoric's sword evokes a metaphor, for the Latin *acuere* (Italian, *aguzzare*) means both to sharpen a cutting instrument and to sharpen a rhetorical point, neatly fixing their allegorical overlap.[37] Another allusion can be recognized in this potent image of mother–daughter symbiosis. The mirror held by the allegorical Prudence – for the purpose of correcting one's faults, according to Ripa – brings to mind the mirror presented to the despairing Christine de Pizan by Lady Reason, to encourage the young author's self-confidence. Marie de' Medici would have known the text of the *Cité des dames* well, because it was the basis for European queen mothers' arguments to justify female regency.[38]

 This imagery was necessarily covert. Marie de' Medici (illus. 71) was an unwelcome figure at the English court. She posed a political danger to Charles I, because her recent intrigues against Richelieu compromised his diplomatic relations with the French, and her ongoing political intentions were unclear. Marie's threatening presence was mediated through theatrical performances that carried political overtones. William Davenant's masque *Salmacida Spolia* was designed to negotiate the tensions generated by the queen mother.[39] Addressed to Marie de' Medici, the masque included the subversive figure of Discord, who causes trouble yet is controlled by the king's strong hand. While seeming to praise the queen mother, the masque also expressed concern about her influence on her daughter and her potential to destabilize domestic harmony.

 Henrietta Maria's appearance as an Amazon in Davenant's masque was possibly meant to refer to her support of

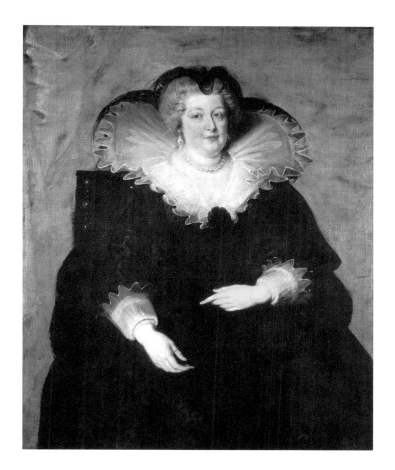

Charles's war effort, a manipulation of Amazonian iconography commonly used by male writers at the English court.[40] Yet the queen's star turn as an Amazon also linked her to the feminist iconography of powerful women, so brilliantly deployed by the queen mother. Marie de' Medici adapted the story of Artemisia of Caria to her own political goals, representing herself as her husband's 'living tomb' to legitimize

71 Peter Paul Rubens, *Marie de' Medici*, unfinished portrait, 1622, oil on canvas.

her rule by way of Queen Artemisia, who swallowed the ashes of her husband King Mausolus, incorporating his masculinity in her body. When Amazonian power was invoked in *Salmícida Spolía*, whose plot involved themes of emasculation and female agency,[41] it might not have calmed but instead exacerbated anxiety about the queens at court. For the underlying political concern encoded in this masque, necessarily displaced and allegorized, was the fear of women's usurping of male power.

The fear is detectable in Marie de' Medici's French adviser, who, invited to choose illustrious queens to commemorate in the Luxembourg dome statues, rejected Artemisia, Semiramis and Dido, and instead picked the mothers of famous men.[42] Rubens's painting of Marie de' Medici as Bellona/Minerva, and other pictures in the Luxembourg cycle that show the queen with an Amazonian single breast, invoked the topos of the dangerous power of women,[43] and raised the spectre of modern women's proven ability to fight, lead troops and govern, as had the Amazons and queens Thomyris and Artemisia. The fear that female rule could become normative lived in conventions like the French Salic law, which was constructed to prevent a frightening possibility from ever happening.

If the interactions of Artemisia Gentileschi, Marie de' Medici and Henrietta Maria are not sufficiently documented, it is perhaps because their very association carried overtones of subversion. The Greenwich ceiling imagery was the creative product of women: two queens and a female artist. Its covert theme, female empowerment through matriarchal succession, opposed the creed of the masculine Stuart court, and joined a succession of challenges that Marie de'

Medici had posed to male rulers in France, and her daughter Henrietta Maria had issued to a Protestant establishment in England. The concept can be traced to the queen and queen mother, but the particular forms this idea took were surely the contribution of Artemisia Gentileschi, who was adept at creating visual metaphors for living experience (a capability Orazio never exhibited). With consummate skill, Artemisia manipulates the traditional language of allegory to enlarge upon the concerns of living women. Through fixed signs that carry shifting meaning, she invokes the ghostly presence of real people, most of all Marie de' Medici, who loom the larger for not being seen.

In declaring that she had served both these queens (see Chapter One), Artemisia laconically understated the nature of her service. The three women must have collaborated in some way to realize this imagery. One imagines conversations that crossed the boundaries of class, lubricated by their common Italian language and the fact that they shared, if from different perspectives, the yoke of patriarchy and the difficulty of life in a man's world. There would have been much to discuss. As Vouet's portrait tells us, Artemisia of Caria was a hero to the painter, and she was a role model for Marie de' Medici, as were queens Judith and Esther, whom Artemisia Gentileschi had painted.

Beyond this, Artemisia had reason to identify with the ideas she gave visual form. She had at least one daughter, more likely two, whom she trained in painting, and the possibility of a mother–daughter succession of artists – something as yet unknown – might have appealed to her. Although neither daughter ever made a mark as a painter, the adolescent

daughter would have been with her mother in England, and might figure in the ceiling's imagery, encoded in the relationship of the mature Rhetoric and youthful Grammar. A personal association could explain the mysterious inclusion of Prudence in the figure of Rhetoric. Artemisia's own mother was named Prudentia, the name Artemisia gave to her first daughter. Prudentia Montone's singular importance for her daughter's artistic career was indicated in Bronzini's biography of Artemisia, which was probably based on an origin myth of Artemisia's own invention. In this account, as Sheila Barker points out, Artemisia situated her creative beginnings 'within a feminine, even matriarchal, matrix'.[44] The young Artemisia lengthens a skirt her mother had made for her, adding an embroidery design of her own invention. Experts recognize the girl's potential for great artistic achievement and Artemisia, having inherited her mother's talent, goes on to great glory. In this potent passage of the Greenwich ceiling, the metaphor is fluid, for Prudence/Rhetoric and Grammar might represent Artemisia and her daughter, or Artemisia's mother and herself. Either way, the meaning is consistent with the theme of matriarchal succession that dominates the ceiling painting as a whole.

It is early in the year 1642. Bathsua Makin, said to be the most learned woman in England, stands in the Great Hall of the Queen's House at Greenwich. She has joined the English court as tutor to the children of Charles I and Henrietta Maria. Marie de' Medici, banished by the king, will die in Cologne in July. With the Civil War raging, the king and queen have been uprooted and, in September, the Queen's

House and other royal residences will be seized by Parliament. Queen Henrietta Maria will go into exile in France in 1644, not to return until the restoration of the monarchy in 1660 and her son's ascent to the throne as Charles II. Artemisia Gentileschi has returned to Naples, where she works in a very different cultural environment, apparently lacking female patronage and support, until her death more than a decade later, perhaps in the plague of 1656.

In this fictional (but not improbable) scenario, Bathsua Makin stares at the Greenwich ceiling paintings. On the perimeter of the celestial vision sits a crowned woman who is not the Queen of Heaven, though she could be thought of that way. Surrounding this queenly figure are some remarkably palpable women, those on one side equipped with the helmets and swords of battle, and on the other with the apparatus of science and the arts. The memory of the real women who took centre stage in this imagery, women she had known, who inhabit and revitalize the allegories, will stay with Bathsua Makin thirty years later, when she writes a pamphlet to argue vigorously for women's education. In *An Essay to Revive the Antient Education of Gentlewomen* (1673), Makin asks, 'Why should the seven Liberal arts be expressed in Womens Shapes?' One reason, she explains (echoing Marinella), is that women invented these arts, promoted them and since have studied and attained excellence in them. Hence, as a token of honour, 'we make Women the emblems of these things.' Makin juxtaposes this point with the contradictory reality that women are denied access to these very arts: 'Doubtless if that generation of Sots (who deny more Polite Learning to Women) would speak out, they would tell you, If Women

should be permitted arts, they would be wiser than themselves (a thing not to be endured).'[45]

Makin would not exclude women from any branch of learning. She would not deny them grammar and rhetoric; logic must be allowed, because it is the key to all sciences. They must study physics and languages, mathematics and geography. Makin invokes the canonical seven liberal arts, then adds music and poetry to the list, and, quite unusually, she names painting, which like music and poetry is 'a great ornament and pleasure'. Thus is the art of painting graciously included among the liberal arts, an inclusion so long contested. Makin may have been thinking of Painting's singular prominence in a corner roundel of the Greenwich ceiling, highlighted by Astronomy's pointing gesture – perhaps both the figure and emphasis contributed by Artemisia. (Unusual too is that three of the four arts that anchor the ceiling are Painting, Sculpture and Architecture.) Reading Makin's words, one cannot help but picture the figures of the ceiling – as she may have done when writing them – who, through their corporeality, specificity and interactive behaviour, give substance to the arts they embody, and almost believably have invented.

In the years between Makin's work for the English crown and her composition of the pamphlet, many brilliant educated women emerged in England, women like Margaret Cavendish, Duchess of Newcastle-upon-Tyne, who broke intellectual ground in her writings on natural philosophy (that is, science) and gender. Cavendish joined Queen Henrietta Maria as lady-in-waiting in 1643 and followed her into exile. Inspired by the queen's example, Cavendish would become a living fulfilment of the ceiling's promise for women. In her

play *Bell in Campo*, Cavendish showcased heroic martial women (she called them 'heroickesses'), such as Lady Victoria, who is modelled on Henrietta Maria and carries visual references to Marie de' Medici.[46] Bathsua Makin herself took up the idea of female networks across generations, as if to amplify the matriarchal successions of the ceiling. In her *Essay*, like the Italian feminist writers, she reiterates a female family tree, naming ancient and modern women who excelled in learning, not the least of them 'the present Dutchess of New-Castle' (Margaret Cavendish), who 'by her own Genius, rather than any timely Instruction over-tops many grave Gown-Men'. As discussed in Chapter One, Makin's own arguments would be echoed by Mary Astell, in her 'A Serious Proposal to the Ladies, Part I' (1694).[47]

I would not claim that Artemisia's painted allegories of the liberal arts and muses influenced the expansion of feminist ideals in England. But publicly prominent images shape us, as Winston Churchill said of architecture; they can reinforce our core beliefs, or stir us to achieve. In the larger history of the early modern feminist movement in Europe, this image of female achievement and matriarchal succession deserves a place, and the artist who painted it no less, for Artemisia Gentileschi was one of the human connections, a carrier of ideas between feminism's origins in Italy and France and its legacy in England and America for the feminist activists of the nineteenth, twentieth and twenty-first centuries.

REFERENCES

1 Artemisia and the Writers: Feminism in Early Modern Europe

1 Emmanuel Rodocanachi, *La femme italienne, avant, pendant et après la Renaissance* (Paris, 1920), pp. 322–3. On the growing imprisonment of nuns in convents, see Sharon Strocchia, *Nuns and Nunneries in Renaissance Florence* (Baltimore, MD, 2009).

2 Torquato Tasso, *Della virtù feminile e donnesca* (1582). For English translation and discussion, see Lori J. Ultsch, 'Torquato Tasso: Discourse on Feminine and Womanly Virtue', in *In Dialogue with the Other Voice in Sixteenth-century Italy: Literary and Social Contexts for Women's Writing*, ed. Julie D. Campbell and Maria Galli Stampino (Toronto, 2011), pp. 115–41.

3 Giuseppe Passi, *I donneschi difetti* (Venice, 1599). An English translation is given by Suzanne Magnanini with David Lamari, 'Giuseppe Passi's Attacks on Women in *The Defects of Women*', in *In Dialogue with the Other Voice*, ed. Campbell and Stampino, pp. 143–94. On the 'backlash' of misogyny that began in the late Cinquecento, see Ginevra Conti Odorisio, *Donna e società nel seicento: Lucrezia Marinelli e Arcangela Tarabotti* (Rome, 1979), pp. 35–47, and Virginia Cox, *Women's Writing in Italy, 1400–1650* (Baltimore, MD, 2008), pp. 166–227.

4 Stephen Kolsky, 'Moderata Fonte, Lucrezia Marinella, Giuseppe Passi: An Early Seventeenth-century Controversy', *Modern Language Review*, XCVI (2001), pp. 973–89.

5 Lucrezia Marinella, *The Nobility and Excellence of Women and the Defects and Vices of Men*, ed. and trans. Anne Dunhill, intro. Letizia Panizza (Chicago, IL, and London, 1999). On Marinella and Aristotle,

see Constance Jordan, *Renaissance Feminism: Literary Texts and Political Models* (Ithaca, NY, and London, 1990), pp. 257–61.

6 Kolsky, 'Moderata Fonte, Lucrezia Marinella, Giuseppe Passi', pp. 987–8.

7 *Le Roman de la rose*, by Guillaume de Lorris and Jean de Meun. English translations of Christine's *La Livre de la cité des dames* (The Book of the City of Ladies) are by Earl Jeffrey Richards (New York, 1982) and Rosalind Brown-Grant (London and New York, 1999). In this book, I use Richards's translations. Sarah Gwyneth Ross, *The Birth of Feminism: Woman as Intellect in Renaissance Italy and England* (Cambridge MA, 2009), pp. 133–43, discusses Christine's position in the history of feminism. A classic overview of feminist writings in early modern Europe is Joan Kelly, 'Early Feminist Theory and the "Querelles de Femmes", 1400–1789', *Signs: Journal of Women in Culture and Society*, VIII (1982), pp. 4–28.

8 Giovanni Boccaccio, *Famous Women*, trans. Virginia Brown (Cambridge, MA, and London, 2003).

9 Patricia H. Labalme, *Beyond Their Sex: Learned Women of the European Past* (New York, 1980); Margaret L. King and Albert Rabil, Jr, *Her Immaculate Hand: Selected Works by and about the Women Humanists of Quattrocento Italy* (Asheville, NC, 2000).

10 Laura Cereta, *Collected Letters of a Renaissance Feminist*, ed. and trans. Diana Robin (Chicago, IL, and London, 1997). Ross, *Birth of Feminism*, pp. 151–7, discusses Cereta's important arguments for women's education.

11 Moderata Fonte (Modesta Pozzo), *The Worth of Women, Wherein Is Clearly Revealed Their Nobility and Their Superiority to Men*, ed. and trans. Virginia Cox (Chicago, IL, and London, 1997). For the Italian text of *Il merito delle donne*, see Conti Odorisio, *Donna e società nel seicento*, pp. 159–96, with discussion, pp. 57–63. On Fonte's dialogue, see also Cox's introduction to *Worth of Women*, and Ross, *Birth of Feminism*, pp. 278–86.

12 Virginia Cox, *The Renaissance Dialogue: Literary Dialogue in its Social and Political Contexts, Castiglione to Galileo* (Cambridge, 1992).

13 Baldasar Castiglione, *The Book of the Courtier*, trans. Charles S. Singleton (Garden City, NY, 1959), chap. 3.

14 Jordan, *Renaissance Feminism*, pp. 84–5, and Valeria Finucci, *The Lady Vanishes: Subjectivity and Representation in Castiglione and Ariosto* (Stanford, CA, 1992), pp. 27–103.

15 Mary D. Garrard, *Brunelleschi's Egg: Gender, Art and Nature in Renaissance Italy* (Berkeley, CA, and London, 2010), pp. 157–8.

16 In a sequel to *The Defects of Women*, Passi hinted that men should behave better towards women, lest they cede their natural position of leadership to threatening females. Kolsky, 'Moderata Fonte, Lucrezia Marinella, Giuseppe Passi', pp. 984–6.

17 Robert C. Davis, 'The Geography of Gender in the Renaissance', in *Gender and Society in Renaissance Italy*, ed. Judith C. Brown and Robert C. Davis (London and New York, 1998), pp. 19–38. On the tense public interface of the sexes, see Sharon Strocchia, 'Gender and the Rites of Honour in Italian Renaissance Cities', ibid., pp. 39–60.

18 For Orazio's early Roman patronage, see Keith Christiansen, 'The Art of Orazio Gentileschi', in Keith Christiansen and Judith W. Mann, *Orazio and Artemisia Gentileschi: Father and Daughter Painters in Baroque Italy*, exh. cat., Museo del Palazzo di Venezia, Rome; Metropolitan Museum of Art, New York; and the Saint Louis (MO) Art Museum (New York, 2002), pp. 3–19. In March 1610, the Gentileschi family moved from Via Babuino to a more spacious residence in Via Margutta, and in April 1612 to Via della Croce.

19 Of Orazio's three sons, only Francesco was trained in painting, but he wound up serving as art agent for his father and sister. On Artemisia's training in painting and her father as an inattentive teacher, see Patrizia Cavazzini, 'Artemisia in her Father's House', in Christiansen and Mann, *Orazio and Artemisia Gentileschi*, pp. 283–95.

20 Ibid.

21 For an English translation of the rape trial testimony, see Mary D. Garrard, *Artemisia Gentileschi: The Image of the Female Hero in Italian Baroque Art* (Princeton, NJ, 1989), app. B. For Artemisia's testimony, including this quote, see pp. 413–18. An Italian edition of the trial testimony is *Artemisia Gentileschi/Agostino Tassi: Atti di un processo per stupro*, ed. Eva Menzio (Milan, 1981).

22 See Edward Peters, *Torture* (Oxford, 1985), pp. 67–83, as cited
 by Elizabeth Cohen, 'No Longer Virgins: Self-presentation by
 Young Women in Late Renaissance Rome', in *Refiguring Woman:
 Perspectives on Gender and the Italian Renaissance*, ed. Marilyn Migiel
 and Juliana Schiesari (Ithaca, NY, and London, 1991), p. 191.
 The *sibille* torture to which Artemisia was subjected, cords
 tightened by strings around the fingers, was a comparatively
 minor form of torture at the time, and was used on Artemisia
 to support her testimony, not punish her. The experience
 prompted some wit under pressure. As the torture was
 administered in the presence of the accused, Agostino Tassi,
 Artemisia exclaimed 'this is the ring that you give me, and
 these are your promises!'
23 Garrard, *Artemisia Gentileschi*, p. 22. For more on this, and Orazio's
 supportive relationship with Tassi, see Cavazzini, 'Artemisia in her
 Father's House', pp. 285–6.
24 Patrizia Cavazzini, *Painting as a Business in Early Seventeenth-century
 Rome* (University Park, PA, 2008), pp. 41–2.
25 Babette Bohn, 'Patronizing *pittrici* in Early Modern Bologna',
 in *Bologna: Cultural Crossroads from the Medieval to Baroque*, ed. Gian
 Mario Anselm, Angelia De Benedictis and Nicholas Terpstra
 (Bologna, 2013), pp. 113–26; and Bohn's forthcoming book
 (University Park, PA, 2021), tentatively titled *Women Artists,
 Their Patrons, and Their Publics in Early Modern Bologna*.
26 Julia Vicioso, 'Costanza Francini: A Painter in the Shadow
 of Artemisia Gentileschi', in *Women Artists in Early Modern Italy:
 Careers, Fame, and Collectors*, ed. Sheila Barker (Turnhout, 2016),
 pp. 99–120.
27 Mary D. Garrard, 'Identifying Artemisia: The Archive and the
 Eye', in *Artemisia Gentileschi in a Changing Light*, ed. Sheila Barker
 (Turnhout, 2017), pp. 14–19.
28 Francesco Solinas, ed., with the collaboration of Michele Nicolaci
 and Yuri Primarosa, *Lettere di Artemisia: Edizione critica e annotate con
 quarantatre documenti inediti* (Rome, 2011), nos 3, 7 and 10, written
 between 1618 and 1620.
29 Garrard, *Artemisia Gentileschi*, no. 25, p. 398. See also nos 16, 17, 21
 and 24.

30 Sheila Barker, 'Artemisia's Money: The Entrepreneurship of a Woman Artist in Seventeenth-century Florence', in *Changing Light*, ed. Barker, p. 60 and n. 18.

31 Ibid., p. 71.

32 Ibid., pp. 69–70.

33 Ibid., pp. 80–81, n. 9.

34 The appellation of Suzanne G. Cusick, *Francesca Caccini at the Medici Court: Music and the Circulation of Power* (Chicago, IL, and London, 2009), p. 47. On the Florentine court under female rule, see Cusick, chap. 3; and Kelley Harness, *Echoes of Women's Voices: Music, Art, and Female Patronage in Early Modern Florence* (Chicago, IL, and London, 2006).

35 See Lisa Goldenberg Stoppato, 'Arcangela Paladini and the Medici', in *Women Artists*, ed. Barker, pp. 81–97; and Sheila Barker, '"Marvellously Gifted": Giovanna Garzoni's First Visit to the Medici Court', *Burlington Magazine*, CLX (2018), pp. 654–9.

36 Harness, *Echoes of Women's Voices*, pp. 53–6.

37 R. Ward Bissell, *Artemisia Gentileschi and the Authority of Art* (University Park, PA, 1999), p. 1.

38 Barker, 'Artemisia's Money', p. 62 and n. 47.

39 Harness (*Echoes of Women's Voices*, introduction) discusses forms of indirect patronage by female consorts in an era when male rulers typically signed the documents.

40 For Artemisia's lost Diana, see Bissell, *Artemisia Gentileschi*, cat. L-26, p. 363. On Marinella's *L'Enrico*, see Paola Malpezzi Price and Christine Ristaino, *Lucrezia Marinella and the 'Querelles des Femmes' in Seventeenth-century Italy* (Madison, WI, and Teaneck, NJ, 2008), chap. 4, pp. 80–104. Laurie Shannon, *Sovereign Amity: Figures of Friendship in Shakespearean Contexts* (Chicago, IL, and London, 2002), discusses Diana in English literature as a figure for female friendship and independence from males.

41 Bissell, *Artemisia Gentileschi*, cat. L-25, p. 363.

42 See Cox, *Women's Writing in Italy*, pp. 155–8, for dedications of writings to women; and pp. 185–7 for the five treatises published in Florence.

43 Cristofano Bronzini, *Della dignità e nobiltà delle donne* (Florence, 1625). Bronzini began writing the 22-volume treatise around 1614; the

first part was published in 1624–5, dedicated to Grand Duchess
Maria Maddalena. Two more parts, dedicated to Christine of
Lorraine, appeared in 1628 and 1632. See Sheila Barker, 'The
First Biography of Artemisia Gentileschi: Self-fashioning and
Proto-feminist Art History in Cristofano Bronzini's Notes on
Women Artists', *Mitteilungen des Kunsthistorischen Institutes*, 60 (2018),
pp. 404–35. Cusick, *Caccini*, pp. xix–xxi, discusses Bronzini's
treatise in its Florentine context.

44 Pamela Joseph Benson, *The Invention of the Renaissance Woman: The
Challenge of Female Independence in the Literature and Thought of Italy and
England* (University Park, PA, 1992), chap. 2, pp. 33–64.

45 Henricus Cornelius Agrippa, *Declamation on the Nobility and
Preeminence of the Female Sex*, trans. and ed. Albert Rabil, Jr (Chicago,
IL, and London, 1996), pp. 94–5. Lodovico Dolce, *Dialogo della
istitution delle donne* (Venice, 1547).

46 On such treatises by men, see Androniki Dialeti, 'The Publisher
Gabriel Giolito de' Ferrari, Female Readers, and the Debate about
Women in Sixteenth-century Italy', *Renaissance and Reformation /
Renaissance et Réforme*, n.s., XXVIII (2004), pp. 5–32; Wendy Heller,
Emblems of Eloquence: Opera and Women's Voice in Seventeenth-century Venice
(Berkeley, CA, Los Angeles, CA, and London, 2003), pp. 31–47;
and Ross, *Birth of Feminism*, pp. 95–111.

47 On male writers' dedications to women, see Dialeti, 'Gabriel
Giolito'; and for an analysis of differing modes of masculinity,
Dialeti, 'Defending Women, Negotiating Masculinity in Early
Modern Italy', *Historical Journal*, LIV (2011), pp. 1–23.

48 See Barker, 'The First Biography', n. 14, for pro-feminist male
writers cited by Bronzini; and n. 10 for Bronzini's identification
of Florentine families whose women produced pro-feminist texts.

49 Ibid., p. 411 and app. 22 for the Italian text of Bronzini's biography
of Fontana.

50 Ibid., pp. 413–17. Bronzini's biography of Artemisia appears in
the unpublished second half of the manuscript preserved in the
Biblioteca Nazionale Centrale di Firenze (ibid., p. 408).

51 For Marinella's visit to Bronzini, see Suzanne G. Cusick, *Francesca
Caccini at the Medici Court: Music and the Circulation of Power* (Chicago, IL,
and London, 2009), pp. xx and 340, n. 10.

52 Barker, 'Artemisia's Money', pp. 68–9.

53 Solinas, *Lettere*.

54 For a letter vilifying Artemisia and her husband, see ibid., no. 10, p. 34, n. 5; and Barker, 'Artemisia's Money', p. 69; another defaming letter is discussed in Chapter Two below.

55 See Garrard, *Artemisia Gentileschi*, no. 9, pp. 283–4.

56 Cusick (*Francesca Caccini*, pp. 66–71) thus characterizes Buonarroti's comedies *La Tancia*, *Il passatempo* and *La fiera*. For more on Buonarroti and his circle, see Janie Cole, *Music, Spectacle, and Cultural Brokerage in Early Modern Italy: Michelangelo Buonarroti il giovane* (Florence, 2011).

57 Letizia Panizzi, introduction to Marinella, *Nobility and Excellence*, pp. 7–8; and Ross, *Birth of Feminism*, pp. 203–5.

58 Solinas, *Lettere*, no. 29, p. 69.

59 Ibid., nos 12–15, 18 and 19.

60 Garrard, *Artemisia Gentileschi*, p. 63 and letter no. 13.

61 See Bissell, *Artemisia Gentileschi*, pp. 157–62, for details.

62 Solinas, *Lettere*, no. 33, pp. 75–6.

63 Bissell, *Artemisia Gentileschi*, fig. 99 and p. 39.

64 Vouet's portrait of Artemisia is discussed by Judith W. Mann, 'The Myth of Artemisia as Chameleon: A New Look at the London *Allegory of Painting*', in *Artemisia Gentileschi: Taking Stock*, ed. Mann (Turnhout, 2005), p. 69 and n. 7; and Garrard, 'Identifying Artemisia', pp. 11 and 33–4.

65 Consuelo Lollobrigida, 'Women Artists in Casa Barberini: Plautilla Bricci, Maddalena Corvini, Artemisia Gentileschi, Anna Maria Vaiani, and Virginia da Vezzo', in *Changing Light*, ed. Barker, pp. 119–30.

66 As quoted by David Freedberg, *The Eye of the Lynx: Galileo, his Friends, and the Beginnings of Modern Natural History* (Chicago, IL, 2002), pp. 75–6 and n. 42.

67 Cassiano described the queen's apartment in his diary; see Deborah Marrow, *The Art Patronage of Maria de' Medici* (Ann Arbor, MI, 1978), p. 18.

68 Katherine Crawford, *Perilous Performances: Gender and Regency in Early Modern France* (Cambridge, MA, and London, 2004), chap. 3, esp. pp. 84–9.

69 For the *femme forte* during Anne of Austria's regency, see Garrard, *Artemisia Gentileschi*, pp. 165–9; and Crawford, *Perilous Performances*, chap. 4.

70 Ian Maclean, *Woman Triumphant: Feminism in French Literature, 1610–1652* (Oxford, 1977), chaps 2 and 3. See also Lula McDowell Richardson, *The Forerunners of Feminism in French Literature of the Renaissance: From Christine de Pizan to Marie de Gournay* (Baltimore, MD, London and Paris, 1929).

71 Marie le Jars de Gournay, *L'Egalité des hommes et des femmes* (Paris, 1622). An English translation is Marie le Jars de Gournay, *Apology for the Woman Writing, and Other Works*, ed. and trans. Richard Hillman and Colette Quesnel (Chicago, IL, and London, 2002), pp. 69–95.

72 For Marie de' Medici as Minerva, see Maclean, *Woman Triumphant*, pp. 213–15 and pl. 6; and Marrow, *Art Patronage of Marie de' Medici*, pp. 57–8; and see Vouet's portrait of Anne of Austria as Minerva, in the Hermitage Museum, St Petersburg.

73 Garrard, *Artemisia Gentileschi*, no. 9, p. 384. For Philip IV of Spain, Artemisia painted a *Hercules and Omphale* (1627–9) and a *Birth of St John Baptist* (early 1630s). By 1635, she had sent a *Tarquin and Lucretia* to the Stuart court in England (see Chapter Seven).

74 On Artemisia's unidentified self-portrait for Cassiano and the prominence of women in his portrait collection, see Garrard, *Artemisia Gentileschi*, pp. 85–7.

75 See Garrard, 'Here's Looking at Me: Sofonisba Anguissola and the Problem of the Woman Artist', *Renaissance Quarterly*, XLVII/3 (1994), pp. 566–8; and Fredrika H. Jacobs, *Defining the Renaissance 'Virtuosa': Women Artists and the Language of Art History and Criticism* (Cambridge, 1997), esp. pp. 127–9. Bissell, *Artemisia Gentileschi*, p. 40, quotes generous samples of the 'effusive' praise by male writers of Artemisia's beauty.

76 This painting, which has suffered both overcleaning and overpainting, did not go unclaimed; it was owned by Niccolò Arrighetti, a Florentine friend of Michelangelo Buonarroti the Younger, which places him in a circle unusually receptive to iconoclastic art and independent women.

77 Pighetti's *Amoretto* and the anonymous poems are discussed in Chapter Five below; and by Bissell, *Artemisia Gentileschi*,

cat. L-1, pp. 355–6; and Jesse M. Locker, *Artemisia Gentileschi: The Language of Painting* (New Haven, CT, and London, 2015), pp. 45–50.

78 On this portrait and Artemisia's Venetian sojourn, see Bissell, *Artemisia Gentileschi*, pp. 36–41; and Locker, *Artemisia Gentileschi*, pp. 44–67.

79 Letizia Panizza, introduction to Arcangela Tarabotti, *Paternal Tyranny* (Chicago, IL, and London, 2004), trans. Letizia Panizza, p. 1.

80 Tarabotti, *Paternal Tyranny*, p. 66.

81 On Tarabotti's use of the convent *parlatorio* for wider communication, see Meredith Kennedy Ray, 'Letters from the Cloister: Defending the Literary Self in Arcangela Tarabotti's *Lettere familiari e di complimento*', *Italica*, LXXXI (2004), pp. 27–9; and Panizzi's introduction to Tarabotti, *Paternal Tyranny*, pp. 6–7.

82 For this debate, see ibid., pp. 16–21.

83 Arcangela Tarabotti, *Letters Familiar and Formal*, ed. and trans. Meredith K. Ray and Lynn Lara Westwater (Toronto, 2012), p. 101, n. 145. Another avenue of contact is that Arcangela's convent of St Anna was famous for the production of the *punto in aria* lace that appears in many of Artemisia's paintings (she is wearing it in the David portrait). Tarabotti brokered sale of the lace for the convent.

84 Locker (*Artemisia Gentileschi*, pp. 59–61) discusses the participation in the *Incogniti* of Artemisia and the women named above.

85 As characterized by Virginia Cox, *Women's Writing in Italy*, p. 183 and p. 351 n. 76. Also, Emilia Biga, *Una polemica antifemminista del '600: La Maschera scoperta di Angelico Aprosio* (Ventimiglia, 1989), pp. 28–9; and Nina Cannizzaro, 'Studies on Guido Casoni, 1561–1642, and Venetian Academies', PhD dissertation, Harvard University, 2001.

86 Wendy Heller, *Emblems of Eloquence*, p. 53. Heller's book is immensely useful on feminism and anti-feminism in early modern Venice, far beyond its nominal subject.

87 Loredan, 'In biasimo delle donne', in his *Bizzarrie*, II: 166; as quoted in English translation by Heller, *Emblems of Eloquence*, p. 56.

88 Solinas, *Lettere*, p. 13; and no. 14, p. 44 (Petrarch), no. 16, p. 28 (Ovid) and no. 25, p. 64 (Ariosto).

89 Ludovico Ariosto, *Orlando furioso* (Ferrara, 1516). On opposing
 uses of Ariosto's text, see Francesco Lucioli, 'L'*Orlando furioso* nel
 dibattito sulla donna in Italia in età moderna', *Italianistica: Rivista di
 letteratura italiana*, XLVII (2018), pp. 99–130.

90 Key analyses of *Orlando furioso* are by Benson (*Invention of the
 Renaissance Woman*, chap. 5, pp. 91–115); and Finucci (*The Lady
 Vanishes*, pp. 107–253).

91 A feminist reading of Tasso's poem is Marilyn Migiel, *Gender and
 Genealogy in Tasso's Gerusalemme Liberata* (Lewiston, NY, Queenston and
 Lampeter, 1993).

92 Letizia Panizza and Sharon Wood, eds, *A History of Women's Writing
 in Italy* (Cambridge, 2000); Cox, *Women's Writing in Italy*; Virginia
 Cox, *The Prodigious Muse: Women's Writing in Counter-Reformation Italy*
 (Baltimore, MD, 2011); and Virginia Cox, *Lyric Poetry by Women of the
 Italian Renaissance* (Baltimore, MD, 2013). The pro-female publisher
 Gabriel Giolito brought out the first all-woman anthology of
 poetry in 1559; see Dialeti, 'Gabriel Giolito'; and Diana Robin,
 *Publishing Women: Salons, the Presses, and the Counter-Reformation in
 Sixteenth-century Italy* (Chicago, IL, and London, 2007), p. xii.

93 Laura Terracina, *Discorso sopra tutti li primi canti d'Orlando furioso*
 (Venice, 1550). A valuable analysis is Deanna Shemek, 'Getting a
 Word in Edgewise: Laura Terracina's Discourse on the Orlando
 Furioso', in *Ladies Errant: Wayward Women and Social Order in Early
 Modern Italy* (Durham, NC, 1998), pp. 126–57.

94 Tullia d'Aragona, *Dialogue on the Infinity of Love* (*Dialogo della infinità di
 amore*, Venice, 1547), ed. and trans. Rinaldina Russell and Bruce
 Merry (Chicago, IL, and London, 1997).

95 D'Aragona, *Dialogue*, p. 69.

96 On the love dialogues, see Panizza and Wood, *History of Women's
 Writing*, pp. 66–9.

97 Veronica Franco, *Poems in Terza Rima* (1575), in *Veronica Franco: Poems
 and Selected Letters*, ed. and trans. Ann Rosalind Jones and Margaret
 F. Rosenthal (Chicago, IL, and London, 1998).

98 Franco, *Terza Rima*, capitolo 16, ll. 74–5 and 94–5, p. 165, in Jones
 and Rosenthal, *Veronica Franco*. See also Margaret F. Rosenthal, *The
 Honest Courtesan: Veronica Franco, Citizen and Writer in Sixteenth-century
 Venice* (Chicago, IL, 1992).

99 *Paternal Tyranny* was published posthumously in 1654, as *Innocence Betrayed*. On Loredan's role, see Panizzi's introduction to Tarabotti, *Paternal Tyranny*, pp. 13–15; and Ray, 'Letters from the Cloister'.

100 Locker, *Artemisia Gentileschi*, pp. 45–50, discusses the paintings by Artemisia eulogized in the anonymous poems, which scholars concur were probably written by Loredan.

101 This oddly popular little picture was similarly praised by another poet in the Loredano circle. See Locker, *Artemisia Gentileschi*, pp. 54–6, apps I and II.

102 Bissell, *Artemisia Gentileschi*, pp. 56–8.

103 Letter of 24 August 1630, Garrard, *Artemisia Gentileschi*, no. 2, pp. 377–8; and (for the duchess), no. 4, p. 378.

104 For the biographers, see Locker, *Artemisia Gentileschi*, p. 100.

105 In letters to Andrea Cioli (Garrard, *Artemisia Gentileschi*, nos 8, 10, 11, 12) and to Galileo (no. 9), she expresses a desire to return to Florence, 'my home city'. In letters to Cassiano dal Pozzo (nos 13 and 14), she reiterates her wish to return to Rome, 'my native city', to serve her 'friends and patrons'.

106 Ibid., nos 15a, 15b.

107 On Anna Colonna Barberini's patronage, see Marilyn R. Dunn, 'Spiritual Philanthropists: Women as Convent Patrons in Seicento Rome', in *Women and Art in Early Modern Europe: Patrons, Collectors and Connoisseurs*, ed. Cynthia Lawrence (University Park, PA, 1997), pp. 166–75.

108 In letters to Cassiano dal Pozzo (Garrard, *Artemisia Gentileschi*, nos 13 and 14, pp. 387–8), Artemisia states her plan to offer two pictures to the Barberini brothers. On these paintings, never delivered, see Richard E. Spear, 'Artemisia Gentileschi's "Christ and the Woman of Samaria"', *Burlington Magazine*, CLIII (2011), pp. 804–5.

109 For these examples, see Bissell, *Artemisia Gentileschi*, cat. 37, 48, L-102, and L-104. On the Italian market for sensual religious pictures, see Cavazzini, *Painting as a Business*, chap. 3, esp. pp. 88–95 and 115.

110 Letter of 13 November 1649 (Garrard, *Artemisia Gentileschi*, no. 24, pp. 396–7; Solinas, *Lettere*, no. 60, pp. 132–3). Artemisia's *Bath of Diana* was delivered to Ruffo in April 1650, but is now lost.

111 Artemisia's English period has been examined by Maria Cristina Terzaghi, 'Artemisia Gentileschi a Londra', in *Artemisia Gentileschi e il suo tempo*, exh. cat., Palazzo Braschi, Rome, 30 November 2016 – 7 May 2017 (Geneva and Milan, 2017), pp. 69–77.

112 Solinas, *Lettere*, no. 43, p. 104 (not in Garrard, *Artemisia Gentileschi*).

113 Garrard, *Artemisia Gentileschi*, no. 13, p. 387.

114 In a letter of 16 December 1639 (ibid., no. 15a), Artemisia mentions her brother's travel to Italy for 'Her Majesty the Queen, my mistress' [*mia signora*]. In the next sentence, she says, 'I did not take this decision [to leave] without the approval of Her Majesty and of the Queen Mother [*il consenso di questa Maestà et della Regina Madre mia Signora*]'. Solinas, *Lettere*, no. 51, p. 121, and n. 6.

115 See Katherine Usher Henderson and Barbara F. McManus, *Half Humankind: Contexts and Texts of the Controversy about Women in England, 1540–1640* (Urbana, IL, and Chicago, IL, 1985), pp. 11–20. Also, Joan Kelly, 'Early Feminist Theory', pp. 16–17.

116 Rachel Speght, *A Muzzle for Melastomus* (London, 1617); Ester Sowernam, *Ester Hath Hang'd Haman* (London, 1617); Constantia Munda, *The Worming of a Mad Dogge* (London, 1617).

117 Elizabeth Clarke, 'Anne Southwell and the Pamphlet Debate: The Politics of Gender, Class, and Manuscript', in *Debating Gender in Early Modern England, 1500–1700*, ed. Cristina Malcolmson and Mihoko Suzuki (Basingstoke, 2002), pp. 37–53; and Lisa J. Schnell, 'Muzzling the Competition: Rachel Speght and the Economics of Print', pp. 57–77 in the same volume.

118 As analysed by Schnell, 'Muzzling the Competition'.

119 The names combine the Latin feminine *Haec* ('this') with *Vir* ('man'), and *Hic* (masculine gender) with *Mulier* ('woman'). A useful discussion is Sandra Clark, '*Hic Mulier, Haec Vir,* and the Controversy over Masculine Women', *Studies in Philology*, LXXXII (1985), pp. 157–83.

120 See Schnell, 'Muzzling the Competition', pp. 64–8.

121 Mary Tattle-well and Ioane Hit-him-home, *The Women's Sharpe Revenge* (London, 1640), University of Michigan Library Digital Collections, quod.lib.umich.edu, pp. 115–16, accessed 24 May 2019.

122 Marinella, *Nobility and Excellence*, pp. 139–41; she is challenging Tasso's misogynist discourse, *Della virtù feminile e donnesca* (Venice, 1582).

123 Garrard, *Artemisia Gentileschi,* no. 15a, pp. 388–9.

124 Ibid., no. 17, p. 391.

125 Locker, *Artemisia Gentileschi,* pp. 184–6, describes Artemisia's circumstances and shortfall in patronage in her last years in Naples.

126 Dialeti, 'Gabriel Giolito', pp. 20–21, summarizes these developments.

127 Lucrezia Marinella, *Exhortations to Women and to Others if They Please* [1645], ed. and trans. Laura Benedetti (Toronto, 2012), pp. 80–98.

128 Ibid., p. 97.

129 Cox, *Women's Writing in Italy,* p. 227. Price and Ristaino (*Lucrezia Marinella and the 'Querelles des Femmes',* pp. 120–55) argue that Marinella coded ironic messages in her exhortations, appealing subversively to readers familiar with her earlier treatise and her humour. Ross, *Birth of Feminism,* pp. 296–8, supports this reading.

130 For the Potsdam *Lucretia* and Capodimonte *Judith,* two of three paintings Artemisia supplied to the Duke of Parma, see Bissell, *Artemisia Gentileschi,* cat. 48, pp. 281–7; and for the possibility that these are parodic works, see Garrard, *Artemisia Gentileschi,* pp. 131–5. For the Brno *Susanna* and the problematic late works, see Bissell, *Artemisia Gentileschi,* cat. 50, pp. 292–3.

131 Quoted by Sandra Clark, '*Hic Mulier*', p. 174.

132 Mihoko Suzuki, 'Elizabeth, Gender, and the Political Imaginary of Seventeenth-century England', in *Debating Gender,* ed. Malcolmson and Suzuki, pp. 231–53.

133 Hilda L. Smith, *Reason's Disciples: Seventeenth-century English Feminists* (Urbana, IL, Chicago, IL, and London, 1982), introduction. This short summary is indebted to Smith's classic study, especially chaps 3 and 4.

2 Sexuality and Sexual Violation: Susanna and Lucretia

1 In Roman law and thereafter, the crime of adultery existed solely to safeguard the honour of husbands and fathers. See Marina Graziosi, 'Women and Criminal Law: The Notion of Diminished Responsibility in Prospero Farinaccio (1544–1618) and Other

Renaissance Jurists', in *Women in Italian Renaissance Culture and Society*, ed. Letizia Panizza (Oxford, 2000), pp. 166–81. On the legal history of rape, see Susan Brownmiller, *Against Our Will: Men, Women and Rape* (New York, 1975).

2 Giuseppe Passi, *I donneschi difetti* (Venice, 1618), pp. 38–57.

3 Ibid., pp. 103–52.

4 Lucrezia Marinella, *The Nobility and Excellence of Women, and the Defects and Vices of Men*, ed. and trans. Anne Dunhill, intro. Letizia Panizza (Chicago, IL, 1999).

5 Arcangela Tarabotti, *Paternal Tyranny*, ed. and trans. Letizia Panizza (Chicago, IL, 2004) pp. 110–11.

6 Ibid., pp. 114–15.

7 Passi, *I donneschi difetti*, p. 322.

8 Tarabotti, *Paternal Tyranny*, p. 115. As Panizza notes, Daniel has conveniently been eliminated from the story.

9 See Mary D. Garrard, *Artemisia Gentileschi: The Image of the Female Hero in Italian Baroque Art* (Princeton, NJ, 1989), chap. 3, for examples. Patricia Simons argues that these erotically charged Susannas were consistent with the agenda of Catholic reform, presenting images of sinful acts viewers were encouraged to avoid ('Artemisia Gentileschi's *Susanna and the Elders* (1610) in the Context of Counter-Reformation Rome', in *Artemisia Gentileschi in a Changing Light*, ed. Sheila Barker (Turnhout, 2017), pp. 41–57.

10 Key literature on Artemisia's *Susanna* includes Garrard, *Artemisia Gentileschi*, chap. 3 (pp. 183–209); R. Ward Bissell, *Artemisia Gentileschi and the Authority of Art: Critical Reading and Catalogue Raisonné* (University Park, PA, 1999), pp. 2–10 and cat. 2 (pp. 187–9); and Keith Christiansen and Judith W. Mann, *Orazio and Artemisia Gentileschi: Father and Daughter Painters in Baroque Italy*, exh. cat., Museo del Palazzo di Venezia, Rome; Metropolitan Museum of Art, New York; and the Saint Louis (MO) Art Museum (New York, 2002), cat. 51 (pp. 296–9).

11 Moderata Fonte, *The Worth of Women, Wherein Is Clearly Revealed Their Nobility and Their Superiority to Men*, ed. and trans. Virginia Cox (Chicago, IL, and London, 1997).

12 Ibid., pp. 84–91.

13 Ibid., p. 90.

14 Tarabotti, *Paternal Tyranny*, pp. 54, 56.
15 This picture's intended viewer has been much debated. Elizabeth Cropper, 'Life on the Edge: Artemisia Gentileschi, Famous Woman Painter', in Christiansen and Mann, *Orazio and Artemisia Gentileschi*, pp. 272–6, discusses *Susanna* in the context of eroticized female nudes produced for a market.
16 See Virginia Cox, *Women's Writing in Italy, 1400–1650* (Baltimore, MD, 2008), pp. 2–8, on the social ranks of learned women in Renaissance Italy, most of whom were from the upper classes and received a humanistic education.
17 Guido Ruggiero, *The Boundaries of Eros: Sex Crime and Sexuality in Renaissance Venice* (New York and Oxford, 1985), p. 90.
18 For speculation about Orazio's motives, see Elizabeth S. Cohen, 'The Trials of Artemisia Gentileschi: A Rape as History', *Sixteenth Century Journal*, XXXI (2000), pp. 57–61. For the legal structures supporting honour culture, see *idem.*, 'No Longer Virgins: Self-presentation by Young Women in Late Renaissance Rome', in *Refiguring Woman: Perspectives on Gender and the Italian Renaissance*, ed. Marilyn Migiel and Juliana Schiesari (Ithaca, NY, and London, 1991), pp. 169–91.
19 For Tutia's quotation of Artemisia's words, see Garrard, *Artemisia Gentileschi*, p. 421; the consequences of the rape and trial for Artemisia, including Tutia's role, are discussed ibid., pp. 20–23.
20 Testimonies of Luca Penti and Mario Trotta (ibid., p. 480). Patrizia Cavazzini ('Artemisia in her Father's House', in Christiansen and Mann, *Orazio and Artemisia Gentileschi* (pp. 283–95), p. 286, n. 41) gives other examples.
21 On this rumour, see Christiansen and Mann, *Orazio and Artemisia Gentileschi*, p. 98.
22 Cohen, 'Trials of Artemisia Gentileschi', p. 68.
23 On legal stipulations about blood, resistance and promises, see Cohen, 'No Longer Virgins', p. 176.
24 Rachel A. Van Cleave, 'Sex, Lies, and Honor in Italian Rape Law', *Suffolk University Law Review*, XXXVIII (2005), p. 437.
25 Christiansen and Mann (*Orazio and Artemisia Gentileschi*, cat. 51, pp. 296–9) outline the issues the inscription has raised for scholars (technical analysis has confirmed its authenticity).

Orazio's hand in the *Susanna* is generally believed to have been minimal, but Christiansen makes a case for his participation (Keith Christiansen, 'Becoming Artemisia: Afterthoughts on the Gentileschi Exhibition', *Metropolitan Museum Journal*, XXXIX (2004), pp. 101–26).

26 Garrard, *Artemisia Gentileschi*, chap. 3.

27 Mary D. Garrard, *Artemisia Gentileschi around 1622: The Shaping and Reshaping of an Artistic Identity* (Berkeley, CA, Los Angeles, CA, and London, 2001), pp. 18–23.

28 Francesco Solinas, ed., with Michele Nicolaci and Yuri Primarosa, *Lettere di Artemisia: Edizione critica e annotate con quarantatre documenti inediti* (Paris, 2011), no. 10, p. 34.

29 Solinas, *Lettere*, no. 14, pp. 44–5; no. 23, pp. 62–3. See also Elizabeth S. Cohen, 'More Trials for Artemisia Gentileschi: Her Life, Love and Letters in 1620', in *Patronage, Gender and the Arts in Early Modern Italy: Essays in Honor of Carolyn Valone*, ed. Katherine A. McIver and Cynthia Stollhans (New York, 2015), pp. 260–61, 264–5. According to Sharon T. Strocchia ('Gender and the Rites of Honour in Italian Renaissance Cities', in *Gender and Society in Renaissance Italy*, ed. Judith C. Brown and Robert C. Davis (London and New York, 1998), p. 56), women in the period 'shouted the same sexual slurs against other women as did men'.

30 See Garrard, *Artemisia Gentileschi*, pp. 474, 480, for Tassi's self-serving descriptions of Artemisia as promiscuous; and pp. 206–7, for her similar characterization in later centuries.

31 Livy, I.57–8. See Ian Donaldson, *The Rapes of Lucretia: A Myth and Its Transformation* (Oxford, 1982); Stephanie Jed, *Chaste Thinking: The Rape of Lucretia and the Birth of Humanism* (Bloomington, IN, and Indianapolis, IN, 1989); Robert L. Herbert, *David, Voltaire, 'Brutus' and the French Revolution: An Essay in Art and Politics* (New York and London, 1972); Garrard, *Artemisia Gentileschi*, pp. 216–44; and Linda Hults, 'Dürer's "Lucretia": Speaking the Silence of Women', *Signs: Journal of Women in Culture and Society*, XVI (1991), pp. 205–37.

32 Giambattista Marino, *La galeria* (Venice, 1619), p. 266.

33 Christine de Pizan, *City of Ladies*, II.37.1.

34 Scholars earlier dated Artemisia's *Lucretia* in the 1620s, but X-rays made in 2002 indicated that the Etro painting might

be Artemisia's replica of a lost original of *c.* 1612–13 (Christiansen, 'Becoming Artemisia', pp. 109–11). Here I treat the Etro picture as a fair version of the original, and use the earlier date. On this painting, see Garrard, *Artemisia Gentileschi*, pp. 210–44; Bissell, *Artemisia Gentileschi*, cat. 3 (pp. 189–91); and Christiansen and Mann, *Orazio and Artemisia Gentileschi*, cat. 67 (pp. 361–4).

35 On the counselling of women to be silent, particularly onstage, see Wendy Heller, *Emblems of Eloquence: Opera and Women's Voices in Eighteenth-century Venice* (Berkeley, CA, Los Angeles, CA, and London, 2003), pp. 45–7. For literature on the suppression of women's speech in the Renaissance, see Virginia Cox, 'Gender and Eloquence in Ercole de' Roberti's *Portia and Brutus*', *Renaissance Quarterly*, LXII (2009), pp. 61–101 and n. 72.

36 See Garrard, *Artemisia Gentileschi*, chap. 4, for examples of these types.

37 For these, see Cohen, 'No Longer Virgins'.

38 Garrard, *Artemisia Gentileschi*, pp. 228–31.

39 Laura Cereta, *Collected Letters of a Renaissance Feminist*, trans. and ed. Diana Robin (Chicago, IL, 1997), no. XVII to Pietro Zecchi, pp. 70–71. See also Robin's introductory remarks, ibid., pp. 11 and 64–5; and Diana Robin, 'Humanism and Feminism in Laura Cereta's Public Letters', in *Women in Italian Renaissance Culture and Society* (Oxford, 2000), ed. Letizia Panizza, pp. 368–84.

40 Robin in Cereta, *Letters*, p. 65.

41 Tarabotti, *Paternal Tyranny*, pp. 115–16.

42 Cereta, *Letters*, p. 66.

43 On Penelope, see Giovanni Boccaccio, *Famous Women*, trans. Virginia Brown (Cambridge, MA, and London, 2003), chap. XL, pp. 78–81; and Cereta, *Letters*, 66–7.

44 Pamela Joseph Benson (*The Invention of the Renaissance Woman: The Challenge of Female Independence in the Literature and Thought of Italy and England* (University Park, PA, 1992), pp. 9–31) emphasizes this point, while acknowledging Boccaccio's occasionally 'sensitive and profeminist voice'.

45 Cereta, *Letters*, no. XVIII, pp. 75–6.

46 Ibid., p. 75.

3 The Fictive Self: Musicians and Magdalenes

1 A Medici inventory of 1638 names a 'portrait of Artemisia playing
 a lute painted by her own hand'. See Keith Christiansen and
 Judith W. Mann, *Orazio and Artemisia Gentileschi: Father and Daughter
 Painters in Baroque Italy*, exh. cat., Museo del Palazzo di Venezia,
 Rome; Metropolitan Museum of Art, New York; and the Saint
 Louis (MO) Art Museum (New York, 2002), cat 57, pp. 322–5.

2 Jesse M. Locker, *Artemisia Gentileschi: The Language of Painting* (New
 Haven, CT, and London, 2015), pp. 136–42, including the
 prostitute identification. On Artemisia's limited musical exposure,
 see Linda Phyllis Austern, 'Portrait of the Artist as (Female)
 Musician', in *Musical Voices of Early Modern Women*, ed. Thomasin
 Lamay (Aldershot, 2005), pp. 47–53.

3 Judith Mann (in Christiansen and Mann, *Orazio and Artemisia
 Gentileschi*) proposed that Artemisia presents herself in costume
 playing a role; Locker (*Artemisia Gentileschi*, pp. 136–42) connected
 the portrait with Caccini's *Ballo*. The four performers named
 in a court diarist's account were Caccini, her stepmother, an
 unidentified 'Laura' and an 'Artemisia', who, by a process of
 elimination, was most likely Artemisia Gentileschi. Mary D.
 Garrard, *Artemisia Gentileschi: The Image of the Female Hero in Italian
 Baroque Art* (Princeton, NJ, 1989), pp. 37 and 497, n. 51; Locker,
 Artemisia Gentileschi, p. 211, n. 33.

4 Laura Cereta, *Collected Letters of a Renaissance Feminist*, ed. and trans.
 Diana Robin (Chicago, IL, and London, 1997), p. 84.

5 Moderata Fonte, *The Worth of Women, Wherein Is Clearly Revealed
 Their Nobility and Their Superiority to Men*, ed. and trans. Virginia Cox
 (Chicago, IL, and London, 1997), pp. 234–6; quote from p. 235.

6 Judith Butler, *Gender Trouble: Feminism and the Subversion of Identity*
 (New York and London, 1990).

7 The Neapolitan poet Girolamo Fontanella; see Locker, *Artemisia
 Gentileschi*, pp. 140–42.

8 For the painted copy in Casa Buonarroti, see Ernst Steinmann,
 Die Portraitdarstellungen des Michelangelo (Leipzig, 1913), pp. 19–20
 and pl. 5; and for the ink drawing here illustrated, ibid., pp. 17–18
 and pl. 2. For these and other images of turban-wearing artists,

see Mary D. Garrard, 'Michelangelo in Love: Decoding the Children's Bacchanal', *Art Bulletin*, XCVI (2014), p. 32 and p. 47, n. 74.

9 On the Renaissance idea of the artist as *magus*, see Frances A. Yates, *Giordano Bruno and the Hermetic Tradition* (London, 1964).

10 For arguments supporting its attribution to Artemisia, see Christiansen and Mann, *Orazio and Artemisia Gentileschi* cat. 56, pp. 320–21. For arguments against the attribution, see Mary D. Garrard, 'Artemisia's Hand', in *Reclaiming Female Agency*, ed. Norma Broude and Mary D. Garrard (Berkeley, CA, Los Angeles, CA, and London, 2005), pp. 67–8.

11 Because the *St Catherine* has lost a few centimetres at the top (the full halo would surely have been included), its original height was probably close to that of the *Lute Player*.

12 Garrard, *Artemisia Gentileschi*, p. 48; Locker, *Artemisia Gentileschi*, p. 134.

13 'I segreti di Artemisia Gentileschi: un autoritratto dietro Santa Caterina', www.intoscana.it, accessed 3 April 2019.

14 The Uffizi *St Catherine of Alexandria* was likely commissioned for the grand duke's sister, Catherine de' Medici (Garrard, *Artemisia Gentileschi*, pp. 499–500).

15 Francesco Solinas, ed., with the collaboration of Michele Nicolaci and Yuri Primarosa, *Lettere di Artemisia: edizione critica e annotate con quarantatre documenti inediti* (Rome, 2011).

16 The ballet was performed at Palazzo Pitti on 24 February 1615, for the marriage of Sofia Binesta, *dama* of Maria Maddalena. Suzanne G. Cusick, *Francesca Caccini at the Medici Court: Music and the Circulation of Power* (Chicago, IL, and London, 2009), pp. 297–8.

17 Gianni Papi, review of R. Ward Bissell, 'Artemisia Gentileschi and the Authority of Art', *Burlington Magazine*, CXLII (2000), pp. 450–53, gives the inventory entry for Artemisia's Amazonian self-portrait. See Cusick, *Francesca Caccini*, pp. 194–8, on Maria Maddalena as a virile female ruler, and for descriptions of her that evoke Amazons.

18 Sheila Barker, with Tessa Gurney, 'House Left, House Right: A Florentine Account of Marie de Medici's 1615 *Ballet de Madame*', *Society for Court Studies*, XX (2015), pp. 151–3.

19 Tinghi's account is cited by Locker (*Artemisia Gentileschi*, pp. 139–40), who noted the connection of the metal-laced fabrics with Artemisia's *Lute Player*.

20 Sheila Barker, 'Artemisia's Money: The Entrepreneurship of a Woman Artist in Seventeenth-century Florence,' in *Artemisia Gentileschi in a Changing Light*, ed. Sheila Barker (Turnhout, 2017), pp. 64–6.

21 Kelley Harness, *Echoes of Women's Voices: Music, Art, and Female Patronage in Early Modern Florence* (Chicago, IL, and London, 2006), pp. 62–4, cites Elizabeth I of England, among other female rulers who 'made virginity central to their self-fashioning'.

22 Cusick, *Francesca Caccini*, pp. 128–37; see also Ann Suter, ed., *Lament: Studies in the Ancient Mediterranean and Beyond* (Oxford, 2008).

23 Cusick, *Francesca Caccini*, pp. 133, 136–7.

24 Ibid., pp. 215–16.

25 Valeria Finucci, introduction to Moderata Fonte, *Floridoro: A Chivalric Romance*, ed. Valeria Finucci, trans. Julia Kisacky (Chicago, IL, 2006). Also, Meredith K. Ray, *Daughters of Alchemy: Women and Scientific Culture in Early Modern Italy* (Cambridge, MA, 2015), esp. pp. 78–83.

26 Virginia Woolf, *Orlando: A Biography*, first published in 1928.

27 The picture is signed 'Artimisia Lomi', the name she used in Florence. The inscriptions on the chair and mirror may have been added by a calligrapher, probably at the time the picture was painted.

28 See Garrard, *Artemisia Gentileschi*, pp. 45–8; and R. Ward Bissell, *Artemisia Gentileschi and the Authority of Art* (University Park, PA, 1999), cat. 10 and pp. 26–31; also Christiansen and Mann, *Orazio and Artemisia Gentileschi*, cat. 58, pp. 325–8.

29 Emily Wilbourne, 'A Question of Character: Artemisia Gentileschi and Virginia Ramponi Andreini', *Italian Studies*, LXXI (2016), pp. 335–55, doi.org/10.1080/00751634.2016.1189254, accessed 24 May 2019.

30 Ibid., pp. 347–8.

31 For Fetti's image of Andreini in Monteverdi's *L'Arianna*, see ibid., fig. 2. Artemisia and Andreini moved in overlapping circles; for example, Artemisia's friend Cristofano Allori painted portraits of both Virginia Andreini and Francesca Caccini (for Andreini's portrait, see Wilbourne, 'Question of Character', p. 347; for Caccini's, see n. 38 below). Wilbourne's case for the Seville

Magdalene is plausible, but she argues unconvincingly that Andreini also modelled for Artemisia's Pitti *Magdalene* and Detroit *Judith*.

32 Quoted by Wilbourne, 'Question of Character', pp. 345–6.

33 The Seville *Magdalene* was purchased from Artemisia in Rome in 1625–6 by Fernando Afán de Ribera, Duke of Alcalá. See Bissell, *Artemisia Gentileschi*, cat. 16, pp. 222–4; Mary D. Garrard, *Artemisia Gentileschi around 1622: The Shaping and Reshaping of an Artistic Identity* (Berkeley, CA, Los Angeles, CA, and London, 2001), pp. 25–35; and Christiansen and Mann, *Orazio and Artemisia Gentileschi*, cat. 68, pp. 365–6. The picture was probably in Artemisia's Florentine studio in 1620 (two Magdalenes of this size are inventoried, one just begun; see Christiansen and Mann, app. 3, pp. 446–7), and is likely the Magdalene sent to Artemisia in Rome the same year (Solinas, *Lettere*, no. 13, p. 40).

34 See Garrard, *Artemisia Gentileschi around 1622*, fig. 22, for the Michelangelo print, and chap. 1 for this interpretation of the painting.

35 Wilbourne, 'Question of Character', p. 349.

36 Ibid., p. 340.

37 In G. B. Andreini's own Magdalene play of 1617, three of five acts are devoted to the saint's lascivious early life. 'Giovan Battista Andreini', in *Dizionario biografico degli Italiani*. For the Magdalene in Fonte and Marinella's poetry, see Paola Malpezzi Price and Christine Ristaino, *Lucrezia Marinella and the 'Querelles des Femmes' in Seventeenth-century Italy* (Madison, WI, and Teaneck, NJ, 2008), pp. 65–74; and Virginia Cox, *The Prodigious Muse: Women's Writing in Counter-Reformation Italy* (Baltimore, MD, 2011), pp. 134–7.

38 No authenticated portraits of Caccini survive. Cristofano Allori painted a portrait of her, unfinished at his death (Cusick, *Francesca Caccini*, p. 339, n. 3). Lisa Goldenberg Stoppato has tentatively identified this work with an unfinished portrait miniature in the Uffizi, which does not particularly resemble the Spada lute player, but neither face is very specific. Stoppato, 'Le "musiche" delle granduchesse e i loro ritratti', in *Con dolce forza: Donne nell'universo musicale del Cinque e Seicento*, ed. Laura Donati, exh. cat., Oratorio di Santa Caterina delle Ruote, Bagno a Ripoli (Florence, 2018), fig. 2; cat. 4, p. 103; and pp. 46–50.

39 The Pirrey engraving is the frontispiece of a collection of poetry
 celebrating Basile. It was first published in Venice, where the
 singer resided in 1623–4, and republished in Naples in 1628. See
 Locker, *Artemisia Gentileschi*, pp. 106–7.

40 For Fontanella's poem of 1640, see *Parnaso Italiano Repertorio della poesia
 italiana del Cinquecento e del Seicento*, www.poesialirica.it, no. 80 in the
 Fontanella file labeled 'Cielo del Sole', accessed 24 May 2019.

41 See Cusick, *Francesca Caccini*, p. 63, and p. 343, n. 18.

42 For discussions of this new *Magdalene*, see *Changing Light*, ed.
 Barker, with essays by Mary Garrard ('Identifying Artemisia:
 The Archive and the Eye' (pp. 11–40), pp. 16–17); Gianni Papi
 ('*Mary Magdalene in Ecstasy* and the *Madonna of the Svezzamento*: Two
 Masterpieces by Artemisia' (pp. 147–66), pp. 147–9); Judith W.
 Mann ('Deciphering Artemisia: Three New Narratives and How
 They Expand Our Understanding' (pp. 149–81), pp. 167–8);
 and Christina Currie et al. ('*Mary Magdalene in Ecstasy* by Artemisia
 Gentileschi: A Technical Study', pp. 217–35).

43 A connection made by Gianni Papi, who notes that the statue was
 earlier known as a Cleopatra ('*Mary Magdalene in Ecstasy*', p. 149).

44 Caravaggio's lost *Magdalene* painted for Scipione Borghese is known
 from numerous replicas. See Garrard, 'Identifying Artemisia', p. 17,
 fig. 7; and Papi, '*Mary Magdalene in Ecstasy*', p. 150, fig. 7.

45 Artemisia consciously chose not to eroticize this Magdalene, for
 conservation revealed that the figure's breasts were originally
 more exposed and swelling; at a late stage, she revised the passage
 towards modesty and decorum (Currie et al., '*Mary Magdalene in
 Ecstasy*', pp. 226–7).

46 Cristoforo Bronzini, *Della dignità e nobilità delle donne* (1525), quoted
 in English by Cusick, *Francesca Caccini*, pp. 62–3, and more fully
 in Italian, app. C, pp. 332–3, where he ascribes the three modes'
 differing characteristics to Grand Duchess Maria Maddalena.

47 I here merge characterizations of the different modes as given by
 Guido of Arezzo (995–1050), Adam of Fulda (1445–1505) and
 Juan de Espinosa Medrano (1632–1688). See 'Mode (music)',
 Wikipedia, en.wikipedia.org, accessed 24 May 2019.

48 See Garrard, *Artemisia Gentileschi around 1622*, pp. 1–23.

4 Women and Political Power: Judith

1 Moderata Fonte, *The Worth of Women, Wherein Is Clearly Revealed Their Nobility and Their Superiority to Men*, ed. and trans. Virginia Cox (Chicago, IL, and London, 1997), pp. 101–3.

2 Christine de Pizan, *The Book of the City of Ladies* [1405], trans. Earl Jeffrey Richards (New York, 1982); trans. Rosalind Brown-Grant (London and New York, 1999), on Judith and Esther, II.31.1 and II.32.1; Semiramis, 1.15.1–2; Thamiris, 1.17.2; and Zenobia, 1.20.1.

3 Arcangela Tarabotti, *Paternal Tyranny*, ed. and trans. Letizia Panizza (Chicago, IL, 2004), pp. 140–41.

4 See Frank Capozzi, 'The Evolution and Transformation of the Judith and Holofernes Theme in Italian Drama and Art before 1627', PhD thesis, University of Wisconsin–Madison, 1975; and Elena Ciletti, 'Patriarchal Ideology in the Renaissance Iconography of Judith', in *Refiguring Woman: Perspectives on Gender and the Italian Renaissance*, ed. Marilyn Migiel and Juliana Schiesari (Ithaca, NY, and London, 1991), pp. 35–70. Also see Mary D. Garrard, *Artemisia Gentileschi: The Image of the Female Hero in Italian Baroque Art* (Princeton, NJ, 1989), chap. 5.

5 Ciletti, 'Patriarchal Ideology', pp. 46–52.

6 Allison Levy, *Widowhood and Visual Culture in Early Modern Europe* (Aldershot, 2003).

7 Giovanni Boccaccio, *Famous Women*, trans. Virginia Brown (Cambridge, MA, and London, 2003), chap. II (Semiramis) and chap. XLIX (Thamiris).

8 Dante, *Inferno*, canto 5, ll. 58–60; Giuseppe Passi, *I donneschi difetti* (Venice, 1599), p. 48.

9 For Renaissance views on Amazons, see Margaret L. King, *Women of the Renaissance* (Chicago, IL, and London, 1991), pp. 188–93. For the woman warrior in early modern literature, see Valeria Finucci, 'Un-dressing the Warrior / Re-dressing the Woman: The Education of Bradamante', in Finucci, *The Lady Vanishes: Subjectivity and Representation in Castiglione and Ariosto* (Stanford, CA, 1992), chap. 8, pp. 227–53.

10 Marina Warner, *Joan of Arc: The Image of Female Heroism* (Berkeley and Los Angeles, CA, 1981), pp. 200–201.

11 Charity Cannon Willard, *Christine de Pizan: Her Life and Works* (New York, 1984), pp. 204–7.

12 As noted by Virginia Brilliant, in *Dangerous Women*, exh. cat., Patricia and Philip Frost Art Museum, Florida International University; and Cornell Fine Arts Museum, Rollins College (New York and London, 2018), p. 52.

13 Margarita Stocker, *Judith, Sexual Warrior: Women and Power in Western Culture* (New Haven, CT, and London, 1998), pp. 17, 22–3.

14 Ibid., pp. 61–5, 71–6; and Aidan Norrie, 'Elizabeth I as Judith: Reassessing the Apocryphal Widow's Appearance in Elizabethan Royal Iconography', *Renaissance Studies*, XXXI/5 (2017), pp. 707–22.

15 *The Book of Judith*, original Greek with English trans. by Morton S. Enslin and Solomon Zeitlin (Leiden, 1972), p. 121.

16 Natalie Tomas, *The Medici Women: Gender and Power in Renaissance Florence* (Aldershot and Burlington VT, 2003), p. 164.

17 See Garrard, *Artemisia Gentileschi*, pp. 291–5, on the conflicting psychological messages of Judith's story and masculine ambivalence about her character.

18 Sarah Blake McHam, 'Donatello's Bronze "David" and "Judith" as Metaphors of Medici Rule in Florence', *Art Bulletin*, LXXXIII (2001), pp. 32–47; Adrian Randolph, *Engaging Symbols: Gender, Politics, and Public Art in Fifteenth-century Florence* (New Haven, CT, and London, 2002), chap. 6; John T. Paoletti, *Michelangelo's David: Florentine History and Civic Identity* (Cambridge, 2015), pp. 39–50; and Mary D. Garrard, 'The Cloister and the Square: Gender Dynamics in Renaissance Florence', *Early Modern Women: An Interdisciplinary Journal*, XI (2016), pp. 18–23.

19 The original base with inscriptions is lost, but the texts are preserved. H. W. Janson, *The Sculpture of Donatello* (Princeton, NJ, 1963), p. 198.

20 Capozzi, 'Judith', pp. 21–5; Ciletti, 'Patriarchal Ideology', pp. 58–60. On Judith's identity in fourteenth-century Tuscany, see Sarah Blake McHam, 'Donatello's *Judith* as the Emblem of God's Chosen People', in *The Sword of Judith: Judith Studies across the Disciplines*, ed. Kevin R. Brine, Elena Ciletti and Henrike Lähnemann (Cambridge, 2010), pp. 307–24.

21 For the patristic description of Judith's 'manly exploits' and later life of the topos, see Capozzi, 'Judith', p. 13, and Ciletti, 'Patriarchal Ideology', p. 63.

22 Kelley Harness, *Echoes of Women's Voices: Music, Art, and Female Patronage in Early Modern Florence* (Chicago, IL, and London, 2006), p. 114.

23 'The Story of Judith, Hebrew Widow', in Lucrezia Tornabuoni de' Medici, *Sacred Narratives*, ed., trans. and intro. Jane Tylus (Chicago, IL, 2001), pp. 118–62. Also see Stefanie Solum, *Women, Patronage, and Salvation in Renaissance Florence: Lucrezia Tornabuoni and the Chapel of the Medici Palace* (Farnham, 2015).

24 Tylus, introduction to Tornabuoni, *Sacred Narratives*, p. 47.

25 On the latter statues, see Yael Even, 'The Loggia dei Lanzi: A Showcase of Female Subjugation', in *The Expanding Discourse: Feminism and Art History*, ed. Norma Broude and Mary D. Garrard (New York, 1992), pp. 127–37; and Margaret D. Carroll, 'The Erotics of Absolutism: Rubens and the Mystification of Sexual Violence', ibid., pp. 139–59.

26 As Capozzi points out ('Judith', pp. 31–6), Judith's earlier political meanings were replaced in the sixteenth century by a religious emphasis, especially in *sacre rappresentazioni* performed in public spaces.

27 On Allori's painting, begun in 1612, see John Shearman, 'Cristofano Allori's "Judith"', *Burlington Magazine*, CXXI (1979), pp. 3–10; Keith Christiansen, 'Becoming Artemisia: Afterthoughts on the Gentileschi Exhibition', *Metropolitan Museum Journal*, XXXIX (2004), pp. 115–16; and Garrard, *Artemisia Gentileschi*, pp. 299–300, figs 262 and 263.

28 The Naples *Judith* was painted just before or soon after Artemisia's arrival in Florence in 1613. Its composition has been altered by reduction on the left and top, and Judith's face has suffered significant overpainting. See Garrard, *Artemisia Gentileschi*, pp. 307–13, for discussion and an X-ray; R. Ward Bissell, *Artemisia Gentileschi and the Authority of Art* (University Park, PA, 1999), cat. 4, pp. 191–8; and Keith Christiansen and Judith W. Mann, *Orazio and Artemisia Gentileschi: Father and Daughter Painters in Baroque Italy*, exh. cat., Museo del Palazzo di Venezia, Rome; Metropolitan Museum of Art, New York; and the Saint Louis (MO) Art Museum (New York, 2002),

cat. 55, pp. 308–11. For the Uffizi version, see Bissell, *Artemisia
Gentileschi*, cat. 12, pp. 213–16; Garrard, *Artemisia Gentileschi*, pp. 321–7;
and Christiansen and Mann, *Orazio and Artemisia Gentileschi*, cat. 62,
pp. 347–50.

29 For discussion of both viewpoints, see Richard Spear, 'Artemisia
 Gentileschi: Ten Years of Fact and Fiction', *Art Bulletin*, LXXXII
 (2000), pp. 568–79.

30 These two notices are cited in Christiansen and Mann, *Orazio and
 Artemisia Gentileschi*, p. 348.

31 Pliny, *Natural History*, XXXIV.17; Leon Battista Alberti, *On the Art of
 Building in Ten Books*, trans. Joseph Rykwert, Neil Leach and Robert
 Tavernor (Cambridge, MA, and London, 1988), p. 240.

32 Boccaccio, *Famous Women*, chap. XXXII, pp. 64–5.

33 Veronica Franco, *Poems and Selected Letters*, ed. and trans. Ann Rosalind
 Jones and Margaret F. Rosenthal (Chicago, IL, 1998), Capitolo 16,
 pp. 160–63; and editors' introduction, pp. 18–19.

34 Lucrezia Marinella, *The Nobility and Excellence of Women, and the Defects
 and Vices of Men*, ed. and trans. Anne Dunhill, intro. Letizia Panizza
 (Chicago, IL, 1999), pp. 79–80.

35 Fonte, *Worth of Women*, p. 100, and Cox's notes 65 and 66 for an
 overview of the issue of women's fitness for combat in Renaissance
 discourse.

36 Virginia Brown, preface to Boccaccio, *Famous Women*, p. 4. Pamela
 Joseph Benson discusses Boccaccio's shifting positions on women's
 strengths and weaknesses in *The Invention of the Renaissance Woman:
 The Challenge of Female Independence in the Literature and Thought of Italy and
 England* (University Park, PA, 1992), pp. 14–23.

37 Benson, *Invention of the Renaissance Woman*, pp. 45–64; and Margaret
 Franklin, *Boccaccio's Heroines: Power and Virtue in Renaissance Society*
 (Aldershot, 2006), pp. 120–26.

38 Baldasar Castiglione, *The Book of the Courtier*, trans. Charles S.
 Singleton (Garden City, NY, 1959), book 3.

39 Carole Levin, *'The Heart and Stomach of a King': Elizabeth I and the Politics
 of Sex and Power* (Philadelphia, PA, 1994), chap. 6.

40 Giulio Cesare Capaccio, *Il Principe* (Venice, 1620), p. 122; quoted
 in Italian by Consuelo Lollabrigida, 'Women Artists in Casa
 Barberini', in *Artemisia Gentileschi in a Changing Light*, ed. Sheila Barker

(Turnhout, 2017), p. 144. For the ongoing debate about women in politics, see Sharon Jansen, *The Monstrous Regiment of Women: Female Rulers in Early Modern Europe* (Basingstoke, 2002); and Carole Levin and Alicia Meyer, 'Women and Political Power in Early Modern Europe', in *The Ashgate Research Companion to Women and Gender in Early Modern Europe*, ed. Allyson M. Poska, Jane Couchman and Katherine A. McIver (London and New York, 2013), pp. 336–53. Natalie Tomas (*The Medici Women*, chap. 6) discusses Florentine views on the unnaturalness of female rule.

41 Julia Vicioso points to Artemisia's friendship with Costanza Francini and suggests that their shared victimization by Agostino Tassi might have led Artemisia to invent a role for Abra. Julia Vicioso, 'Costanza Francini: A Painter in the Shadow of Artemisia Gentileschi', in *Women Artists in Early Modern Italy: Careers, Fame, and Collectors*, ed. Sheila Barker (Turnhout, 2016), pp. 99–120.

42 Defending herself against insults by Maffio Venier, Franco writes: 'And I undertake to defend all women / against you, who despise them so / that rightly I'm not alone to protest' (Franco, *Poems and Selected Letters*, Capitolo 16, lines 79–81). See Jones and Rosenthal, editors' introduction, ibid., pp. 17–19.

43 E.g., novels by Anna Banti (1947), Alexandra Lapierre (1998) and Susan Vreeland (2002); plays by Sally Clark (1994) and Olga Humphrey (1997); films by Agnès Merlet (1998), Ellen Weissbrod (2010) and Bettina Hatami (2011); television programmes both fictional and documentary; folk-rock songs (Linda M. Smith, 2006); a music video (Bett Butler, 2017), the naming of a Chicago art gallery (Artemisia), and innumerable paintings, theses and dissertations inspired by Artemisia's art and career.

44 Garrard, *Artemisia Gentileschi*, pp. 326–7, with comparative images.

45 On the Pitti *Judith*, see ibid., pp. 313–20; Bissell, *Artemisia Gentileschi*, cat. 5, pp. 198–203; and Christiansen and Mann, *Orazio and Artemisia Gentileschi*, cat. 60, pp. 330–33.

46 Some scholars (see Christiansen and Mann, *Orazio and Artemisia Gentileschi*, cat. 13, pp. 82–6) consider the Pitti painting's composition to be derived from two similar *Judith*s, one by Orazio Gentileschi and another dubiously ascribed to Orazio. In my opinion, both paintings postdate Artemisia's version.

47　On Donatello's statue as a patriarchal civic guardian, see Patricia Simons, 'Separating the Men from the Boys: Masculinities in Early Quattrocento Florence and Donatello's *Saint George*', in *Rituals, Images, and Words: Varieties of Cultural Expression in Late Medieval and Early Modern Europe*, ed. F. W. Kent and Charles Zika (Turnhout, 2005), pp. 147–76.

48　For a detail of the image on this brooch, see Garrard, *Artemisia Gentileschi*, fig. 285, p. 319.

49　Harness, *Echoes of Women's Voices*, chap. 4, esp. pp. 123–36.

50　Ibid., pp. 111–13. Salvadore claimed that the opera improves on negative depictions of women, offering a new vision of women that is the glory of Tuscany (ibid., pp. 130–31).

51　Harness records other easel pictures at Villa Imperiale, including a Judith by Rutilio Manetti. Ibid., p. 123, n. 48, and p. 125, n. 52.

52　More precisely, it's a tiara, which is also worn by queens and royalty. For discussion of the Detroit picture, see Garrard, *Artemisia Gentileschi*, pp. 328–36; Bissell, *Artemisia Gentileschi*, cat. 14, pp. 219–20; Christiansen and Mann, *Orazio and Artemisia Gentileschi*, cat. 69, pp. 368–70.

53　The medallion is labelled 'MAUSOLEION'; for a detail view, see Jesse M. Locker, *Artemisia Gentileschi: The Language of Painting* (New Haven, CT, and London, 2015), p. 129, fig. 5.3. For Artemisia's identification with Artemisia II of Caria, see Garrard, 'Identifying Artemisia: The Archive and the Eye', in *Changing Light*, ed. Barker, pp. 33–4.

54　Cristofano Bronzini, *Della dignità e nobiltà delle donne* (Florence, 1624), pp. 34–85. For Palmira/Prudentia's alternating names, see Bissell, *Artemisia Gentileschi*, pp. 157–62; and for the possibility that Artemisia called her daughter Palmira after Zenobia of Palmyra, see Garrard, 'Identifying Artemisia', p. 33.

55　For these cycles, see Deborah Marrow, *The Art Patronage of Maria de' Medici* (Ann Arbor, MI, 1982), pp. 65–8.

56　Sheila ffolliott, 'Catherine de' Medici as Artemisia: Figuring the Powerful Widow', in *Rewriting the Renaissance: The Discourses of Sexual Difference in Early Modern Europe*, ed. Margaret W. Ferguson, Maureen Quilligan and Nancy J. Vickers (Chicago, IL, and London, 1986), pp. 227–41. On the *femmes fortes* and Marie de' Medici's Luxembourg cycle, see Chapter One above.

57 Boccaccio, *Famous Women*, chap. LVII, pp. 64–5.

59 Letter of 13 November 1649, Garrard, *Artemisia Gentileschi*, no. 24, pp. 396–7.

59 On the trope of a male spirit in a female body, see Benson, *Invention of the Renaissance Woman*, pp. 5, 13, 21–2.

60 Letter of 13 March 1649, Garrard, *Artemisia Gentileschi*, no. 17, pp. 391–2.

61 Roger Crum described this as the 'redomestication of Judith'; see Crum, 'Judith between the Private and Public Realms in Renaissance Florence', in *The Sword of Judith*, ed. Brine, Ciletti and Lähnemann, pp. 291–306.

62 Letter of 7 August 1649, Garrard, *Artemisia Gentileschi*, no. 21, pp. 394–5.

5 Battle of the Sexes: Women on Top

1 Tamar Kadari, 'Jael Wife of Heber the Kenite: Midrash and Aggadah', *Jewish Women's Archive: Encyclopedia*, https://jwa.org/encyclopedia/article/jael-wife-of-heber-kenite-midrash-and-aggadah; accessed 22 November 2017. Also, Colleen M. Conway, *Sex and Slaughter in the Tent of Jael: A Cultural History of a Biblical Story* (Oxford, 2017).

2 H. Diane Russell, *Eva/Ave: Women in Renaissance and Baroque Prints*, exh. cat., National Gallery of Art (Washington, DC, and New York, 1990); Susan L. Smith, *The Power of Women: A 'Topos' in Medieval Art and Literature* (Philadelphia, PA, 1995).

3 On this painting, see R. Ward Bissell, *Artemisia Gentileschi and the Authority of Art: Critical Reading and Catalogue Raisonné* (University Park, PA, 1999), cat. 11, pp. 211–13; and Keith Christiansen and Judith W. Mann, *Orazio and Artemisia Gentileschi: Father and Daughter Painters in Baroque Italy*, exh. cat., Museo del Palazzo di Venezia, Rome; Metropolitan Museum of Art, New York; and the Saint Louis (MO) Art Museum (New York, 2002), cat. 61, pp. 344–7.

4 Babette Bohn, 'Death, Dispassion, and the Female Hero: Artemisia Gentileschi's *Jael and Sisera*', in *The Artemisia Files: Artemisia Gentileschi for Feminists and Other Thinking People*, ed. Mieke Bal (Chicago, IL, 2005), pp. 107–27.

5 Jesse M. Locker, *Artemisia Gentileschi: The Language of Painting*
 (New Haven, CT, and London, 2015), p. 82; Mary D. Garrard,
 'Identifying Artemisia: The Archive and the Eye', in *Artemisia
 Gentileschi in a Changing Light*, ed. Sheila Barker (Turnhout, 2017)
 (pp. 11–40), p. 24.

6 Natalie Zemon Davis, 'Women on Top: Symbolic Sexual Inversion
 and Political Disorder in Early Modern Europe', in *The Reversible
 World: Symbolic Inversion in Art and Society*, ed. Barbara A. Babcock
 (Ithaca, NY, and London, 1978), pp. 147–90.

7 Joan de Jean, 'Violent Women and Violence against Women:
 Representing the "Strong" Woman in Early Modern France',
 Signs: Journal of Women in Culture and Society, XXIX (2003), pp. 117–47.

8 Ibid, pp. 135–6. The title of the print, *Il est brave comme un boureaux
 qui faict ses pasques* ('he is well-dressed like an executioner on Easter
 holiday'), is a French idiom.

9 Ibid., p. 143.

10 Marie le Jars de Gournay, 'The Equality of Men and Women', in
 Apology for the Woman Writing, and Other Works, ed. and trans. Richard
 Hillman and Colette Quesnel (Chicago, IL, and London, 2002)
 (pp. 69–95), p. 76.

11 Moderata Fonte, *Floridoro, A Chivalric Romance*, ed. and intro. Valeria
 Finucci, trans. Julia Kisacky (Chicago, IL, 2006), p. 144.

12 Arcangela Tarabotti, *Paternal Tyranny*, ed. and trans. Letizia Panizza
 (Chicago, IL, 2004), pp. 49–51.

13 For the texts and Plata's probable identification as G. F. Loredan,
 see Panizza, n. 53, p. 144, in Tarabotti, *Paternal Tyranny*.

14 Charles Darwin, *The Descent of Man and the Selection in Relation to Sex*
 (New York, 1871), vol. II, pt II, chap. XIX, pp. 326–9. For Otto
 Weininger's misogynist extension of Darwin's views on women,
 see Chandak Sengoopta, *Otto Weininger: Sex, Science, and Self in Imperial
 Vienna* (Chicago, IL, 2000).

15 Moderata Fonte, *The Worth of Women, Wherein Is Clearly Revealed
 Their Nobility and Their Superiority to Men*, ed. and trans. Virginia Cox
 (Chicago, IL, and London, 1997); Cristofano Bronzini, *Della dignità
 e nobilità delle donne* (Florence, 1624). On gender equality in these
 and other works, see Constance Jordan, *Renaissance Feminism: Literary
 Texts and Political Models* (Ithaca, NY, and London, 1990), chap. 4,

pp. 248–307; and Sarah Gwyneth Ross, *The Birth of Feminism: Woman as Intellect in Renaissance Italy and England* (Cambridge, MA, and London, 2009), chap. 7, pp. 276–99.

16 *Veronica Franco: Poems and Selected Letters* (Chicago, IL, and London, 1998), ed. and trans. Ann Rosalind Jones and Margaret F. Rosenthal, pp. 246–7.

17 Lucrezia Marinella, *The Nobility and Excellence of Women, and the Defects and Vices of Men*, ed. and trans. Anne Dunhill, intro. Letizia Panizza (Chicago, IL, 1999). Henricus Cornelius Agrippa, *Declamation on the Nobility and Preeminence of the Female Sex* [1529], trans. and ed. Albert Rabil, Jr (Chicago, IL, and London, 1996).

18 See Chapter One for these pairings.

19 *Faciebat* should be *faciebat*, which Artemisia spelled correctly in five other signed paintings. For these, see Judith W. Mann, 'Identity Signs: Meanings and Methods in Artemisia Gentileschi's Signatures', *Renaissance Studies*, XXIII (2009), pp. 71–107. Renaissance artists often signed their works *fecit*, but since the Latin verb means both 'did' and 'made', it could here signify both making the picture and doing the deed. The Uffizi *Judith* is signed at lower right 'Ego Artemitia/Lomi fec.'

20 For this identification and a self-portrait in Caravaggio's *David with Head of Goliath*, see Garrard, 'Identifying Artemisia', p. 18.

21 See Garrard, 'Artemisia's Hand', in *Artemisia Gentileschi: Taking Stock*, ed. Judith W. Mann (Turnhout, 2005), p. 117 and fig. 27. Some scholars ascribe the Barberini *Allegory* to Artemisia herself. Contrasting opinions are summarized in Garrard, 'Identifying Artemisia', p. 37, n. 31.

22 So speculate Bissell, *Artemisia Gentileschi*, cat. L-40; and Steven N. Orso, *Philip IV and the Decoration of the Alcázar of Madrid* (Princeton, NJ, 1986), pp. 55, 109–10. Another 'Hercules Spinning' by Artemisia, of different dimensions, is listed in the inventory of Carlo de Cárdenas (d.1691), a Spanish prince whose family lived in Naples (Bissell, *Artemisia Gentileschi*, cat. L-41).

23 Suzanne G. Cusick, *Francesca Caccini at the Medici Court: Music and the Circulation of Power* (Chicago, IL, and London, 2009), p. 91; Kelley Harness, *Echoes of Women's Voices: Music, Art, and Female Patronage in Early Modern Florence* (Chicago, IL, and London, 2006), p. 2.

24 Linda Woodbridge, *Women and the English Renaissance: Literature and the Nature of Womankind, 1540–1620* (Urbana, IL, and Chicago, IL, 1984), chap. 6 (pp. 139–51).

25 Angelico Aprosio, *Lo scudo di Rinaldo overo lo specchio di disganno* (Venice, 1646). See Wendy Heller, *Emblems of Eloquence: Opera and Women's Voices in Seventeenth-century Venice* (Berkeley, CA, Los Angeles, CA, and London, 2003), pp. 66–9.

26 Ginevra Conti Odorisio, *Donna e società nel Seicento: Lucrezia Marinelli e Arcangela Tarabotti* (Rome, 1979), pp. 137–8. This passage is not included in Marinella, *Nobility and Excellence*, an abridged version of Marinella's text.

27 Heller, *Emblems of Eloquence*, p. 8 and *passim*.

28 Heller discusses this and other role-reversal operas; ibid., p. 70.

29 Locker, *Artemisia Gentileschi*, pp. 97–9.

30 Heller, *Emblems of Eloquence*, p. 28.

31 And, as Heller suggested, paintings and texts about women are likely to have been a catalyst for opera, not the other way around. Locker, *Artemisia Gentileschi*, p. 98 and n. 92.

32 Carolyn Valone, 'Il Padovanino: A New Look and a New Work', *Arte Veneta*, XXXVI (1982), pp. 161–6; and Locker, *Artemisia Gentileschi*, pp. 70–72, 85–6.

33 For the X-rays and discussion see Garrard, *Artemisia Gentileschi*, pp. 72–9 and figs 66 and 67.

34 Mary responded to her son's tragic death with both grief and strength in the thirteenth-century hymn 'Stabat Mater dolorosa', but in Renaissance art this unified concept split into two iconographic types: the *mater dolorosa* was prevalent in northern Europe, while the *stabat mater* was preferred by the Italians.

35 Locker, *Artemisia Gentileschi*, pp. 78–83. Artemisia was probably thinking of Caravaggio's *Calling of St Matthew* of *c.* 1600, in S. Luigi dei Francesi, Rome. Ahasuerus resembles the two dandies on the right, with plumed hats, striped sleeves and well-toned legs in tight leggings.

36 Marinella, *Nobility and Excellence*, ch. 22 (pp. 166–75).

37 Tarabotta's 'anti-satirical' retort (*Antisatira*, Venice, 1644) was published a few years after Buoninsegna's satire (against the objections of her brother-in-law Pighetti and Padre Angelico

Aprosio), along with Buoninsegna's text, as *Satira e antisatira. Francesco Buoninsegni e Suor Arcangela Tarabotti*, ed. Elissa Weaver (Rome, 1998).

38 On these texts, see Heller, *Emblems of Eloquence*, pp. 63–72; and Panizza's introduction to Tarabotti, *Paternal Tyranny*, pp. 10–11. Also, Daniela De Bellis, 'Attacking Sumptuary Laws in Seicento Venice: Arcangela Tarabotti', in *Women in Italian Renaissance Culture and Society*, ed. Letizia Panizza (Oxford, 2000), pp. 227–42.

39 For the Italian texts of the poems and their now-accepted ascription to Loredan, see Bissell, *Artemisia Gentileschi*, cat. no. L-1 (pp. 355–60), L-54 (p. 374) and L-105 (pp. 388–9). For contrasting interpretations of the poems, see Garrard, *Artemisia Gentileschi*, pp. 172–4; and Bissell, *Artemisia Gentileschi*, pp. 38–41.

40 Bissell, *Artemisia Gentileschi*, app. III B, pp. 165–6.

41 Heller (*Emblems of Eloquence*, pp. 52–7) considers the possibility that his voice was satirical; also Locker, *Artemisia Gentileschi*, pp. 66–7, 87.

42 For Loredan's suppression of Tarabotti's treatise and his active support of clausura for women, see Panizza, introduction to *Paternal Tyranny*, pp. 14–15.

43 Moderata Fonte, *Worth of Women*, p. 61 (in the voice of Leonora).

44 *La secretaria di Apollo* (Amsterdam, 1653), pp. 193–4, as recounted by Panizza, introduction to *Paternal Tyranny*, p. 25.

45 For pro- and anti-Artemisia attributions of the Fogg *Joseph*, see Bissell, *Artemisia Gentileschi*, cat. X-11, pp. 316–17.

46 E.g., the Persian poet Ferdowsī (b.935), in his poem *Yūsof o-Zalikhā*. See *Encyclopaedia Britannica*, s.v. 'Ferdowsī'.

47 Garrard, *Artemisia Gentileschi*, no. 28, pp. 400–401. The *Joseph and Potiphar's Wife* Artemisia described in her last letter to Ruffo never entered his collection.

48 For versions of the theme by Orazio, Cigoli, Properzia de' Rossi and others, see Garrard, *Artemisia Gentileschi*, pp. 80–83.

49 On Properzia de' Rossi, see Fredrika H. Jacobs, *Defining the Renaissance 'Virtuosa': Women Artists and the Language of Art History and Criticism* (Cambridge, 1997), chap. 4, pp. 64–84.

50 On this picture, see Babette Bohn, 'The Antique Heroines of Elisabetta Sirani', in *Reclaiming Female Agency: Feminist Art History after*

Postmodernism, ed. Norma Broude and Mary D. Garrard (Berkeley, CA, Los Angeles, CA, and London, 2005), pp. 85–7.

51 On *donne infame*, see Locker, *Artemisia Gentileschi*, pp. 86–90, 98–9.

52 Christine de Pizan, *The Book of the City of Ladies* [1405], trans. Earl Jeffrey Richards (New York, 1982); trans. Rosalind Brown-Grant (London and New York, 1999), I.32.1, I.32.2 and II.56.1. In *Floridoro*, Moderata Fonte similarly redeemed Circe (Virginia Cox, 'Fiction, 1560–1650', in *A History of Women's Writing in Italy*, ed. Letizia Panizza and Sharon Wood (Cambridge, 2000), pp. 52–64, p. 60).

53 Boccaccio, *Famous Women*, trans. Virginia Brown (Cambridge, MA, and London, 2003), ch. XVII, pp. 37–9.

54 For this reading of the story, see Emma Griffiths, *Medea* (London and New York, 2006), pp. 41–50.

55 Emily McDermott, *Euripides' Medea: The Incarnation of Disorder* (University Park, PA, 1989), pp. 9–20; and Griffiths, *Medea*, p. 81.

56 Virginia Cox, *Lyric Poetry by Women of the Italian Renaissance* (Baltimore, MD, 2013), pp. 141–5.

57 Judith L. Mann, 'Deciphering Artemisia: Three New Narratives and How They Expand Our Understanding,' in *Changing Light*, ed. Barker, pp. 168–71. Artemisia's name is incised on the stone pillar behind Medea, as in *Jael and Sisera*.

58 Locker, *Artemisia Gentileschi*, pp. 86–7. I have doubted this attribution, despite the signature, because it is a stylistic anomaly in Artemisia's *oeuvre*. It could be a good copy of a lost painting, but it is also possible is that its unusual facture, with a broad, fluid brushstroke, was Artemisia's way of setting the work in a comic mode.

59 G. F. Loredan, *Scherzi geniali di Loredano* (Bologna, 1641), pp. 103–17 (Lucretia) and p. 79 (Helen).

60 See Griffiths, *Medea*, pp. 41–6, for Medea's early history and the literature.

61 Madlyn Millner Kahr, 'Delilah', in Norma Broude and Mary D. Garrard, *Feminism and Art History: Questioning the Litany* (New York, 1982), p. 119. The contested ascription of this painting to Artemisia, which I support, is summarized by Roberto Contini, in *Artemisia Gentileschi: The Story of a Passion*, ed. Roberto Contini and Francesco Solinas (Milan, 2011), cat. 35, p. 214.

62 Kahr, 'Delilah', pp. 134–5.

63 Tarabotti, *Paternal Tyranny*, p. 137.

64 Marinella, *Nobility and Excellence*, pp. 121–2. On Artemisia's painting, see Mary D. Garrard, 'Artemisia Gentileschi's "Corisca and the Satyr"', *Burlington Magazine*, CXXXV (1993), pp. 34–8, in which the painting's subject was first identified.

65 Marco Boschini, *La carta del navegar pittoresco* [1660], ed. Anna Pallucchini (Venice and Rome, 1964), p. 445. The frescoes were painted, probably in the 1590s, by Benedetto Cagliari and Giuseppe Alabardi, detto lo Schioppi.

66 Giambattista Guarini, *Il pastor fido, tragi-commedia pastorale* (Venice, 1590), Act II, scene 6.

67 Noted by J. H. Whitfield (Guarini, *Il pastor fido. The Faithfull Shepherd*, trans. Sir Richard Fanshawe, ed. and intro. J. H. Whitfield (Austin TX, 1977), p. 19).

68 Guarini, *Pastor fido*, Act II, scene 6.

69 Ibid., Act I, scene 3.

70 Garrard, 'Corisca', p. 36 and n. 20.

71 Guarini, *Pastor fido*, Act II, scene 6, ll. 2009–14. In this encounter, the satyr repeatedly describes Corisca as a wicked sorceress (*perfida maga, incantatrice*), invoking Circe and Medea without naming them. In Act III, scene 9, he rails against Corisca and all womankind.

72 See Virginia Cox, *The Prodigious Muse: Women's Writing in Counter-Reformation Italy* (Baltimore, MD, 2011), p. 93; and pp. 92–118, on the numerous pastoral dramas written by early modern women. Another pastoral involving nymphs outwitting satyrs is Valeria Miani's *Amorosa Speranza* (1604); see Cox, 'Fiction, 1560–1650', pp. 54–7.

73 Maddalena Campiglia, *Flori, A Pastoral Drama: A Bilingual Edition*, ed. and intro. Virginia Cox and Lisa Sampson, trans. Virginia Cox (Chicago, IL, and London, 2004); see especially the editors' introduction, pp. 20–24.

74 Isabella Andreini, *La mirtilla favola pastorale* (Verona, 1588), Act III, scene 2, ll. 1488–9. An English translation is Julie D. Campbell, *Isabella Andreini, La Mirtilla: A Pastoral* (Tempe, AZ, 2002). See also Julie D. Campbell, *Literary Circles and Gender in Early Modern Europe: A Cross-cultural Approach* (Aldershot and Burlington, VT, 2006), chap. 2, pp. 55–67.

75 Andreini, *La mirtilla*, Act v, scenes 2 and 3. The carving of a
 beloved's name on a tree is an ancient literary topos, newly
 popularized by Ariosto's Angelica and Medoro in *Orlando furioso*.
 Rensselaer W. Lee, *Names on Trees: Ariosto into Art* (Princeton, nj,
 1977).

76 Meredith Kennedy Ray discusses differing gender dynamics
 in pastoral dramas written by women and men in 'La Castità
 Conquistata: The Function of the Satyr in Pastoral Drama', *Romance
 Languages Annual*, ix (1998), pp. 312–21.

77 On Andreini as an intellectual and writer, see Ross, *Birth of
 Feminism*, pp. 212–34.

78 Andreini, *Mirtilla*, Act iv, scene 4; see Campbell, *Isabella Andreini, La
 Mirtilla*, introduction, p. xxi.

79 See Cox and Sampson, introduction to Campiglia's *Flori*, pp. 22–8;
 and for Circetta, see Finucci's introduction to Fonte, *Floridoro*,
 pp. 24–5.

80 Ferrante Pallavicino, *Il Corriero svaligiato* (Venice, 1641), pp. 10–15,
 letter 5; an English translation appears as appendix two in *Paternal
 Tyranny* (pp. 158–62).

81 On Terracina's *sopra il principio di tutti canti dell' Orlando furioso Discorso*
 (cited in Chapter One above), see Finucci, introduction to Fonte,
 Floridoro, p. 20. For the popularity of Fonte's *Floridoro*, see Cox,
 'Fiction, 1560–1650', p. 60. On female readership for women's
 writings and feminist treatises, see Cox, *Prodigious Muse*, pp. 92–118;
 and Androniki Dialeti, 'The Publisher Gabriel Giolito de' Ferrari,
 Female Readers, and the Debate about Women in Sixteenth-
 century Italy', *Renaissance and Reformation / Renaissance et Réforme*, n.s.,
 xxviii/4 (2004), pp. 5–32.

82 Leaving aside Maria Maddalena de' Medici and Henrietta Maria of
 England, I know one example: a Florentine widow, Laura Corsini,
 purchased a 'Judith' from Artemisia on 31 July 1617, which could
 have been the Naples version; see Francesca Baldassari, 'Artemisia
 nel milieu del Seicento fiorentino', in *Artemisia e il suo tempo*, exh.
 cat., Palazzo Braschi, Rome (Geneva and Milan, 2016), p. 27 and
 p. 33 n. 31.

6 The Divided Self: Allegorical and Real

1 R. D. Laing, *The Divided Self: An Existential Study in Sanity and Madness* (Harmondsworth, 1960).

2 I'm obliged to use the word 'feminine', a socially constructed identity that differs by grammatical nuance from 'female,' a biological identity, because there was no word yet for a stereotype-free female until the word 'feminist' was invented.

3 Moderata Fonte, *The Worth of Women, Wherein Is Clearly Revealed Their Nobility and Their Superiority to Men*, ed. and trans. Virginia Cox (Chicago, IL, and London, 1997), p. 68.

4 Moderata Fonte, *Floridoro, A Chivalric Romance*, ed. and intro. Valeria Finucci, trans. Julia Kisacky (Chicago, IL, 2006), pp. 97–8, and for the episode discussed here, pp. 89–98.

5 See Virginia Cox, 'Fiction, 1560–1650', in *A History of Women's Writing in Italy*, ed. Letizia Panizza and Sharon Wood (Cambridge, 2000), pp. 59–60, for an incisive discussion of the contrasting sisters.

6 See Finucci's introduction to Fonte, *Floridoro*, pp. 27–32.

7 I refer to the feminist classic by Sandra Gilbert and Susan Gubar, *The Madwoman in the Attic: The Woman Writer and the Nineteenth-century Literary Imagination* (New Haven, CT, and London, 1979).

8 On women and allegory, see Angus Fletcher, *The Theory of a Symbolic Mode* (Ithaca, NY, 1964); and Madeline Gutworth, *The Twilight of the Goddesses: Women and Representation in the French Revolutionary Era* (New Brunswick, NJ, 1992).

9 Fonte, *Worth of Women*, p. 83.

10 Lucrezia Marinella, *The Nobility and Excellence of Women, and the Defects and Vices of Men*, ed. and trans. Anne Dunhill, intro. Letizia Panizza (Chicago, IL, 1999), pt I, chap. 5, and p. 79.

11 Christine de Pizan, *The Book of the City of Ladies* [1405], trans. Earl Jeffrey Richards (New York, 1982); trans. Rosalind Brown-Grant (London and New York, 1999), I.34; I.35; I.39.

12 Cited by Christine Kooi, review of Anne R. Larsen, *Anna Maria van Schurman, 'The Star of Utrecht': The Educational Vision and Reception of a Savante in Early Modern Women, An Interdisciplinary Journal*, XI (2017), p. 210.

13 Arcangela Tarabotti, *Paternal Tyranny*, ed. and trans. Letizia Panizza (Chicago, IL, 2004), pp. 105–6.

14 Marie le Jars de Gournay, *Apology for the Woman Writing, and Other Works*, ed. and trans. Richard Hillman and Colette Quesnel (Chicago, IL, 2002), pp. 77–9. For Cereta, see Chapter 1.

15 Tarabotti, *Paternal Tyranny*, p. 99.

16 Ibid., p. 102. See also Paul F. Grendler, *Schooling in Renaissance Italy, Literacy and Learning, 1100–1600* (Baltimore, MD, and London, 1989), pp. 42–70.

17 Tarabotti, *Paternal Tyranny*, p. 109.

18 Quoted by Ginevra Conti Odorisio, *Donna e società nel Seicento: Lucrezia Marinelli e Arcangela Tarabotti* (Rome, 1979), p. 55. The passage is not included in Marinella, *Nobility and Excellence*, which is abridged.

19 Marinella, *Nobility and Excellence*, pp. 83–93.

20 Mary Tattle-well and Ioane Hit-him-home, *The Women's Sharpe Revenge* (London, 1640), University of Michigan Library Digital Collections, quod.lib.umich.edu, pp. 313–14, accessed 24 May 2019. This pamphlet is discussed in Chapter One.

21 Juan Luis Vives, *Instruction of a Christian Woman* (1523), as cited by Margaret L. King, *Women of the Renaissance* (Chicago, IL, and London, 1991), p. 165. King, ibid., pp. 164–88, surveys women's impoverished education in early modern Europe. See also J. R. Brink, ed., *Female Scholars: A Tradition of Learned Women before 1800* (Montreal, 1980); and Barbara J. Whitehead, ed., *Women's Education in Early Modern Europe: A History, 1500–1800* (New York, 1999).

22 Lodovico Dolce, *Dialogo della instituzion delle donne* (Venice, 1559), as cited by Grendler, *Schooling in Renaissance Italy*, pp. 87–8.

23 King, *Women of the Renaissance*, pp. 172–4.

24 Lavinia Fontana was a native of Bologna, a city noted for its inclusive education of women. On this picture, see Caroline P. Murphy, *Lavinia Fontana: A Painter and her Patrons in Sixteenth-century Bologna* (New Haven, CT, and London, 2003), pp. 73–6; and Joanna Woods-Marsden, *Renaissance Self-portraiture: The Visual Construction of Identity and the Social Status of the Artist* (New Haven, CT, and London, 1998), pp. 218–22.

25 Pizan, *City of Ladies*, 1.27.1.

26 Gournay, *Apology*, p. 81. Anna Maria van Schurman, *Whether a Christian Woman Should be Educated and Other Writings* (Chicago, IL, and London, 1998), pp. 25–37, esp. 36–7; Bathsua Makin, *An Essay to Revive the Antient Education of Gentlewomen in Religion, Manners, Arts and Tongues. With An Answer to the Objections against this Way of Education* (London, 1673) (Penn Libraries – University of Pennsylvania, digital.library.upenn.edu/women/makin/education/education. html, accessed 8 March 2018). The controversy over women's education continued well into the next century. For a summary of the situation for women in eighteenth-century Venice, see Norma Broude, 'G. B. Tiepolo at Valmarana: Gender Ideology in a Patrician Villa of the Settecento', *Art Bulletin*, XCI (June 2009), pp. 172–4.

27 Francesco Solinas, ed., *Lettere di Artemisia*, no. 15, pp. 44–5 (Petrarch); no. 16, pp. 48–9 (Ovid); and no. 21, pp. 64–6 (Ariosto).

28 Jesse Locker, 'The Literary Formation of an Unlearned Artist', in *Artemisia Gentileschi in a Changing Light*, ed. Sheila Barker (Turnhout, 2015), pp. 89–101; see also Ann Sutherland Harris, 'Artemisia Gentileschi: The Literate Illiterate, or Learning from Example', in *Docere, Delectare, Movere: Affetti e retorica nel linguaggio artistico nel primo barocco romano*, ed. Sible de Blaauw et al. (Rome, 1998), pp. 105–20.

29 Fonte, *Worth of Women*, pp. 225–8. On Marietta Robusti, see Carlo Ridolfi, *The Life of Tintoretto and of his Children Domenico and Marietta*, trans. Catherine Enggass and Robert Enggass (University Park, PA, 1984); and Whitney Chadwick, *Women, Art and Society* (London, 1990), pp. 15–20.

30 Strictly speaking, the opposition was between painting, at which the Venetians excelled, and *disegno*, a Florentine strength. For an overview, see David Rosand, *Painting in Cinquecento Venice* (New Haven, CT, and London, 1982), pp. 15–26.

31 A useful compendium of Renaissance positions on the *paragone* is Robert Klein and Henri Zerner, *Italian Art, 1500–1600, Sources and Documents* (Englewood Cliffs, NJ, 1966), pp. 3–16.

32 On this subject, see Anthony Blunt, *Artistic Theory in Italy, 1450–1600* (Oxford, 1940), chap. 4; Nikolaus Pevsner, *Academies of Art Past and Present* (Cambridge, 1940); Jonathan Brown, *Images and Ideas in*

Seventeenth-century Spanish Painting (Princeton, NJ, 1978), pp. 87–110; Mary D. Garrard, *Artemisia Gentileschi: The Image of the Female Hero in Italian Baroque Art* (Princeton, NJ, 1989), chap. 6; and Woods-Marsden, introduction to *Renaissance Self-portraiture* (pp. 1–17).

33 Fonte, *Worth of Women*, pp. 51–3. For this fountain's literary and emblematic connections, see Cox's editorial footnote in Fonte, *Worth of Women*, p. 51, n. 11; and Wendy Heller, *Emblems of Eloquence: Opera and Women's Voices in Eighteenth-century Venice* (Berkeley, CA, Los Angeles, CA, and London, 2003), pp. 37–9.

34 Mary D. Garrard, *Brunelleschi's Egg: Nature, Art and Gender in Renaissance Italy* (Berkeley, CA, Los Angeles, CA, and London, 2010), pp. 292–7.

35 The author transformed her given name, Modesta Pozzo (literally, a modest well), into Moderata Fonte (a mid-sized fountain) to define herself fictionally as 'a spring of life, a source of knowledge, and a stream of learning' (Valeria Finucci, introduction to *Floridoro*, p. 5).

36 For an overview of this pervasive concept, see Garrard, *Brunelleschi's Egg*, pp. 54–6.

37 On Titian's emblem, see Patrizia Costa, 'Artemisia Gentileschi in Venice', *Source: Notes in the History of Art*, XIX (2000), pp. 28–36; Garrard, *Brunelleschi's Egg*, pp. 207–11; and Jesse M. Locker, *Artemisia Gentileschi: The Language of Painting* (New Haven, CT, and London, 2015), pp. 51–3.

38 Fonte, *Floridoro*, Canto 10, stanzas 36–7. Cox discusses this passage in her introduction to Fonte's *Worth of Women*, p. 5.

39 Mary D. Garrard, 'Here's Looking at Me: Sofonisba Anguissola and the Problem of the Woman Artist', *Renaissance Quarterly*, XLVII (1994), pp. 556–622. Because recent conservation of this painting is problematic, I reproduce it in its unrestored state.

40 I proposed that it might be Antoine de Rosières, protégé of Charles of Lorraine, the Duke of Guise. Bissell named instead François de Rosières, a predecessor and supporter of the Duke of Guise's family line. Garrard, *Artemisia Gentileschi*, pp. 92–6; and Bissell, *Artemisia Gentileschi*, cat. 27, pp. 239–41.

41 For these figures' shared akimbo pose, see Mary D. Garrard, 'Artemisia's Hand', in Norma Broude and Mary D. Garrard,

Reclaiming Female Agency: Feminist Art History after Postmodernism (Berkeley, CA, Los Angeles, CA, and London, 2005), p. 74, figs 3.10 and 3.11.

42 Pointed out by Sheila Barker, 'The First Biography of Artemisia Gentileschi: Self-fashioning and Proto-feminist Art History in Cristofano Bronzini's Notes on Women Artists', *Mitteilungen des Kunsthistorischen Institutes*, LX (2018), pp. 422–3.

43 See Garrard, 'Identifying Artemisia: The Archive and the Eye', in *Changing Light*, ed. Barker, pp. 14–15, for this reading. Laura Camille Agoston independently arrived at a similar interpretation: Agoston, 'Allegories of Inclination and Imitation', ibid., pp. 110–12.

44 Agoston, ibid., noted the contrast between Michelangelo's agonistic struggle in sculpture and the light, graceful airiness of Artemisia's painted figure.

45 See Mary D. Garrard, *Artemisia Gentileschi around 1622: The Shaping and Reshaping of an Artistic Identity* (Berkeley, CA, Los Angeles, CA, and London, 2001), pp. 55–6, for the oval portrait and its attribution to an unidentified artist; and for its attribution to Artemisia, see Christiansen and Mann, *Orazio and Artemisia Gentileschi*, p. 253; and Locker, *Artemisia Gentileschi*, pp. 133–4. The Barberini *Allegory* is discussed in Chapter Five above.

46 Garrard, 'Identifying Artemisia', p. 15.

47 Garrard, *Artemisia Gentileschi* (1989), p. 339 and fig. 296.

48 It was identified as a self-portrait by Michael Levey, 'Notes on the Royal Collection – 11: Artemisia Gentileschi's "Self-portrait" at Hampton Court', *Burlington Magazine*, CIV (1962), pp. 78–80; Garrard, *Artemisia Gentileschi*, pp. 337–70; and Bissell, *Artemisia Gentileschi*, cat. 42, pp. 272–5. Judith W. Mann maintains the self-portrait identification. Mann, 'The Myth of Artemisia as Chameleon: A New Look at the London *Allegory of Painting*', in Judith W. Mann, *Artemisia Gentileschi: Taking Stock* (Turnhout, 2005), pp. 51–77.

49 Some of the documented self-portraits may overlap; see Bissell, *Artemisia Gentileschi*, cat. L-61 and L-62 (pp. 375–6); and cats L-88 through L-92 (p. 384). In cat. 42, Bissell discusses the two allegories of painting inventoried in 1649.

50 For the concepts discussed in this paragraph, and on Artemisia's innovative merging of portrait and allegory, see Garrard, *Artemisia Gentileschi*, chap. 6. For more on honorific gold chains and the picture's art-craft allusions, see Mann, 'Myth of Artemisia as Chameleon', pp. 58–60.

51 These include the keys at his belt and the cross of Santiago on his chest. See Brown, *Images and Ideas in Seventeenth-century Spanish Painting*, pp. 93–7.

7 Matriarchal Succession: The Greenwich Ceiling

 1 Revising Henrietta Maria's earlier negative image, recent scholars have investigated her political activity and patronage of theatre and the arts. See Erica Veevers, *Images of Love and Religion: Queen Henrietta Maria and Court Entertainments* (Cambridge, 1989); Erin Griffey, ed., *Henrietta Maria: Piety, Politics and Patronage* (Aldershot, 2008); and Grace Y. S. Cheng, 'Henrietta Maria as a Mediatrix of French Court Culture: A Reconsideration of the Decorations in the Queen's House', in *Perceiving Power in Early Modern Europe*, ed. Francis K. H. So (Kaohsiung, Taiwan, 2016), pp. 141–65. On the attribution of Henrietta Maria's patronage to King Charles I, who paid for many of her projects, see Griffey, *Henrietta Maria*, pp. 3–4; and Caroline Hibbard, '"By Our Direction and For Our Use": The Queen's Patronage of Artists and Artisans Seen through her Household Accounts', in *Henrietta Maria*, ed. Griffey, pp. 124–5.

 2 Works acquired by Henrietta Maria for the Greenwich House are detailed in John Bold, *Greenwich: An Architectural History of the Royal Hospital for Seamen and the Queen's House* (New Haven, CT, and London, 2000), pp. 63–76. See also Gabriele Finaldi, ed., *Orazio Gentileschi at the Court of Charles I* (London, Bilbao and Madrid, 1999); and Karen Serres, 'Henrietta Maria, Charles I and the Italian Baroque', in *Charles I, King and Collector*, exh. cat., London, Royal Academy of Arts (London, 2018), pp. 172–9.

 3 A 'Susanna and the Elders' and a half-length 'Fame' by Artemisia appear in the crown's inventory of 1639, acquired before her arrival. A self-portrait, an Allegory of Painting and a Bathsheba appear in the 1649 inventory, presumably painted during

Artemisia's English sojourn. Of these, only the *Allegory of Painting* at Kensington Palace is known to be preserved.

4 See R. Ward Bissell, *Artemisia Gentileschi and the Authority of Art: Critical Reading and Catalogue Raisonné* (University Park, PA, 1999), cat. 41, pp. 271–2; Finaldi, *Orazio Gentileschi at the Court of Charles I*, pp. 9–37; Gabriele Finaldi and Jeremy Wood, 'Orazio Gentileschi at the Court of Charles I', in Keith Christiansen and Judith W. Mann, *Orazio and Artemisia Gentileschi: Father and Daughter Painters in Baroque Italy*, exh. cat., Museo del Palazzo di Venezia, Rome; Metropolitan Museum of Art, New York; and the Saint Louis (MO) Art Museum (New York, 2002), pp. 223–31; and Cheng, 'Henrietta Maria as a Mediatrix'.

5 Clare McManus, ed., *Women and Culture at the Courts of the Stuart Queens* (Basingstoke and New York, 2003), Introduction, p. 7. See also Helen Payne, Aristocratic Women, Power, Patronage and Family Networks at the Jacobean Court, 1603–1625', in *Women and Politics in Early Modern England*, ed. James Daybell (Aldershot, 2004), pp. 164–80.

6 See especially McManus, *Women and Culture*, and Griffey, *Henrietta Maria*.

7 The description of the building as a 'House of Delight' dates from 1659. G. H. Chettle, *The Queen's House, Greenwich (London Survey XIV)* (London, 1937), p. 35.

8 Gabriele Finaldi, 'Orazio Gentileschi', in *Orazio Gentileschi at the Court of Charles I*, ed. Finaldi, pp. 24–7.

9 For documentation of the ceiling painting (destroyed) in the Queen's Cabinet in Somerset House, see Edward Croft-Murray, *Decorative Painting in England, 1537–1837* (London, 1962), vol. I, p. 197, no. 6.

10 Cheng, 'Henrietta Maria as a Mediatrix', p. 160.

11 I thank Allison Goudie, Curator of Art, Royal Museums Greenwich, for pointing out to me the proximity of the Queen's rooms to the Great Hall gallery.

12 Finaldi and Wood, 'Orazio Gentileschi at the Court of Charles I', pp. 229–30 and fig. 90.

13 See Veevers, *Images of Love and Religion*, Introduction, pp. 1–13; also Cheng, 'Henrietta Maria as a Mediatrix', pp. 146–50.

14 The characterization is Veevers's (*Images of Love and Religion*, p. 3).
 See also Colleen Fitzgerald, 'To Educate or Instruct? Du Bosc
 and Fénelon on Women', in *Women's Education in Early Modern Europe,
 1500–1800*, ed. Barbara J. Whitehead (New York and London,
 1999), pp. 159–91; and Carolyn Lougee, *Le Paradis des Femmes:
 Women, Salons, and Social Stratification in Seventeenth-century France*
 (Princeton, NJ, 1976), esp. pp. 27–30 and 53–4.
15 Jacques Du Bosc, *The Accomplish'd Woman*, trans. Walter Montague
 (1656), p. 69; cited by Cheng, 'Henrietta Maria as a Mediatrix',
 p. 159. Marinella's similar views on Minerva and the Muses are
 discussed in Chapter Six above.
16 When the ceiling canvases were moved to the Blenheim Saloon
 at Marlborough House, they were cut down to fit the smaller
 compartments of that space. Finaldi, *Orazio Gentileschi at the Court
 of Charles I*, pp. 29–30, gives details. Finaldi identifies the figures
 in the lower half of the central roundel as the best preserved,
 and observes that the three allegories at the top are likely
 eighteenth-century additions. The ceiling has suffered significant
 paint loss from damp, and many portions were at some point
 repainted. Cleaning and conservation in 1959–61 removed
 these overpaintings, and conservators concluded, regarding the
 Muse panels and corner roundels, that the original design was,
 on the whole, 're-enforced by repaint rather than invented'. The
 conservation state of the central roundel has not been precisely
 determined, but photographs taken after cleaning in 1960 indicate
 that the original design and arrangement of the lower figures (the
 liberal arts) and their attributes has been preserved. I am grateful
 to Lucy Whitaker, Senior Curator of Paintings, Royal Collection
 Trust, for generously sharing conservation records, and facilitating
 my inspection of the Marlborough House ceiling in the company
 of conservators and curators from the Royal Collection Trust, the
 Royal Museums Greenwich and the National Gallery (London).
17 Finaldi and Wood, 'Orazio Gentileschi at the Court of Charles I',
 p. 229.
18 E.g. Aurelian Townshend's masque *Albion's Triumph* (1632) and
 James Shirley's *The Triumph of Peace* (1634). See Finaldi, *Orazio
 Gentileschi at the Court of Charles I*, p. 29.

19 See Erin Griffey, *On Display: Henrietta Maria and the Materials of Magnificence at the Stuart Court* (London and New Haven, CT, 2015), chaps 3 and 4, for the multiple ways that imagery in the queen's residences reinforced the themes of fertility and motherhood.

20 See Diana Barnes ('*The Secretary of Ladies* and Feminine Friendship at the Court of Henrietta Maria', in *Henrietta Maria*, ed. Griffey, pp. 39–56) on the queen's political affiliations and activity.

21 Jacques Du Bosc, *Nouveau Recueil de lettres des dames de ce temps. Avec leurs responses* (Paris, 1635), trans. Ierome Hainhofer. Barnes (1638), '*Secretary of Ladies*', explains Henrietta Maria's role in circulating Du Bosc's writings in England.

22 See Julie Crawford, *Mediatrix: Women, Politics, and Literary Production in Early Modern England* (Oxford, 2014); and Christina Luckyj and Niamh J. O'Leary, eds, *The Politics of Female Alliance in Early Modern England* (Lincoln, NE, and London, 2017).

23 Barnes, '*Secretary of Ladies*', p. 48.

24 Artemisia arrived sometime in 1638; the exact date is unknown. Maria Cristina Terzaghi ('Artemisia Gentileschi a Londra', in *Artemisia Gentileschi e il suo tempo*, exh. cat., Palazzo Braschi, Rome (Geneva and Milan, 2017), p. 73) suggested the first months of that year; Bissell (*Artemisia Gentileschi*, pp. 59–60) proposed spring to summer 1638; Alexandra Lapierre (*Artemisia* [Paris, 1998], p. 387) thought she might have come with Marie de' Medici in November 1638.

25 In the will made a year before he died (dated 21 January 1638), Orazio left all his assets to his three sons, with no mention of Artemisia. Since a daughter would not normally have the right to inherit, the omission of her name tells us nothing about their relationship or her whereabouts.

26 Final payments are documented by Susan Alexandra Sykes, 'Henrietta Maria's "House of Delight": French Influence and Iconography in the Queen's House, Greenwich', *Apollo*, CXXXIII (1991), p. 332, n. 4. A payment covering the period October 1637 to September 1638 for 'framing and setting up partitions and putting up the Queen's canvases' was interpreted by Finaldi (*Orazio Gentileschi at the Court of Charles I*, p. 32) as indicating that the ceiling paintings were completed before Artemisia could plausibly

have participated. Yet this document is not likely to pertain to the Great Hall ceiling, since its framework was completed in 1636, and the floor tiles of matching design in 1636–7 (Bissell, *Artemisia Gentileschi*, p. 271). With the design and framework for the paintings in place, further partitions would not be needed. The September 1638 notice could refer to other rooms in the Queen's House, such as the Queen's Bedchamber or her Withdrawing Room, where wall, ceiling and cove paintings were installed or projected (Cheng, 'Henrietta Maria as a Mediatrix', pp. 152–3, gives details).

27 Garrard (*Artemisia Gentileschi*, pp. 112–21) and Bissell (*Artemisia Gentileschi*, cat. 41, pp. 271–2) attributed to Artemisia roughly half of the Muses in the side panels; Jacob Hess (cited by Bissell) had earlier ascribed to her Arithmetic in the central roundel. Maria Cristina Terzaghi ('Artemisia Gentileschi a Londra', pp. 69–77) has recently attributed to Artemisia many more figures in the roundel. I have independently come to similar conclusions based on inspection of the ceiling, conservation records and good modern photographs. Gabriele Finaldi (*Orazio Gentileschi at the Court of Charles I*, pp. 30–32) saw no sign of Artemisia's hand in the project, a position repeated in Finaldi and Wood, 'Orazio Gentileschi at the Court of Charles I', p. 230.

28 Orazio's Terpsichore is paired with Artemisia's Erato; Clio is by Orazio and Thalia is by Artemisia. I would tentatively ascribe all three figures in the remaining Muse panel to Orazio. See Garrard, *Artemisia Gentileschi*, figs 106–14.

29 Finaldi, *Orazio Gentileschi at the Court of Charles I*, p. 27.

30 Griffey, *Henrietta Maria*, p. 6, citing a letter of 27 June 1643. See also Michelle Anne White, *Henrietta Maria and the English Civil Wars* (Aldershot and Burlington, VT, 2006).

31 Sykes ('Henrietta Maria's "House of Delight"') discusses French elements imported by Henrietta Maria. Marie de' Medici wanted the Luxembourg Palace to resemble Palazzo Pitti in Florence, a request overruled by her French architects; see Deborah Marrow, *The Art Patronage of Maria de' Medici* (Ann Arbor, MI, 1982), p. 21.

32 On this double marriage alliance, which Marie reportedly considered the crowning achievement of her regency, see

Margaret D. Carroll, 'The Erotics of Absolutism: Rubens and the Mystification of Sexual Violence', in *The Expanding Discourse: Feminism and Art History*, ed. Norma Broude and Mary D. Garrard (New York, 1992), pp. 146–7.

33 See Marrow, *Art Patronage of Maria de' Medici*, pp. 61–3; Veevers, *Images of Love and Religion*, pp. 92–109; Jessica Bell, 'The Three Marys: The Virgin; Marie de Médicis; and Henrietta Maria', in *Henrietta Maria*, ed. Griffey, pp. 89–114; and Geraldine A. Johnson, 'Pictures Fit for a Queen: Peter Paul Rubens and the Marie de' Medici Cycle', in *Reclaiming Female Agency: Feminist Art History after Postmodernism*, ed. Norma Broude and Mary D. Garrard (Berkeley, CA, Los Angeles, CA, and London, 2005), pp. 101–19.

34 Murielle Gaude-Ferragu, *Queenship in Medieval France, 1300–1500 (The New Middle Ages)*, trans. Angela Krieger (London, 2016), chap. 3.

35 Marrow, *Art Patronage of Maria de' Medici*, p. 68.

36 Mary Henrietta, born in 1631, married a Prince of Orange; her son William (III) and his wife served as co-sovereigns of England (William and Mary).

37 I thank Sheila Barker for pointing out to me the meanings of the Italian word *aguzzare* and its relevance to the depicted joining of rasp and sword.

38 Tracy Adams and Glenn Rechtschaffen, 'Isabeau of Bavaria, Anne of France, and the History of Female Regency in France', *Early Modern Women: An Interdisciplinary Journal*, VIII (2013), pp. 119–47.

39 Karen Britland, 'An Under-stated Mother-in-law: Marie de Médicis and the Last Caroline Court Masque', in *Women and Culture*, ed. McManus, pp. 204–23.

40 Ibid.

41 Ibid., esp. pp. 217–18.

42 Marrow, *Art Patronage of Maria de' Medici*, p. 71. See also Geraldine A. Johnson, 'Imagining Images of Powerful Women: Maria de' Medici's Patronage of Art and Architecture', in *Women and Art in Early Modern Europe: Patrons, Collectors, and Connoisseurs*, ed. Cynthia Lawrence (University Park, PA, 1997), pp. 142–3, for the exchange of letters between Rubens and Marie's advisor, Peiresc, in which the political risks of depicting Artemisia or Semiramis (or any powerful woman) are considered.

43 Johnson, 'Pictures Fit for a Queen', pp. 105–7.

44 Sheila Barker, 'The First Biography of Artemisia Gentileschi: Self-fashioning and Proto-feminist Art History in Cristofano Bronzini's Notes on Women Artists', *Mitteilungen des Kunsthistorischen Institutes*, LX (2019), p. 421. (Bronzini's biography of Artemisia is discussed in Chapter One.)

45 Bathsua Makin, *An Essay to Revive the Antient Education of Gentlewomen in Religion, Manners, Arts and Tongues. With An Answer to the Objections against this Way of Education* (London, 1673) (Penn Libraries – University of Pennsylvania, digital.library.upenn.edu/women/makin/education/education.html, accessed 8 March 2018).

46 On *Bell in Campo*, see Margaret Cavendish, *Bell in Campo and The Sociable Companions*, ed. and intro. Alexandra G. Bennett (Ontario, 2002), and Claire Gheeraert-Graffeuille, 'Margaret Cavendish's *Femmes Fortes*: The Paradoxes of Female Heroism in *Bell in Campo* (1662)', *Revue de la Société d'études anglo-américaines des XVIIe et XVIIIe Siècles*, LXXIII (2016), pp. 243–65.

47 Astell and other English feminists are discussed in Chapter One.

SELECT BIBLIOGRAPHY

Agoston, Laura Camille, 'Allegories of Inclination and Imitation', in *Artemisia Gentileschi in a Changing Light*, ed. Sheila Barker (Turnhout, 2017), pp. 103–17

Andreini, Isabella, *La Mirtilla: A Pastoral* [1588], ed. and trans. Julie D. Campbell (Tempe, AZ, 2002)

Aragona, Tullia d', *Dialogue on the Infinity of Love* [1547], ed. and trans. Rinaldina Russell and Bruce Merry (Chicago, IL, and London, 1997)

The Ashgate Research Companion to Women and Gender in Early Modern Europe, ed. Allyson M. Poska, Jane Couchman and Katherine A. McIver (London and New York, 2013)

Bal, Mieke, ed., *The Artemisia Files: Artemisia Gentileschi for Feminists and Other Thinking People* (Chicago, IL, 2005)

Barker, Sheila, 'Artemisia's Money: The Entrepreneurship of a Woman Artist in Seventeenth-century Florence', in *Artemisia Gentileschi in a Changing Light*, ed. Sheila Barker (Turnhout, 2017), pp. 59–88

——, 'The First Biography of Artemisia Gentileschi: Self-fashioning and Proto-feminist Art History in Cristofano Bronzini's Notes on Women Artists', *Mitteilungen des Kunsthistorischen Institutes*, LX (2018), pp. 404–35

——, ed., *Women Artists in Early Modern Italy: Careers, Fame, and Collectors* (Turnhout, 2016)

——, ed., *Artemisia Gentileschi in a Changing Light* (Turnhout, 2017)

Benson, Pamela Joseph, *The Invention of the Renaissance Woman: The Challenge of Female Independence in the Literature and Thought of Italy and England* (University Park, PA, 1992)

Bissell, R. Ward, *Artemisia Gentileschi and the Authority of Art: Critical Reading and Catalogue Raisonné* (University Park, PA, 1999)

Boccaccio, Giovanni, *Famous Women* [1374], trans. Virginia Brown (Cambridge, MA, and London, 2003)

Bohn, Babette, 'Death, Dispassion, and the Female Hero: Artemisia Gentileschi's *Jael and Sisera*', in *The Artemisia Files: Artemisia Gentileschi for Feminists and Other Thinking People*, ed. Mieke Bal (Chicago, IL, 2005), pp. 107–27

Campbell, Julie D., and Maria Galli Stampino, eds, *In Dialogue with the Other Voice in Sixteenth-century Italy: Literary and Social Contexts for Women's Writing* (Toronto, 2011)

Cereta, Laura, *Collected Letters of a Renaissance Feminist* [1488], ed. and trans. Diana Robin (Chicago, IL, 1997)

Cheng, Grace Y. S., 'Henrietta Maria as a Mediatrix of French Court Culture: A Reconsideration of the Decorations in the Queen's House', in *Perceiving Power in Early Modern Europe*, ed. Francis K. H. So (Kaohsiung, Taiwan, 2016), pp. 141–65

Christiansen, Keith, 'Becoming Artemisia: Afterthoughts on the Gentileschi Exhibition', *Metropolitan Museum Journal*, XXXIX (2004), pp. 101–26

Christiansen, Keith, and Judith W. Mann, *Orazio and Artemisia Gentileschi: Father and Daughter Painters in Baroque Italy*, exh. cat., Museo del Palazzo di Venezia, Rome; Metropolitan Museum of Art, New York; and the Saint Louis (MO) Art Museum (New York, 2002)

Cohen, Elizabeth S., 'The Trials of Artemisia Gentileschi: A Rape as History', *Sixteenth Century Journal*, XXXI (2000), pp. 47–75

—, 'More Trials for Artemisia Gentileschi: Her Life, Love and Letters in 1620', in *Patronage, Gender and the Arts in Early Modern Italy: Essays in Honor of Carolyn Valone*, ed. Katherine A. McIver and Cynthia Stollhans (New York, 2015), pp. 249–72

Contini, Roberto and Francesco Solinas, eds, *Artemisia Gentileschi: The Story of a Passion* (Milan, 2011)

Cox, Virginia, *Women's Writing in Italy, 1400–1650* (Baltimore, MD, 2008)

—, *The Prodigious Muse: Women's Writing in Counter-Reformation Italy* (Baltimore, MD, 2011)

—, *Lyric Poetry by Women of the Italian Renaissance* (Baltimore, MD, 2013)

Cropper, Elizabeth, 'Life on the Edge: Artemisia Gentileschi, Famous Woman Painter', in Keith Christiansen and Judith W. Mann, *Orazio and Artemisia Gentileschi: Father and Daughter Painters in Baroque*

Italy, exh. cat, Museo del Palazzo di Venezia, Rome; Metropolitan Museum of Art, New York; and the Saint Louis (MO) Art Museum (New York, 2002), pp. 263–81

Cusick, Suzanne G., *Francesca Caccini at the Medici Court: Music and the Circulation of Power* (Chicago, IL, and London, 2009)

Dialeti, Androniki, 'The Publisher Gabriel Giolito de' Ferrari, Female Readers, and the Debate about Women in Sixteenth-century Italy', *Renaissance and Reformation / Renaissance et Réforme*, n.s., XXVIII (2004), pp. 5–32

Fonte, Moderata, *Floridoro, A Chivalric Romance* [1581], ed. and intro. Valeria Finucci, trans. Julia Kisacky (Chicago, IL, 2006)

—, *The Worth of Women, Wherein Is Clearly Revealed Their Nobility and Their Superiority to Men* [1600], ed. and trans. Virginia Cox (Chicago, IL, and London, 1997)

Franco, Veronica, *Poems and Selected Letters* [1575; 1580], ed. and trans. Ann Rosalind Jones and Margaret F. Rosenthal (Chicago, IL, and London, 1998)

Garrard, Mary D., *Artemisia Gentileschi: The Image of the Female Hero in Italian Baroque Art* (Princeton, NJ, 1989)

—, 'Artemisia Gentileschi's "Corisca and the Satyr"', *Burlington Magazine*, CXXXV (1993), pp. 34–8

—, *Artemisia Gentileschi around 1622: The Shaping and Reshaping of an Artistic Identity* (Berkeley, CA, Los Angeles, CA, and London, 2001)

—, 'Artemisia's Hand', in *Reclaiming Female Agency*, ed. Norma Broude and Mary D. Garrard (Berkeley, CA, Los Angeles, CA, and London, 2005), pp. 63–79. Republished in Mieke Bal, ed., *The Artemisia Files* (Chicago, IL, 2005), pp. 1–31; and in *Artemisia Gentileschi: Taking Stock*, ed. Judith W. Mann (Turnhout, 2005), pp. 99–120

—, 'Identifying Artemisia: The Archive and the Eye,' in *Artemisia Gentileschi in a Changing Light*, ed. Sheila Barker (Turnhout, 2017), pp. 11–40

Gournay, Marie le Jars de, 'The Equality of Men and Women' [1622], in de Gournay, *Apology for the Woman Writing, and Other Works*, ed. and trans. Richard Hillman and Colette Quesnel (Chicago, IL, and London, 2002), pp. 69–95

Griffey, Erin, ed., *Henrietta Maria: Piety, Politics and Patronage* (Aldershot, 2008)

Harness, Kelley, *Echoes of Women's Voices: Music, Art, and Female Patronage in Early Modern Florence* (Chicago, IL, and London, 2006)

Heller, Wendy, *Emblems of Eloquence: Opera and Women's Voices in Eighteenth-century Venice* (Berkeley, CA, Los Angeles, CA, and London, 2003)

Henderson, Katherine Usher, and Barbara F. McManus, *Half Humankind: Contexts and Texts of the Controversy about Women in England, 1540–1640* (Urbana, IL, and Chicago, IL, 1985)

Jacobs, Fredrika H., *Defining the Renaissance 'Virtuosa': Women Artists and the Language of Art History and Criticism* (Cambridge, 1997)

Jordan, Constance, *Renaissance Feminism: Literary Texts and Political Models* (Ithaca, NY, and London, 1990)

Kelly, Joan, 'Early Feminist Theory and the "Querelles de Femmes", 1400–1789', *Signs: Journal of Women in Culture and Society*, VIII (1982), pp. 4–28

King, Margaret L., *Women of the Renaissance* (Chicago, IL, and London, 1991)

—, and Albert Rabil, Jr, *Her Immaculate Hand: Selected Works by and about the Women Humanists of Quattrocento Italy* (Asheville, NC, 2000)

Labalme, Patricia H., *Beyond Their Sex: Learned Women of the European Past* (New York, 1980)

Locker, Jesse M., *Artemisia Gentileschi: The Language of Painting* (New Haven, CT, and London, 2015)

Maclean, Ian, *Woman Triumphant: Feminism in French Literature, 1610–1652* (Oxford, 1977)

Makin, Bathsua, *An Essay to Revive the Antient Education of Gentlewomen in Religion, Manners, Arts and Tongues. With An Answer to the Objections against this Way of Education* (London, 1673) (Penn Libraries – University of Pennsylvania, digital.library.upenn.edu/women/makin/education/ education.html, accessed 8 March 2018)

Malcolmson, Cristina, and Mihoko Suzuki, eds, *Debating Gender in Early Modern England, 1500–1700* (Basingstoke, 2002)

Mann, Judith W., 'Deciphering Artemisia: Three New Narratives and How They Expand Our Understanding', in *Artemisia Gentileschi in a Changing Light*, ed. Sheila Barker (Turnhout, 2017), pp. 167–86

—, ed., *Artemisia Gentileschi: Taking Stock* (Turnhout, 2005)

Marinella, Lucrezia, *The Nobility and Excellence of Women, and the Defects and Vices of Men* (Venice, 1600), ed. and trans. Anne Dunhill, intro. Letizia Panizza (Chicago, IL, 1999)

——, *Exhortations to Women and to Others if They Please* [1645], ed. and trans. Laura Benedetti (Toronto, 2012)

Panizza, Letizia, ed., *Women in Italian Renaissance Culture and Society* (Oxford, 2000)

——, and Sharon Wood, eds, *A History of Women's Writing in Italy* (Cambridge, 2000)

Papi, Gianni, 'Mary Magdalene in Ecstasy and the *Madonna of the Svezzamento*: Two Masterpieces by Artemisia', in *Artemisia Gentileschi in a Changing Light*, ed. Sheila Barker (Turnhout, 2017), pp. 147–66

Pizan, Christine de, *The Book of the City of Ladies* [1405], trans. Earl Jeffrey Richards (New York, 1982); trans. Rosalind Brown-Grant (London and New York, 1999)

Price, Paola Malpezzi, and Christine Ristaino, *Lucrezia Marinella and the 'Querelles des Femmes' in Seventeenth-century Italy* (Madison, WI, and Teaneck, NJ, 2008)

Robin, Diana, *Publishing Women: Salons, the Presses, and the Counter-Reformation in Sixteenth-century Italy* (Chicago, IL, and London, 2007)

Rosenthal, Margaret F., *The Honest Courtesan: Veronica Franco, Citizen and Writer in Sixteenth-century Venice* (Chicago, IL, 1992)

Ross, Sarah Gwyneth, *The Birth of Feminism: Woman as Intellect in Renaissance Italy and England* (Cambridge, MA, and London, 2009)

Schurman, Anna Maria van, *Whether a Christian Woman Should be Educated and Other Writings* [1648], ed. and trans. Joyce L. Irwin (Chicago, IL, and London, 1998)

Smith, Hilda L., *Reason's Disciples: Seventeenth-century English Feminists* (Urbana, IL, Chicago, IL, and London, 1982)

Smith, Susan L., *The Power of Women: A 'Topos' in Medieval Art and Literature* (Philadelphia, PA, 1995)

Solinas, Francesco, ed., with Michele Nicolaci and Yuri Primarosa, *Lettere di Artemisia: edizione critica e annotate con quarantatre documenti inediti* (Paris, 2011)

Tarabotti, Arcangela, *Paternal Tyranny* [1654], ed. and trans. Letizia Panizza (Chicago, IL, and London, 2004)

—, *Letters Familiar and Formal*, ed. and trans. Meredith K. Ray and Lynn
 Lara Westwater (Chicago, IL, 2012)
Veevers, Erica, *Images of Love and Religion: Queen Henrietta Maria and Court
 Entertainments* (Cambridge, 1989)
Wiesner-Hanks, Merry, *Women and Gender in Early Modern Europe*
 (Cambridge, 2002)
Willard, Charity Cannon, *Christine de Pizan: Her Life and Works*
 (New York, 1984)

ACKNOWLEDGEMENTS

I am grateful, first of all, to my fellow Artemisians for collegial stimulation and constructive disagreements: Sheila Barker, R. Ward Bissell, Keith Christiansen, Elizabeth Cohen, Roberto Contini, Ann Sutherland Harris, Riccardo Lattuada, Jesse Locker, Judy Mann, Gianni Papi, Francesco Solinas, Richard Spear and Cristina Terzaghi. I owe special thanks to Sheila Barker for many fruitful intellectual exchanges and favours both large and small.

I extend heartfelt admiration and gratitude to feminist-minded scholars of literature, history and music, pioneers of gender studies in the early modern period, whose writings have informed and continuously inspired my work on this book, especially Pamela Benson, Virginia Cox, Suzanne Cuzick, Valeria Finucci, Kelley Harness, Wendy Heller, Constance Jordan, Letizia Panizza, Hilda Smith and Mihoko Suzuki.

For generous assistance on particular matters, I thank as well Consuelo Lollobrigida, Lisa Goldenberg Stoppato and three very obliging curators: Allison Goudie of the Royal Museums, Greenwich; Letizia Treves at the National Gallery, London; and Lucy Whitaker of the Royal Collection Trust. I am further grateful to François Quiviger, editor of this Renaissance Lives series, for useful editorial suggestions. And I am, as always, deeply indebted to Norma Broude for astute editorial advice and her ongoing support and encouragement.

Finally, and fundamentally, I thank Michael Leaman, publisher at Reaktion Books, for his positive reception of a book on this subject, offered by me in place of the one he invited me to write for the series. At Reaktion Books, I am further grateful to Martha Jay, Managing Editor, and her copy-editor; and to Alex Ciobanu and the entire team for a smooth, efficient and helpful editorial process.

PHOTO ACKNOWLEDGEMENTS

The author and publishers wish to express their thanks to the below sources of illustrative material and/or permission to reproduce it. Some locations of artworks are also given below, in the interests of brevity:

akg-images/Erich Lessing: 7; Alinari/Art Resource, NY: 35, 39, 59; Associazione Metamorfosi, Rome/photo Scala/Art Resource, NY: 62; Bibliothèque nationale de France, Paris/Bridgeman Images: 33; from Domizio Bombarda, ed., *Il teatro delle glorie della signora Adriana Basile* (Naples, 1628), photo courtesy Folger Shakespeare Library, Washington, DC: 31; bpk Bildagentur/Gemäldegalerie Alte Meister, Dresden/Hans-Peter Klut/ Art Resource, NY: 64; © The British Library Board/Leemage/Bridgeman Images: 3; British Museum, London: 11; photo © Christie's Images/ Bridgeman Images: 30, 60, 61; collection of the author: 1, 56; Detroit Institute of Arts, Gift of Mr Leslie H. Green/Bridgeman Images: 10, 42; Fondazione Musei Civici di Venezia – © Photo Archive 2019: 2; photo Francesco Fumagalli/Electa/Mondadori Portfolio via Getty Images: 51; Galleria Nazionale d'Arte Antica, Palazzo Barberini, Rome: 37, 47; Galleria Spada, Rome/Bridgeman Images: 29; Gallerie degli Uffizi, Florence: 24; Gerolamo Etro Collection, Milan/photo Manusardi ArtPhotoStudio: 18; Getty Research Institute, Los Angeles/Bridgeman Images: 46; photo courtesy Allison Goude: 65; Graf von Schönborn Collection, Pommers- felden/Bridgeman Images: 16, 17; Harvard Art Museums/Fogg Museum, Gift of Samuel H. Kress Foundation: 50; The John and Mable Ringling Museum of Art, Sarasota, FL: 34; Marlborough House, Main Hall, London: 66; The Metropolitan Museum of Art, New York: 48; Musée du Louvre, Paris/photo Thierry Le Mage/© RMN-Grand Palais/Art Resource, NY: 20; Museo degli Argenti, Palazzo Pitti, Florence/De Agostini Picture

INDEX

Illustration numbers are indicated by *italics*